LAYOUT LOOK BOOK 2

Max Weber

LAYOUT LOOK BOOK 2

Max Weber

COLLINS DESIGN

An Imprint of HarperCollins Publishers

LAYOUT LOOK BOOK 2
Copyright © 2010 by COLLINS DESIGN and **maomao** publications

First Edition published in 2010 by
Collins Design
An Imprint of HarperCollins*Publishers*
10 East 53rd Street
New York, NY 10022
Tel.: (212) 207 7000
Fax: (212) 207 7654
CollinsDesign@harpercollins.com
www.harpercollins.com

Distributed throughout the world by
HarperCollinsPublishers
10 East 53rd Street
New York, NY 10022
Fax: (212) 207 7654

Packaged by
maomao publications
2010 © **maomao** publications
Via Laietana, 32 4th fl. of. 104
08003 Barcelona, España
Tel. : +34 93 268 80 88
Fax : +34 93 317 42 08
www.maomaopublications.com

Publisher:
Paco Asensio

Editorial Coordinator:
Anja Llorella Oriol

Editor & Art Direction:
Max Weber

Editorial Assistant:
Julia Nestor

Layout:
Maira Purman

Cover Design:
Max Weber

Translation:
Cillero & de Motta

Library of Congress Control Number: 2010924385

ISBN 978-0-06-199511-8

Printed in Spain

First Printing, 2010

Layout Look Book 2

Layout Look Book 2 offers a cross-section of current trends in print design and presents works of a quality that sets them apart from the rest. The examples displayed in this book include everything from business cards, exhibition design materials, posters, and books. People from all around the world are on a quest to find fresh, unusual, and appealing designs.

Both big names and small firms new on the scene are represented here and presented on equal footing. Professional and amateur designers alike can use this book for inspiration. Featuring comprehensive interviews and contact information, this book is more than a source of inspiration; it's also a must-have reference.

The book is deliberately confined to the world of print design and aims to show that printed graphics can still be relevant and contemporary—even in today's world, when the majority of everything that aspires to be modern and "in" is digital. The multitude of artistic and technical resources used in print are represented by the diversity of work collected here. Rough drawings, folding techniques, collage and photographs, and digitally generated imagery are all included. The selected works were chosen for their quality as well as their powerful concept and clarity of design.

Layout Look Book 2 shows what print design has to offer in contrast to the digital world. It goes beyond the call for information to embrace a more immediate and somewhat sensual perception. Print design offers not only the visual dimension but also haptic qualities. The illustrated works also playfully enter a third dimension, when a page from a book is cut into strips, a poster is riddled with holes or folded over, invitations are embroidered or business cards begin to glow. Print design has a tremendous presence, since it forms a ubiquitous part of our everyday life. Thus, despite the e-books and on-line magazines, it is not about to lose its validity.

This book not only illustrates the current work of over 50 offices, but also features accompanying text that places the ideas and concepts into context. In brief interviews, the designers give an exciting insight into their work methods with a very personal touch and plenty of humor, offering a characteristic portrayal of themselves in a few pithy statements. The works are very different from one another, as are their authors, who have their own work methods, opinions, and desires. Both

artistic and scientific approaches, philosophical and pragmatic perspectives offer starting points for your own creation.

The book is divided into the following 5 chapters:
MAGAZINES: In this chapter, magazines and periodicals are presented with diverse subject matter. Thus, the works range from the limited typographic art journal to the striking glossy magazine.
POSTERS: Everywhere in the public domain, individual and serial posters demand our attention, divulging information for a brief instant. To create these eye-catching works, graphic designers avail themselves to a wide range of techniques. Minimalist typography stands alongside handwritten work, and black and white alongside striking color. Paper is folded, cut, or punctured with holes; even a graffiti robot is used.
BOOKS: The examples of book layout included in this chapter not only show how the use of image and text, but also the printing technique, choice of paper, and binding can effect the look and feel of a book. While some of the books illustrated are classic graphic transformations of literature or documentation on art or architecture, others depict individual projects.
MUSIC: This chapter showcases top LP and/or CD layout designs. Layout design of LP and CD covers, on the one hand, offers tremendous creative freedom for the designer to create artwork that visually expresses the music. On the other hand, however, it is also difficult. Designers usually just have a few images (resources) to work with. This chapter highlights the best techniques to make the most of a daunting job.
MISCELLANEOUS: The final chapter is a miscellaneous compilation of event campaign materials, corporate images, business cards, stationery, and programs that show the diversity of resources being used in print design today.

The Internet has made it much easier and faster for designers to exchange ideas. A great many blogs are used as sources of information and inspiration. This book aims to provide an opportunity to pause a while and reflect on a heterogeneous cross-section of contemporary snapshots that span the world of print design and sometimes even effect and help shape the digital world.

MAGAZINES

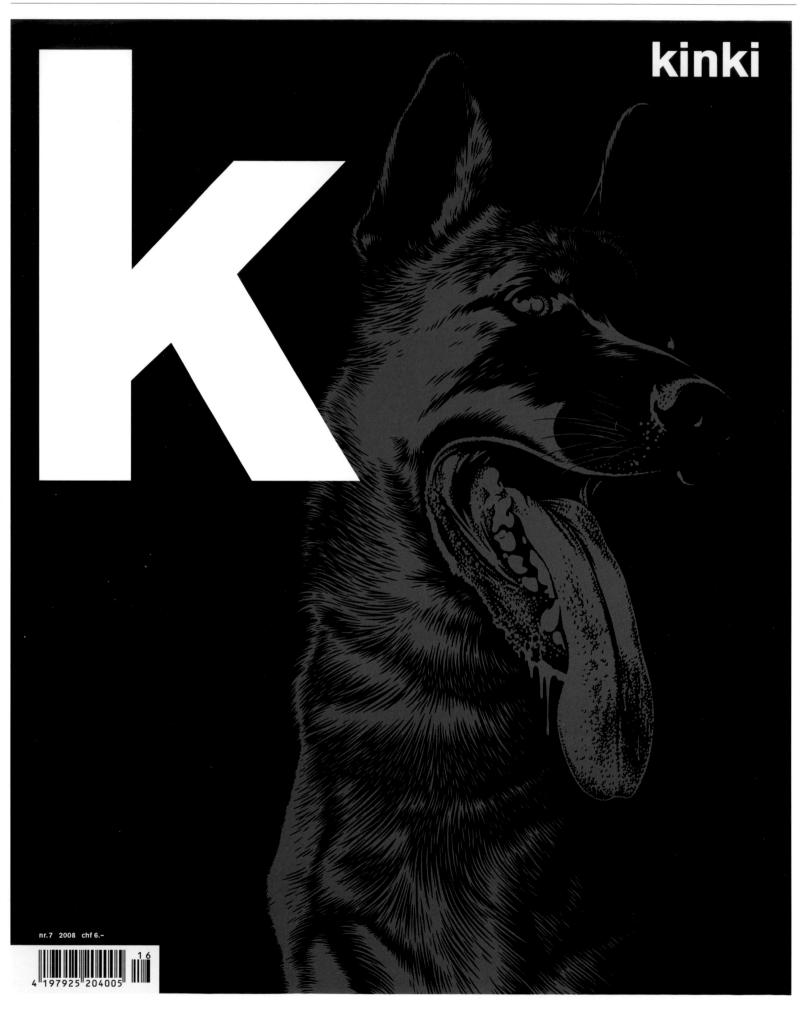

nr.7 2008 chf 6.–

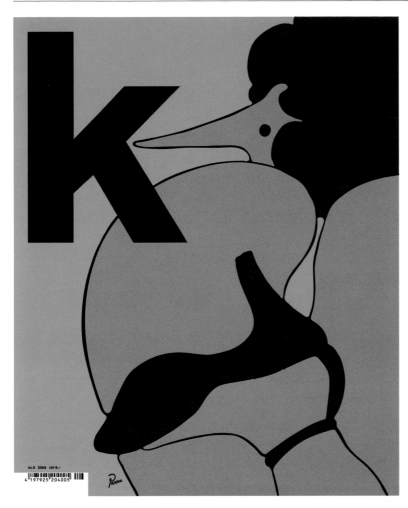

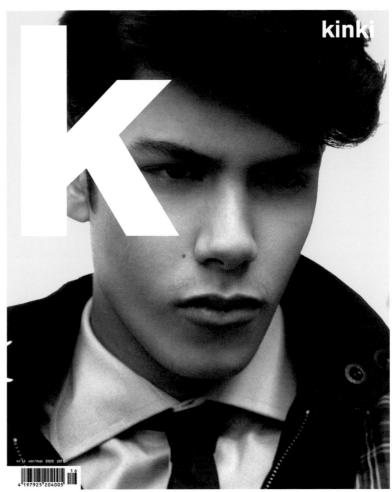

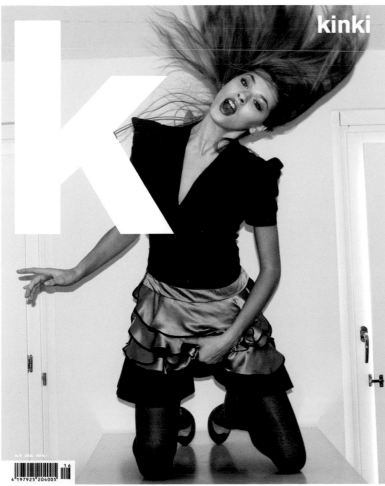

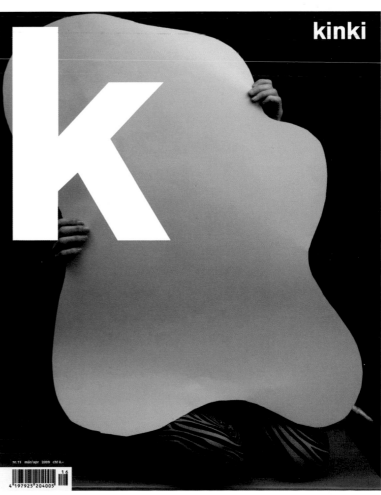

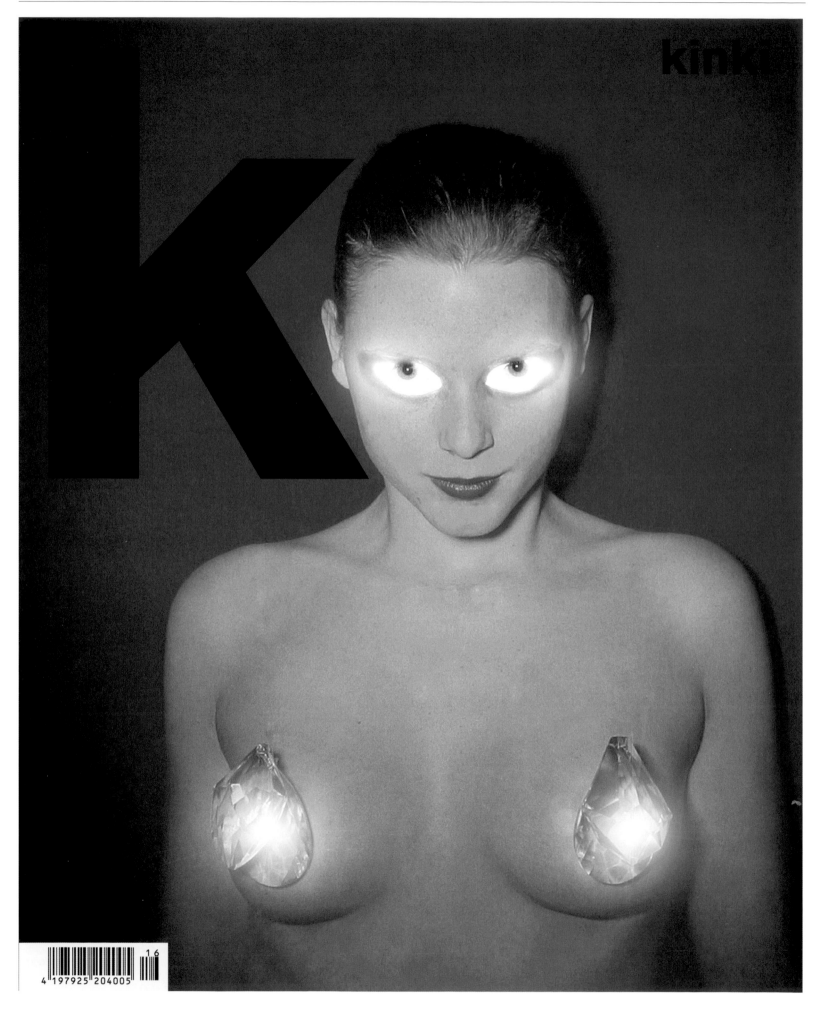

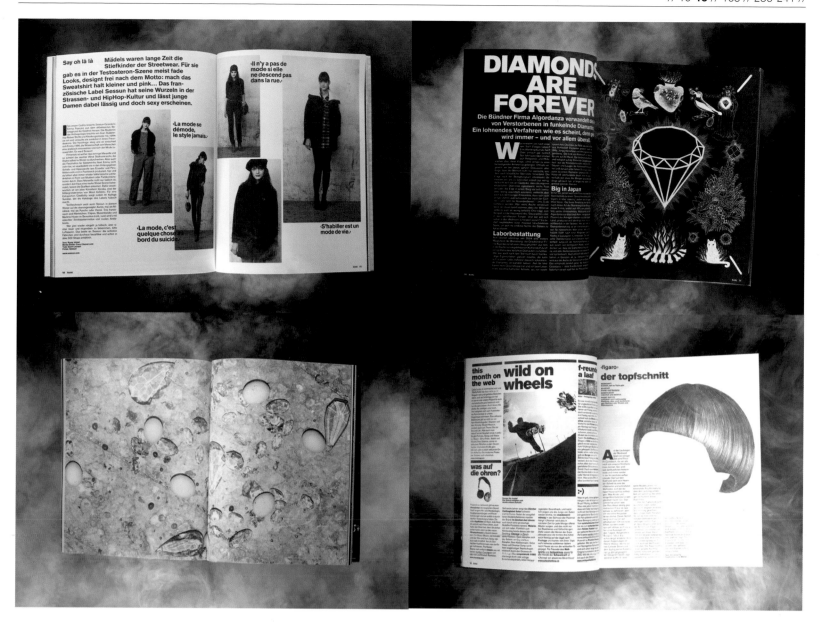

Kinki Magazine

What was your inspiration for this work? The beauty of Akzidenz-Grotesk.
What is special, unusual, or unique about this project? *Kinki* is a good opportunity for us to ask all the good illustrators and photographers we've always wanted to work with, for example Parra, Geoff McFetridge, Anne de Vries, etc.

Did you run into any specific problems or challenges while creating this work? The usual suspect: lack of time.
Do you recall unexpected reactions to this work? In the beginning, it was hard to establish "another lifestyle magazine."

Raffinerie // Reto Ehrbar, Nenad Kovačić // Zurich, Switzerland // www.raffinerie.com

Founded in 2000 by Reto Ehrbar and Nenad Kovačić, Raffinerie is a Zurich-based design studio, working with a versed team of designers and illustrators.
Describe your early influences. Bruno Munari, Josef Müller Brockmann, Max Huber, and Jean-Michel Jarre.
What do you consider quality in graphic design? If something is refined and simple at the same time.
What does your working environment look like? Loft-like, in the back of the building. We have a grill out front.
What inspires you? A blank paper in front of us.
What is your worst nightmare? Working with Windows.

Tell us the story of the name of your studio. It originated from the dot-com time in 1999, when everything in the German language was set in English. We tried to find a name that was the opposite of that. And because the URL was vacant as well. The expressions "to refine" and "refined" are also related to it.
What is your workout for creativity? Going to parties, concerts, exhibitions, and eating half a pound of chocolate every second day.
Where do you find new energy? In the fresh air of the Swiss Alps.
If you could live in another place for one year, where would that be? We would never leave Switzerland.
What is your dream of happiness? Love, peace, and cheese.

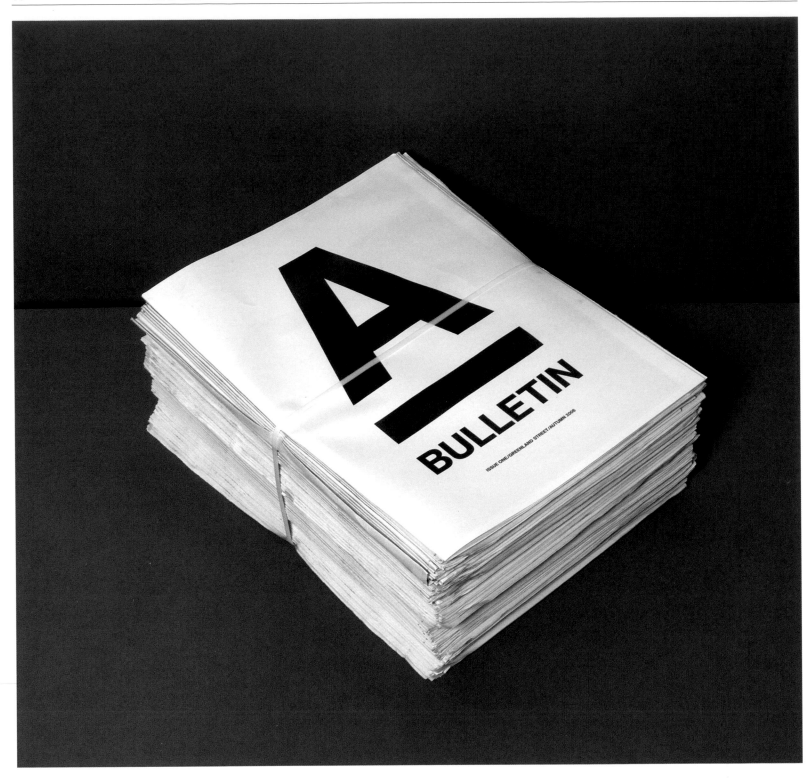

A Bulletin

A Bulletin is an annual publication by A Foundation. Its purpose is to engage a non-arts audience with contemporary art. It is available free of charge and includes editorial and information relating to A Foundation's activities and gallery program. We choose a newspaper format for its immediacy and accessibility. This super-economical format allows print runs and distribution far beyond other means.

Foreword

GREENLAND STREET

What is Greenland Street?

The Blade Factory

The Furnace

The Coach Shed

Greenland Street, March 2006 - photographed by Dan Holdsworth

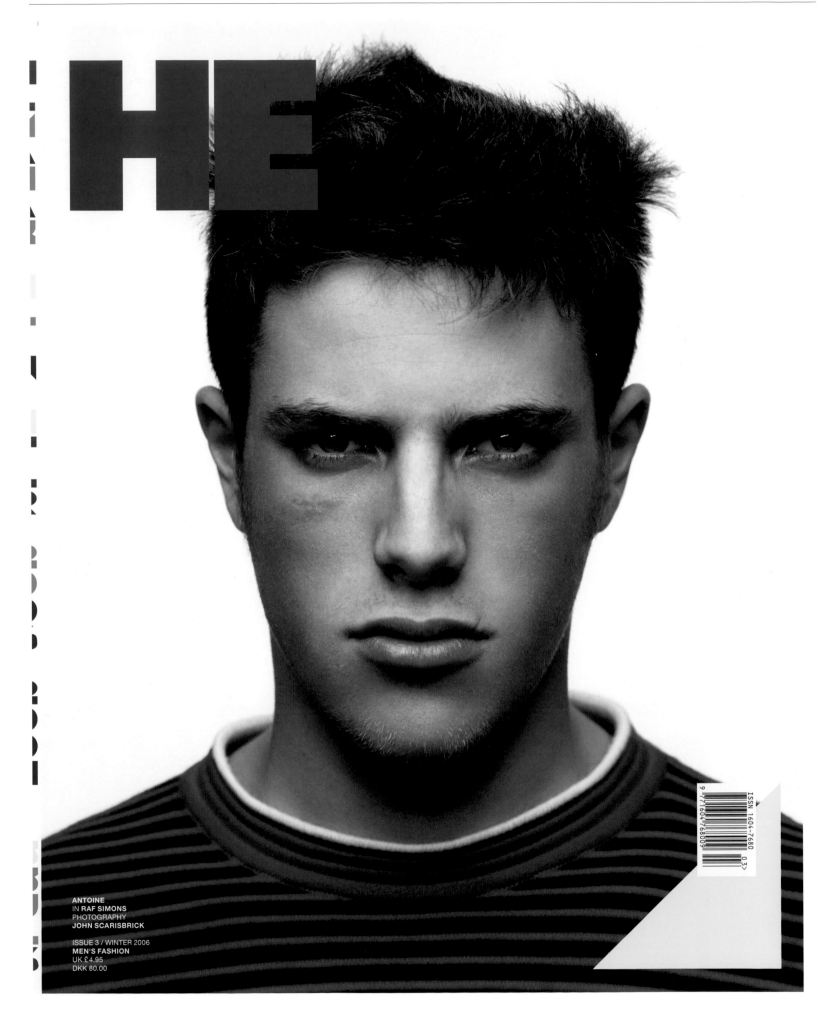

HE

ANTOINE
IN RAF SIMONS
PHOTOGRAPHY
JOHN SCARISBRICK

ISSUE 3 / WINTER 2006
MEN'S FASHION
UK £4.95
DKK 80.00

PHOTOGRAPHY
ARTHUR ELGORT
STYLING
JOHN TAN

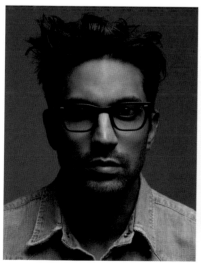

HE Magazine

Editor in chief: Daniel Magnussen
Art director and graphic design: Jack Dahl/Homework
We started out wanting a direction and a men's fashion magazine we couldn't find. The inspiration for the first couple of issues was a very clean format inspired by the Memphis design era, LEGO, and Pacmac—referential elements, but with a modern result. To make it both "hardcore" and "pop"—these were the two words we were working with. Typography will be quite tight, and playful, masculine. We're trying to develop our own style with contemporary elements that will develop in details issue by issue. Also, we wanted to bring subtlety to the overstated world of fashion magazines.

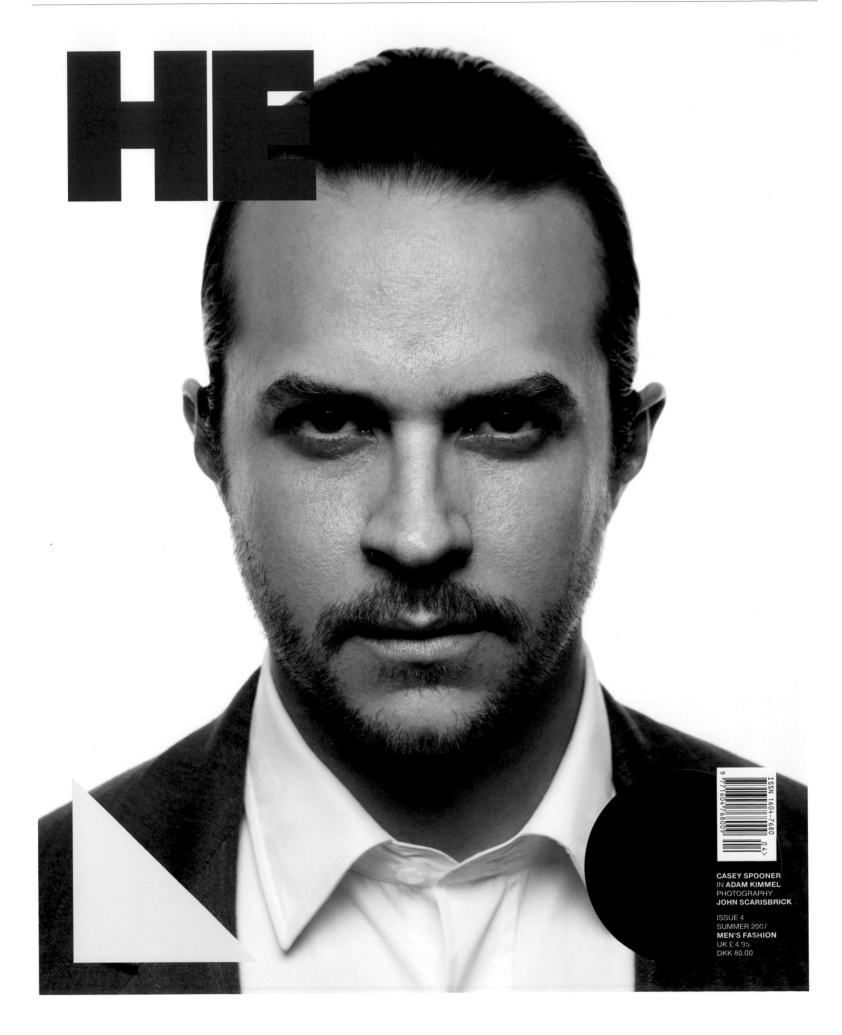

CASEY SPOONER
IN **ADAM KIMMEL**
PHOTOGRAPHY
JOHN SCARISBRICK

ISSUE 4
SUMMER 2007
MEN'S FASHION
UK £ 4.95
DKK 80.00

PHOTOGRAPHY
JOHN SCARISBRICK
STYLING
K8 HARDY

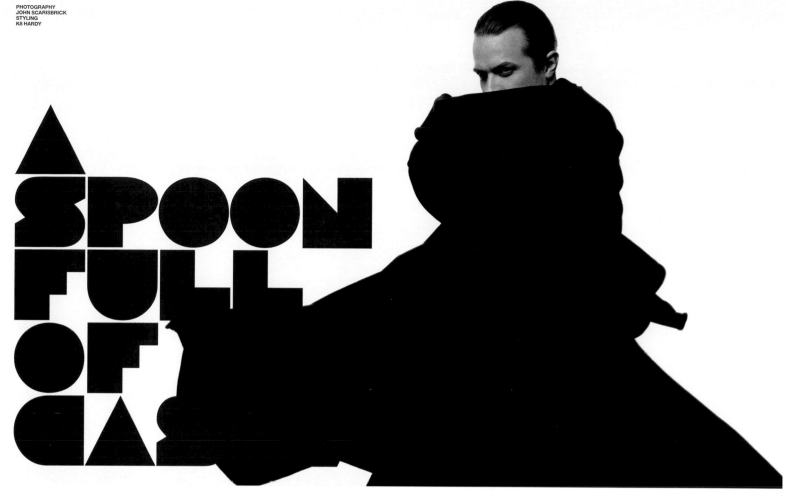

A SPOON FULL OF CLAS

PHOTOGRAPHY
K8U
STYLING
BENJAMIN STURGILL

BELLE ART

LOOK

JIL SANDER

This season, you either cut the crap and go right to the structural core of things, or you reserve the right to self indulge. There is no in-between. You might think that simplicity is the easiest way to go when it comes to clothes, but one look at Raf Simons for Jil Sander tells you there is so much more to it. Minimalism has always been a trademark for Jil Sander, but this time it's taken to a whole new level. There is nothing left but the pure essential, the monochrome lines of grey and blue. The shapes, reduced to square and triangle, almost render the body disposable. Prada follows the same path. It might be the road to the future, or space. It surely feels us somewhere new. This season also offers versions of timeless luxury. Yves Saint Laurent and Burberry Prorsum presented us with clothing that has historical references, ranging from the twenties to the nineties, but the overall look is more about feeling good in general—loose pants, sandals, highly tactile fabrics and soft palettes. This classic notion of opulence is a theme at Comme des Garçons, who presented a collection almost entirely covered in gold. Talk about surplus. But as it is Comme, it never got dandy or too bling-bling. The finest look this season is a few seasons back seems to have evaded designers, and we are once again seeing collections that present new views on modern masculinity. On these pages, we show you some of our favorites. TEXT FREDERIK LARSEN

PHOTOGRAPHY
JOHN SCARISBRICK
STYLING
DANIEL MAGNUSSEN

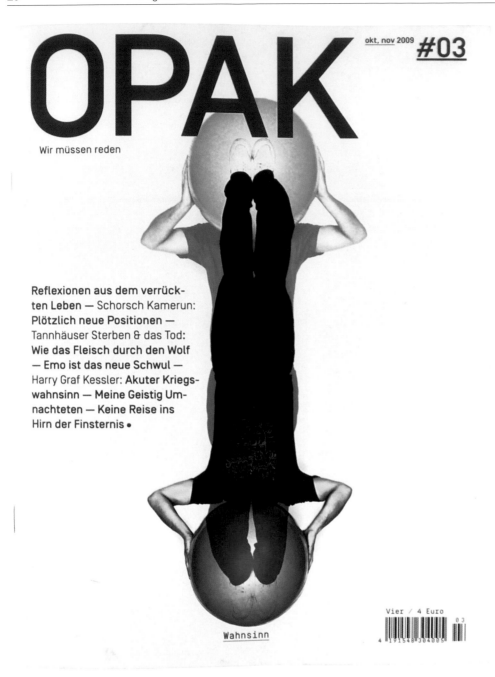

OPAK

okt, nov 2009 **#03**

Wir müssen reden

Reflexionen aus dem verrück-
ten Leben — Schorsch Kamerun:
Plötzlich neue Positionen —
Tannhäuser Sterben & das Tod:
Wie das Fleisch durch den Wolf
— Emo ist das neue Schwul —
Harry Graf Kessler: Akuter Kriegs-
wahnsinn — Meine Geistig Um-
nachteten — Keine Reise ins
Hirn der Finsternis ●

Vier / 4 Euro

Wahnsinn

OPAK Magazine

OPAK is a bimonthly magazine based in Berlin, Germany. Its main focus is the relationship between popular culture and politics. Every issue deals with a new subject, which is analyzed exhaustively in several articles on all kinds of cultural and political expressions. The concept of the *OPAK* cover is based on the letter "O," which is featured as a motif on every cover, and is used as a logo in space. The content is very dense and the text takes up a lot of space in the balance of the layout, so it was important to play with the typography.

Fageta // Adeline Mollard, Philippe Egger // Berlin, Germany // London, United Kingdom // Fribourg, Switzerland // www.fageta.ch

Fageta works across various media: from books, posters, typefaces, identities, and stationeries to signage and Web sites.
Do you have a motto for work? "The simple solution is never boring," from Wolfgang Weingart.
How do you get new ideas when you are stuck? I go out to a concert or I take a walk at Paul-Linke-Ufer in Berlin. I look at some interesting blogs or I look at my favorite books. When I don't need to concentrate I sometimes take my laptop, sit myself on the couch, and do some layout while watching TV, with my feet on the table.

On a more practical level, what can be found on your desktop? Only rubbish. Stuff that I've had to sort for months and are packed in a folder labeled "TO DO." As background: a picture from the May 1, in Kreuzberg, Berlin.
Tell us the story of the name of your studio. Fageta means "little pocket" in Swiss-German dialect. Our philosophy is to keep things or design as simple as possible and to do the best we can with the tools that are available around us. In an imaginary way, using what we have in our pocket, like MacGyver did.

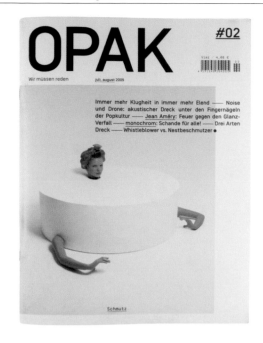

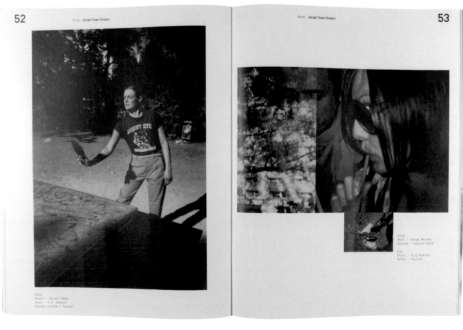

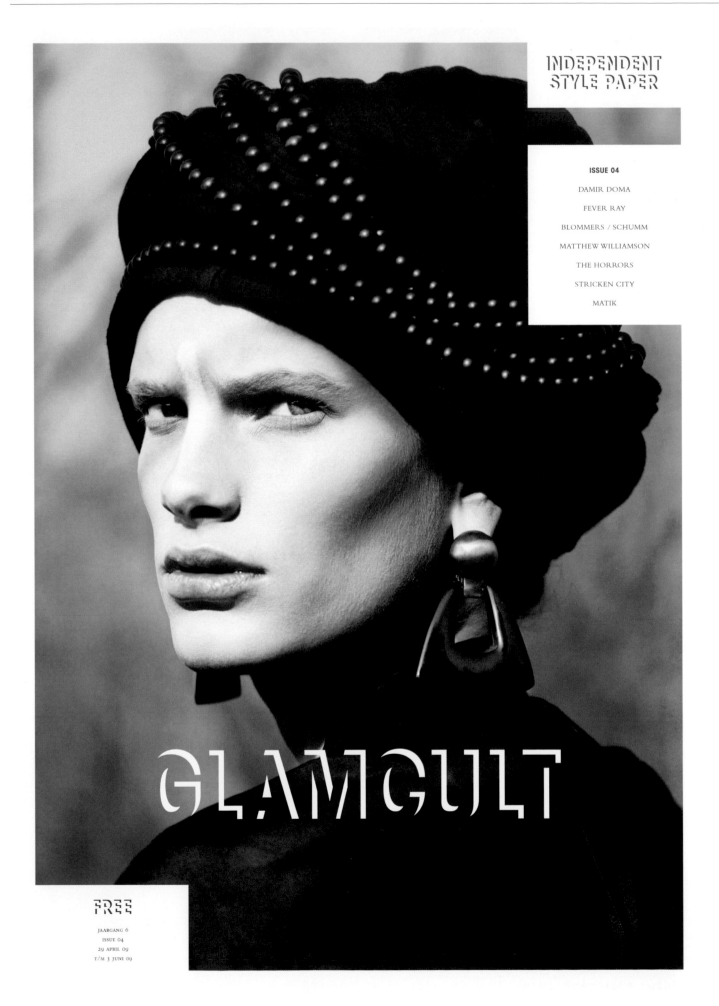

INDEPENDENT
STYLE PAPER

ISSUE 04

DAMIR DOMA

FEVER RAY

BLOMMERS / SCHUMM

MATTHEW WILLIAMSON

THE HORRORS

STRICKEN CITY

MATIK

GLAMCULT

FREE

JAARGANG 6
ISSUE 04
29 APRIL 09
T/M 3 JUNI 09

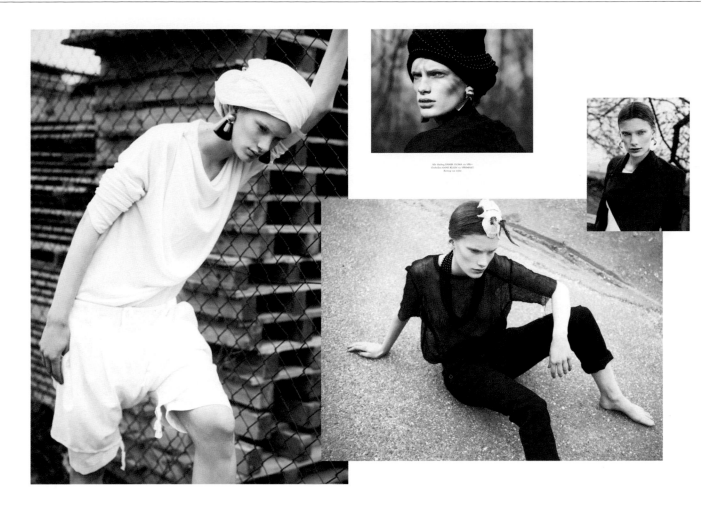

Glamcult **Magazine**

The special thing about *Glamcult* magazine is that it is not our aim to tell our readers what to wear, what music to listen to, or which parties to attend. *Glamcult* just gives them a broad impression of what is going on in the frontlines of fashion, art, music, and film. We select, create, and wander around in today's avant-garde cultures and present what we find. For its design, we really wanted to find a combination between international magazines and the simplicity of Dutch design.

Do you have specific problems or challenges while creating this work? Money! We publish it ourselves, but thank God lots of people and brands believe in its value. We are actually growing in this time of crisis.
Any unexpected reactions to this work? People framing the pages as pieces of art.

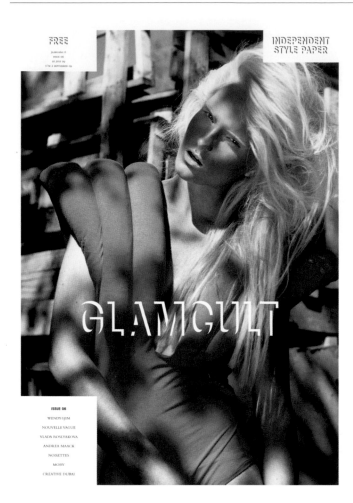

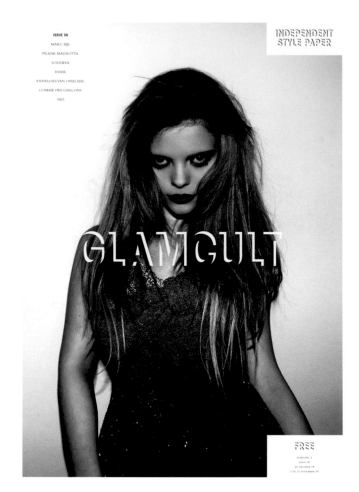

Glamcult Studio // Rogier Vlaming, Marline Bakker // Amsterdam, The Netherlands // www.glamcultstudio.com

Glamcult Studio was founded by Rogier Vlaming and Marline Bakker. The idea was to bring together professionals that work in teams, but come from different professional backgrounds. Therefore, the team consists not only of designers, but also journalists, photographers, artists, and stylists. The different backgrounds and shared passions make Glamcult Studio a modern and multi-talented design agency.

Which work of yours are you especially happy with and why? *Glamcult* is really our own project. We started it five years ago, and since it is ours we are free to let it evolve and recreate it as much as we want. For *Glamcult* we forbid ourselves to think in terms of marketing and target groups; it is just so not important. We create what we feel is interesting and hope others will like it. Fortunately, a lot of people really do!

What guidelines and advice would you give students of graphic design? Think before you start and pick moments during your work to consider whether you're still sticking to the concept. If this is not the case, dare to throw away your work and start over.

What do you consider quality in graphic design? When a design is natural and doesn't need tricks and easy solutions.

What aggravates you? Badly placed text in magazines and books. Lots of designers have great ideas, but ignore the craftsmanship.

What is your workout for creativity? We just work hard. Creativity comes when the pressure is high.

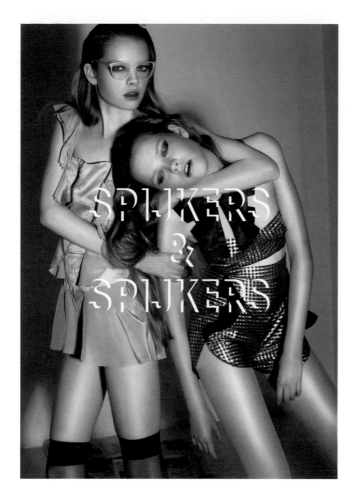

SPIJKERS & SPIJKERS

Door THOMAS VERMEER

TRUUS & RIET SPIJKERS GINGEN, NAÏEF ALS ZIJ DESTIJDS WAREN, NAAR DE MODEACADEMIE MET DE GEDACHTE OOIT EEN EIGEN KLEDINGWINKELTJE TE OPENEN. DEZE DROOM IS VERVOLGENS NOGAL UIT DE HAND GELOPEN, ONDANKS DAT EEN EIGEN WINKEL NOG STEEDS OP HUN VERLANGLIJSTJE STAAT.

GREGOR GONSIOR

Door LILIAN STOLK

ZIJN ONTWERPEN, DIE ONLANGS NOG TE BEWONDEREN WAREN OP DE MODEFABRIEK, ZIJN BIJZONDER VERNIEUWEND EN LIJKEN REGELRECHT UIT EEN HAUTE COUTURE SPROOKJE TE KOMEN. VOLGENS GREGOR GONSIOR BESTAAT ER AL GENOEG EENVOUDIGE MODE, DAAR WIL HIJ VERANDERING IN BRENGEN.

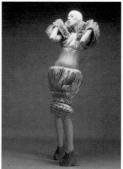

01

tubelight

26

Tubelight is een onafhankelijk recensieblad en biedt korte, kritisch geschreven recensies over met name kleine presentaties op het gebied van de beeldende kunst in Nederland. Tubelight is gratis en wordt verspreid via galeries en kunstinstellingen en door middel van *controlled circulation* onder professionals op het gebied van de beeldende kunst. Overige belangstellenden kunnen tegen een vergoeding van euro 16,00 per jaar het blad thuis ontvangen.

De redactie van Tubelight staat open voor bijdragen.

redactieadres
Witte de Withstraat 53
3012 BN Rotterdam
t/f 010 213 09 91

Martine Stig, uit *DPRK series*, 2002
courtesy Motive Gallery, Haarlem

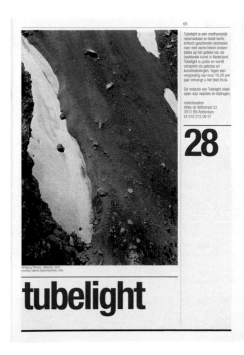

Tubelight, Issues No. 0–34

For this work we were inspired by newspaper layouts.
The production of every issue was always a race against time.
The amount of text and the number of pictures was totally different in each issue.

We came up with a layout system that could be filled or left blank.
Tubelight was made on a nonprofit model. It's a free magazine.

Stout/Kramer // Marco Stout, Evelyne Kramer, Rinus van Dam // Rotterdam, The Netherlands // www.stoutkramer.nl

Stout/Kramer's design is simple, clear, without fuss. Dutch. With a focus on cultural projects and projects for the Dutch government, the Rotterdam-based design studio regularly works with people from various disciplines.
What do you consider to be "quality" in graphic design? Design has to communicate, be simple, and ought to jangle a nerve. That's always a good thing.
What does your working environment look like? A spacious studio in the middle of the city. The interaction with the city is important to us.
What guidelines and advice would you give students of graphic design? Work for people who could be your friend, who can inspire you, or can be inspired by you.

And, please, keep it simple!
How do you get new ideas when you are stuck? Meditation.
Where do you find new energy? A beautiful cup of Colombian espresso (freshly ground beans), with steamed-milk foam and caramel syrup in a Bodum cup.
Tell us the story of the name of your studio. The founders are Evelyne Kramer and Marco Stout. Stout is a Dutch word that can be translated as "naughty." It seems very logical to us to use "Stout" in front of "Kramer." People won't ever forget that name.
If you were not a graphic designer, what would you be? Stout: Architect. Van Dam: Homeless. Kramer: Creative therapist.

domus

CONTEMPORARY ARCHITECTURE INTERIORS DESIGN ART

913 04/08

€ 8.50 ITALY ONLY

B € 18.20 - F € 16.00 - D € 18.50
A € 22.70 - NL € 13.90 - P € 16.10
E € 15.50 - CH CHF 30.00
CANTON TICINO CHF 28.00
UK GBP 9.95 - USA USD 33.95
J YEN 3,780 (INC.TAX)

Periodico mensile/Poste Italiane S.p.A. Spedizione in Abbonamento Postale D.L. 353/2003 (conv. in Legge 27/02/2004 n. 46) Art. 1, Comma 1, DCB – Milano

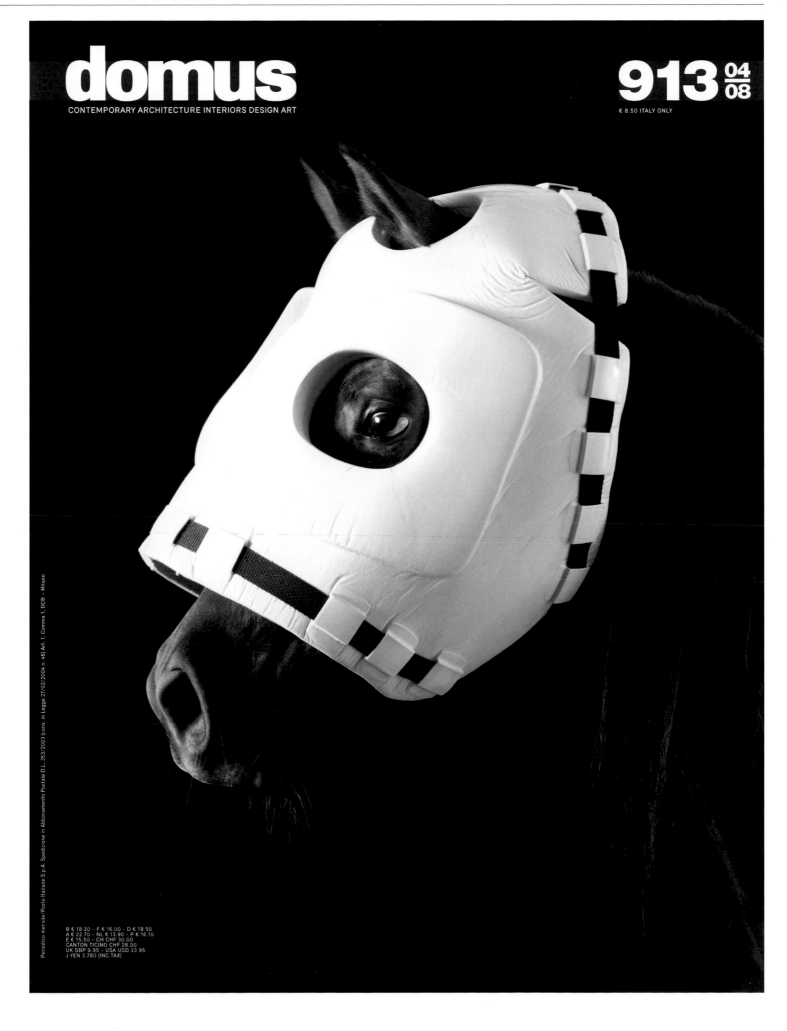

domus

CONTEMPORARY ARCHITECTURE INTERIORS DESIGN ART

913 04/08

€ 8.50 ITALY ONLY

Periodico mensile/Poste Italiane S.p.A. Spedizione in Abbonamento Postale D.L. 353/2003 (conv. in Legge 27/02/2004 n. 46) Art. 1, Comma 1, DCB - Milano

B € 18.20 - F € 16.00 - D € 18.50
A € 22.70 - NL € 13.90 - P € 16.10
E € 15.50 - CH CHF 30.00
CANTON TICINO CHF 28.00
UK GBP 9.95 - USA USD 33.95
J YEN 3,780 (INC.TAX)

Domus Magazine

What was your inspiration for this work? Music. Graphics and typography are the elements of the music score. For example, the pages of the new *Domus* are based, in fact, on an innovative structure of vertical columns of varying length that are utilized differently in each article. Each article extends horizontally over multiple columns, sometimes even continuing on the following page. It is a sort of continuous sheet and the content of *Domus* becomes a flow of ideas that runs across all the pages. In each issue, we build the score of a composition of content in order to create a harmonic whole. The structure and size of the content is thus different on each page and in each issue. The result is a variability that determines the "rhythm" of the issue, a rhythm that could be compared to jazz variation.

What is special, unusual, or unique about this project? *Domus* came out on January 15, 1928. Following the several redesigns by Ettore Sottsass, Alan Fletcher, and Simon Esterson, we created the new *Domus*, starting with its April 2008 issue. The history and particular cult-like following of the magazine within the international architecture scene as well as the famous designer who worked on it before us, put us under pressure to realize the challenging project.

Do you recall unexpected reactions to this work? Firstly the editorial staff in Milan reacted very suspiciously and negatively about the new editorial tools we created. It implies more work for them. After the second issue, they responded positively to the new system. They had new, flexible opportunities and possibilities to edit the magazine and create contrasts or conscious associations, suitable or even unsuitable rhythms, to create new music pieces.

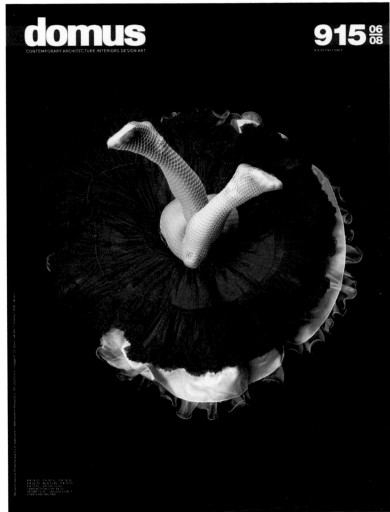

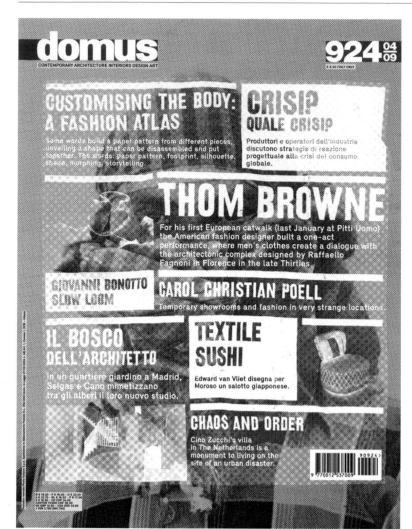

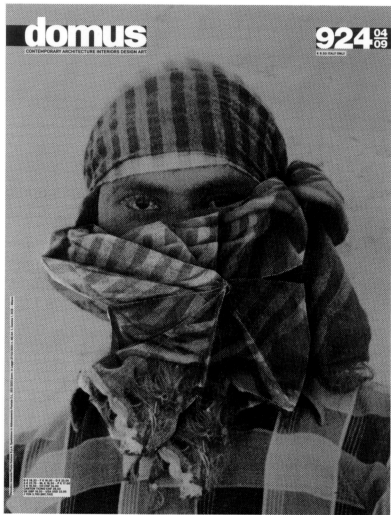

onlab // Nicolas Bourquin // Berlin, Germany // Tramelan, Switzerland / www.onlab.ch

Onlab is working on commissioned, collaborative as well as self-initiated design projects and is a co-founder of ETC Publications, a platform for independent publishing based in Berlin, Germany. Onlab explores the ways of staging complex contents to convey relevant topics and, in doing so, accompanying changes in perceptions.
What do you consider quality in graphic design? Storytelling, readability.
What does your working environment look like? A bright rooftop studio, with terraces and skyline view of Berlin, including the TV Tower.
What inspires you? Films, dance floors, news.
What aggravates you? News, dance floors, films, and Deutsche Bahn.

Tell us the story of the name of your studio. It was in 2000. At that time the trend within the design scene was to have rock bands' names. I was searching for a short name, easy to remember and to use on the Internet. I liked the idea of the "lab" (experimental visual laboratory). I reserved the URL onlab for my Web work (online). And I reserved the URL offlab for my print works (offline)… since we work mainly for editorial design and because the word "off" has a negative connotation, we are working exclusively under the name onlab. But offlab is still in use.
How do you get new ideas when you are stuck? Pause, do something else, and retry.

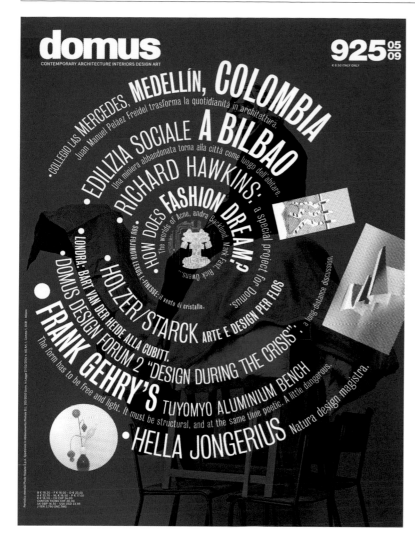

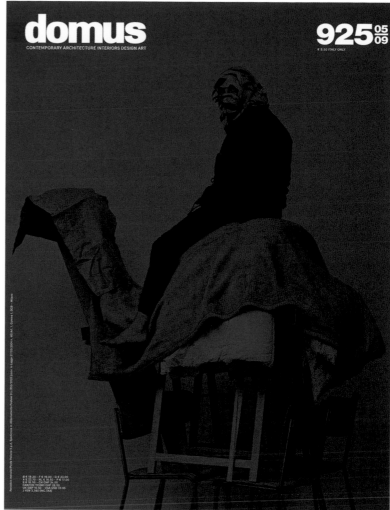

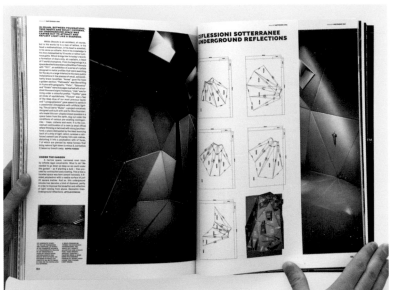

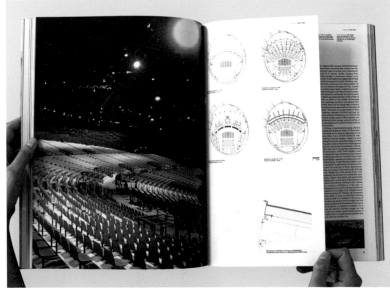

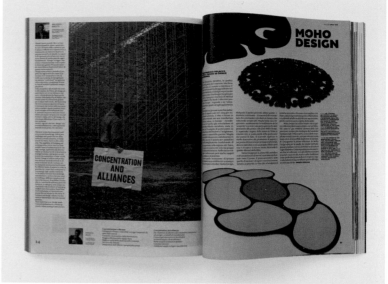

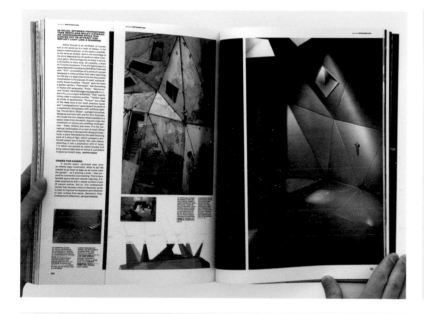

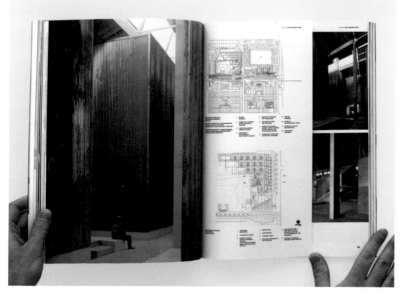

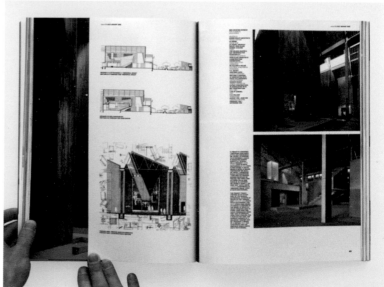

Ce grand héros à la renverse

Very Elle

Art direction and design of special biannual edition of *French ELLE*. Features and editorial spreads employ the typeface Heroine, which was created specially for the magazine.

64

Very elles

Elles sont artistes ou blogueuses, philosophes ou jet-setteuses, déjà célèbres ou sur le point de l'être. Par leur audace, leur talent, leur esprit acéré, cocasse ou indocile, elles nous ont bluffées, intriguées, agacées, fascinées...

Par FLORENCE TREDEZ avec
LAUREN BASTIDE, MARIE BOISMANCELET, ANNE DIATKINE,
EDOUARD DUTOUR, SOPHIE FONTANEL, YANN GONZALES,
LAURENT GOUMARRE, CATHERINE NIVEZ.

Pop Katie White fermière

Elle est née dans une ferme, mais pas question de la fermer ! Katie White, la chanteuse survoltée des Ting Tings, impose au monde son style détonant...

Lorsqu'on demande à Katie White d'où elle vient, elle roule des yeux charbonneux affublés de faux cils, remet en place une mèche peroxydée et avoue, avec un fort accent de Manchester : « d'une ferme perdue dans la campagne. Sur le Web, certains affirment que c'était une ferme à cochons, ce n'est pas vrai, mais ça me fait rire, alors je n'ai pas rectifié. » The Ting Tings, le groupe au son electro-pop de l'année pour beaucoup de magazines spécialisés, est pile-poil dans la tendance - deux personnes excitées qui font autant de bruit que six. Jules de Martino est à la batterie et Katie White fait le show, avec l'énergie blonde d'une Madonna ou d'une Gwen Stefani. « Quelqu'un m'a aussi comparée à Boy George, mais c'était un jour où j'avais forcé sur le maquillage », dit-elle. Sa vocation est née sur les bancs de l'école en triturant sa trousse Take That (sa grande sœur, elle, écoutait New Kids on the Block), puis dans la cuisine familiale où elle répétait, à 14 ans, des chorégraphies avec deux copines. « On avait formé un groupe super mauvais, qu'on avait appelé TKO (Total Knock Out, traduction : de la balle atomique) et qui a sorti un single sur Internet. » Avec Jules, rencontré à Londres, elle fait à 19 ans une autre tentative musicale. Leur duo s'appelle Dear Eskimo et s'inspire de Portishead mâtiné de... comédie musicale. « Dans le clip, j'étais habillée en ballerine et Jules en clown triste. » Mais Katie s'énerve lorsque leur directeur artistique lui demande si elle est prête à se déshabiller dans des magazines masculins pour promouvoir leur album. Elle l'envoie paître ; peu après, le personnel de la maison de disques est viré et le groupe aussi. « Plus personne ne voulait travailler avec nous, et on était persuadés que c'était la fin de notre carrière. » La dépression mène à tout, même au succès. Au bout du rouleau, Katie et Jules inventent les Ting Tings (« écouter » en chinois) et les chansons qui vont avec : des refrains pop assénés comme des slogans sur des rythmes à la Talking Heads ou à la Tom Tom Club. Leur single « That's not My Name » est vite n° 1 des charts anglais, et « Shut Up and Let Me Go », un autre de leurs morceaux, devient la musique de la pub pour l'iPod. Katie, avec ses bottines vintage et ses robes Vivienne Westwood retaillées par ses soins (sacrilège !), est sacrée peu ou prou reine de la hype par les rédactrices de mode. Pas mal pour une fille élevée dans une ferme à cochons, non ?
— F.T.

Écoutez deux titres de son dernier album sur
www.veryelle.fr

Phil Knott/Corbis Outline

20

Janis rebelle forever

Elle fut cette artiste fulgurante dont la mort « inévitable », à 27 ans, signait de poudre blanche un parcours rock'n'roll exemplaire. Phare d'une génération maudite, possédée de musique, de sexe et de poésie, **Janis Joplin** reste un modèle d'authenticité et de pureté. La première égérie trash.

Par MICHKA ASSAYAS
Illustration HELLOVON

Illustration d'après une photo d'Elliott Landy/Corbis

Mélanie

Quand elle ne tourne pas,
elle écrit, met en scène
ou pousse la chansonnette.
Son appétit est no limit
et son talent fait tilt :
Tarantino l'a choisie
pour interpréter l'héroïne
de son prochain film,
« Inglorious Bastards ».
Mélanie Laurent,
une fille à cent à l'heure.

Photos DEREK KETTELA
Réalisation CHLOE DUGAST
Portrait ANNE DIATKINE

Veste en cuir et broderies
incrustées BALMAIN
chez MONTAIGNE MARKET.
Pendentif « Deeva » STONE.

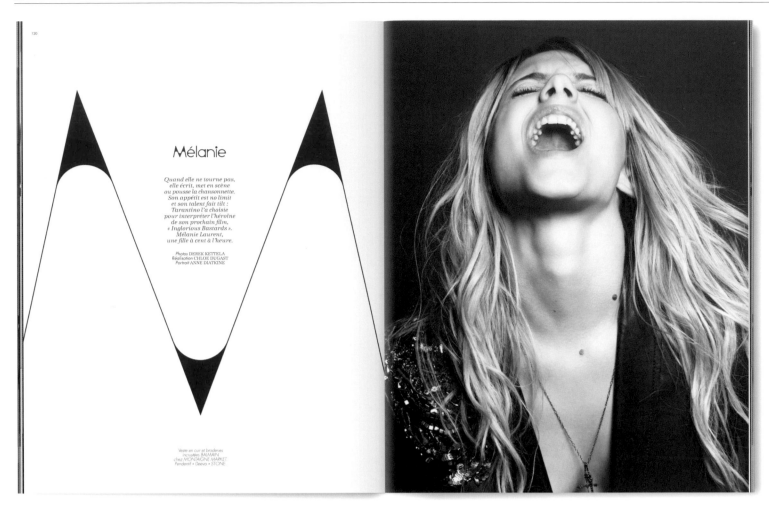

Dree

Une jolie carrière de top model, des envies
de cinéma et surtout un esprit détonant
qui n'aurait pas déplu à son arrière-
grand-père Ernest. Dree Hemingway est
une jeune fille passionnée et passionnante.

Photos CLARE SHILLAND
Réalisation JEANNE LE BAULT
Entretien SOPHIE FONTANEL

A droite. Chemisier en coton
imprimé GAT RIMON.
Robe bustier en satin
duchesse CHANEL.
Chapeau en velours et plumes
de faisan RALPH LAUREN.

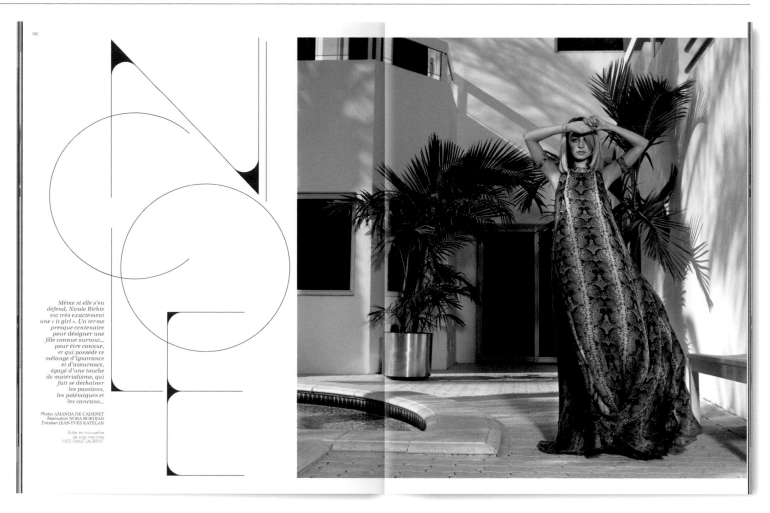

Même si elle s'en défend, Nicole Richie est très exactement une « it girl ». Un terme presque centenaire pour désigner une fille connue surtout... pour être connue, et qui possède ce mélange d'ignorance et d'assurance, égayé d'une touche de matérialisme, qui fait se déchaîner les passions, les polémiques et les cancans...

Photos AMANDA DE CADENET
Réalisation NORA BORDJAH
Entretien JEAN-YVES KATELAN

*Robe en mousseline
de soie imprimée
YVES SAINT LAURENT*

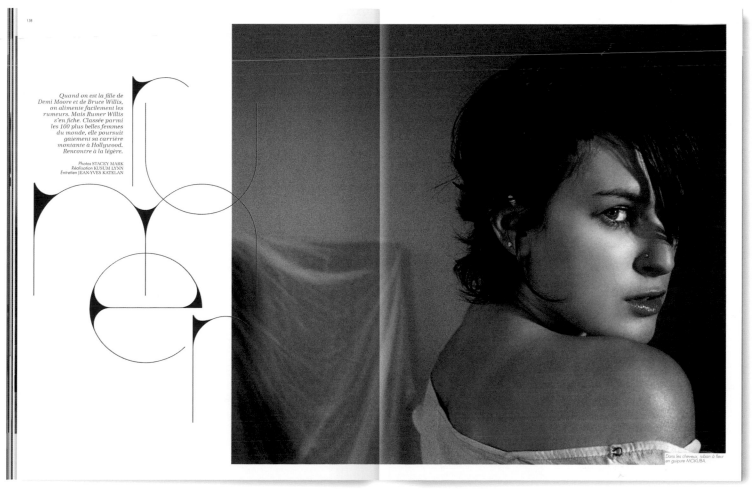

Quand on est la fille de Demi Moore et de Bruce Willis, on alimente facilement les rumeurs. Mais Rumer Willis s'en fiche. Classée parmi les 100 plus belles femmes du monde, elle poursuit gaiement sa carrière montante à Hollywood. Rencontre à la légère.

Photos STACEY MARK
Réalisation KUSUM LYNN
Entretien JEAN-YVES KATELAN

*Dans les cheveux, ruban à fleur
en guipure MOKUBA.*

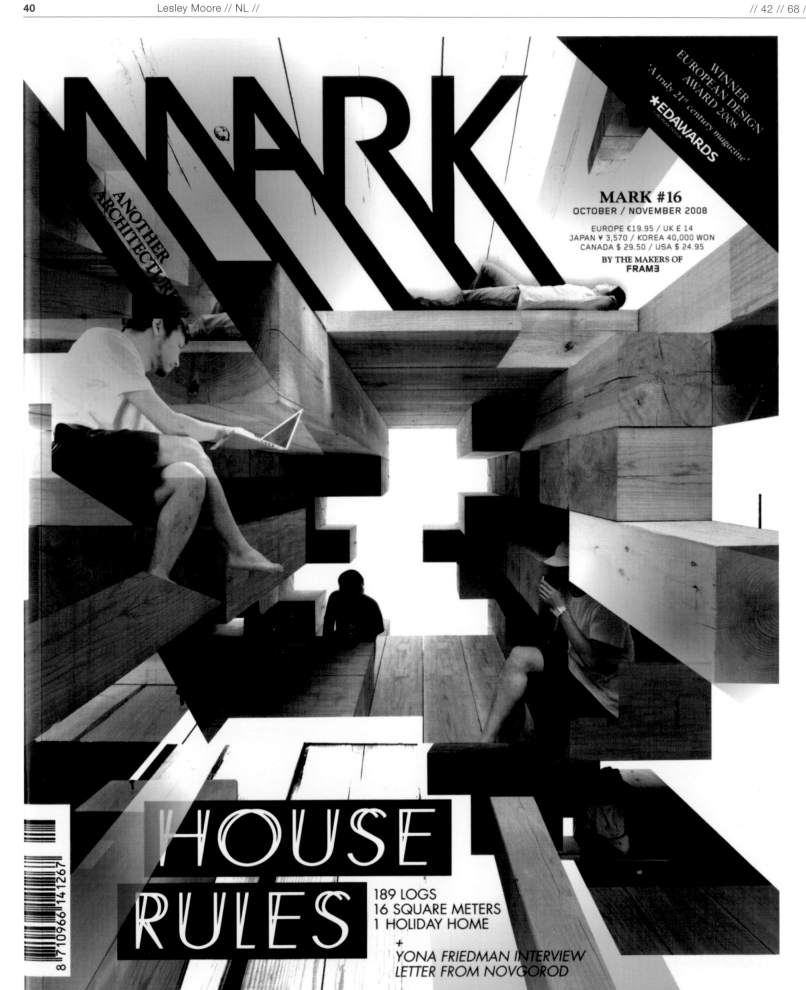

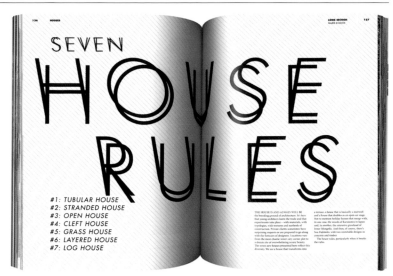

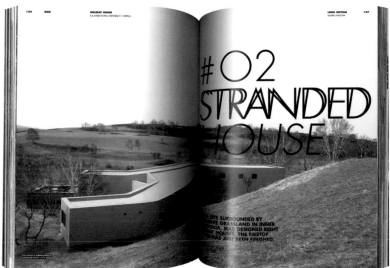

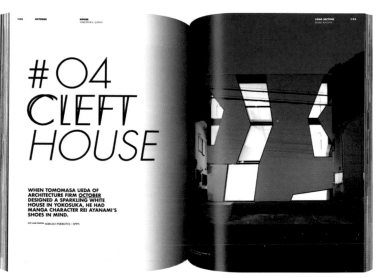

Mark Magazine

What was your inspiration for this work? An ever-changing magazine.
What is unique about this project? That it is always changing.
Did you run into any specific problems or challenges while creating this work? The concept involved that we were working on an endless redesign. Pretty hard work in the long run.

Do you recall unexpected reactions to this work? We discovered that architects can be quite conservative… but not all, luckily!

Lesley Moore // Karin van den Brandt, Alex Clay // Amsterdam, The Netherlands // www.lesley-moore.nl

Playing with the saying "less is more," Lesley Moore is an Amsterdam-based design agency, founded by Karin van den Brandt and Alex Clay, known for their energetic work.
Which work of yours are you especially happy with and why? The ongoing Lesley Moore identity in which visitors to our Web site create logos for us. The logos are like little gifts, every one of them.
What does your working environment look like? A studio with a high ceiling and a garden where famous BBQs have been held.
Do you have a motto for work? Lesley Moore = less is more.
What inspires you? The alphabet.

What aggravates you? The term "Dutch Design."
What guidelines and advice would you give students of graphic design? "Style is fart" —Stefan Sagmeister.
Are you a team worker or a lone fighter? Lesley Moore is a duo, without one of the two, less would not be more.
Tell us the story of the name of your studio. Lesley Moore is a pseudonym based on the saying "less is more." We don't necessarily use a minimalistic approach formally, but we find that the simpler the starting point the more powerful the message.
If you could live in another place for one year, where would that be? Tokyo. We want to go to Tokyo!

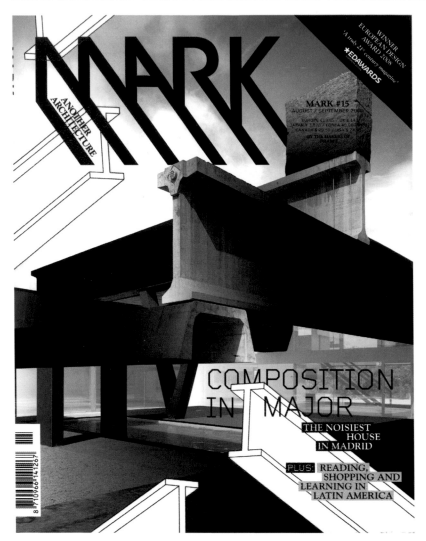

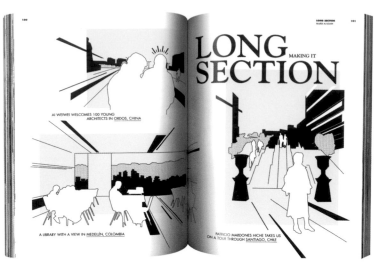

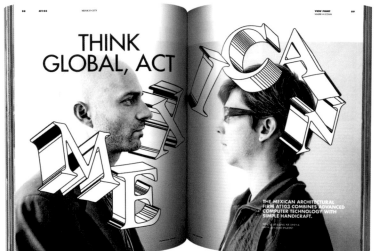

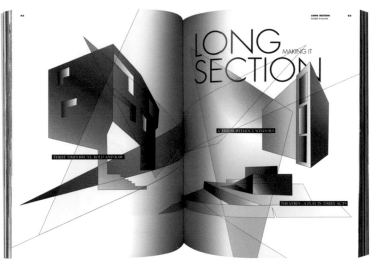

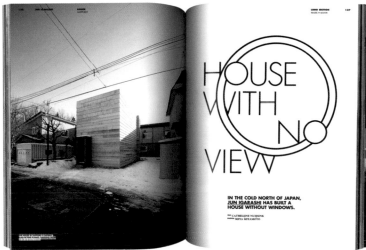

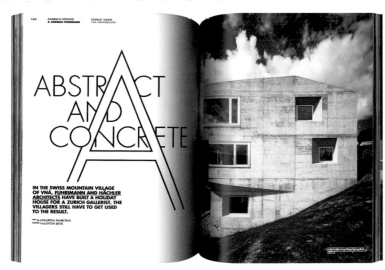

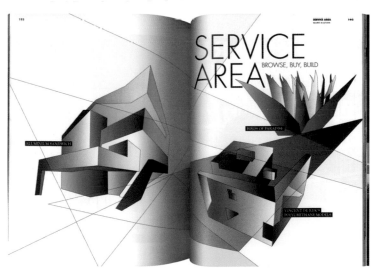

FEW #01

INVIERNO 2009

PVP 5€

CONTENIDO

LA ERÓTICA DEL PODER

FEW Magazine

New magazine directed by Javier Senón with interviews, music and art reports, and,
of course, fashion editorials. This first issue features Rafa Gallar, Bela Alder, Salvador
Frasneda, Antonio Macarro. *Few* magazine is released every three months.

FEW #02

PRIMAVERA 2009

BRUCE LABRUCE
Fotógrafo? Director
de cine porno? Artista?
Quien es Bruce LaBruce
y por qué su obra trans-
gresora causa polémica.

**MY BRIGHTES
DIAMOND**
Indie rock'n'roll y música
clásica van de la mano
superando todos los
límites de la experiment-
ación en el proyecto musi-
cal de Shara Worden.

LUJO IBERICO
El nuevo lujo está menos
relacionado con los artis-
tas y artesanos, y más
vinculado a un concepto,
el mundo de la marca.

CANSEI DE SER SEXY
Sin pelos en la lengua,
ellos transbordan ironía
y un espíritu "viva la fiesta".
CSS es auténtico pop,
pero con chispa indie.

BAZAR
Irónicas piezas de pret
à porter que juegan
a reivindicar la su-
premacía del hombre
ante la máquina.

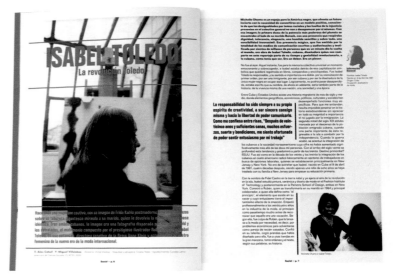

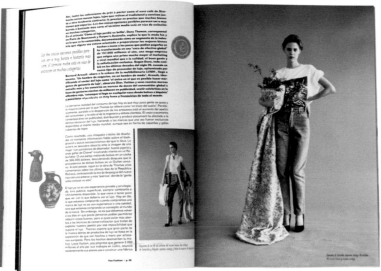

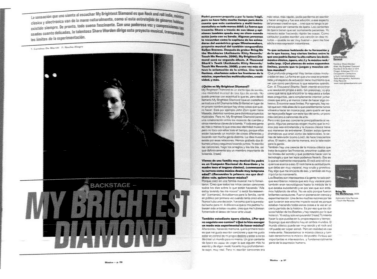

Folch Studio // Albert Folch // Barcelona, Spain // www.folchstudio.com

Folch Studio was founded in 2005 in the city of Barcelona, Spain, and is directed and managed by Albert Folch and Omar Sosa. The studio specializes in editorial design, art direction, and publicity and corporative image.

What do you consider quality in graphic design? For me, good print design means leaving style and good taste by the wayside. These concepts are too subjective to be able to judge something using them. What I would ask for and hope to offer are: comprehensibility and subtlety. I believe that in every graphic work, functionality and healthy human understanding should prevail. Adapted naturally to the order and the requirements of each project. Good typographic work is key for all these requirements.

What does your working environment look like? I always have a white wall in front of me. The shelf with all the books, magazines, etc. is located behind me.

On a more practical level, what can be found on your desktop? Like everywhere else in the world… a large table, full of paper.

What inspires you? Rhythm, work, and pressure. In order to be able to work, I need areas that are not overloaded visually. This is why I try to hide all of the things I need to work or at least not have them right in front of me.

Tell us some things you are crazy about. Galapagos Islands (I've never been there, but I'd love to go there sometime), Grand Canyon of Colorado (likewise), friendly people, the colors black, white, and red, and music.

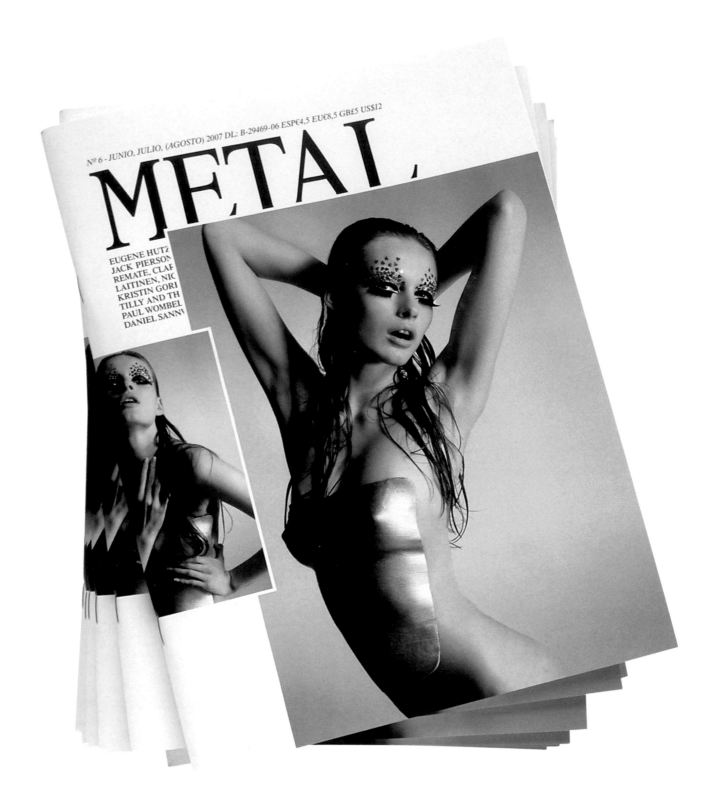

METAL Magazine

METAL magazine was born in June 2006 as a unique blend of fashion and arts with an international forefront scope. It features cutting-edge content that refuses everything that's ordinary, and was born out of the desire to provide an alternative to the bilingual (Spanish/English) audience that is steadily on the rise. The result is a qualitative publication with five issues per year that is also exclusive and collectable.

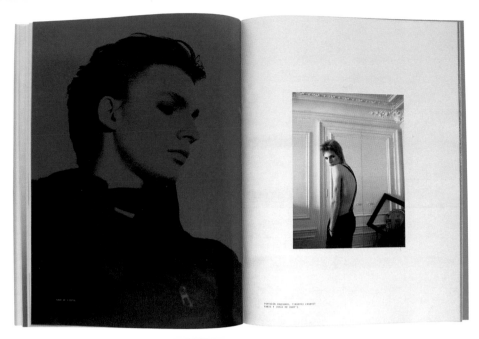

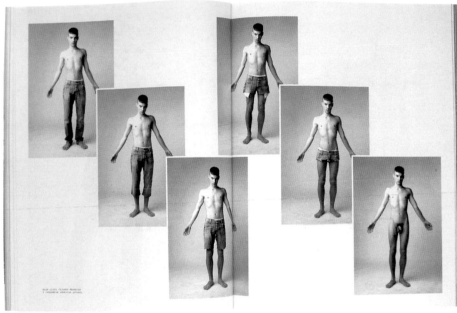

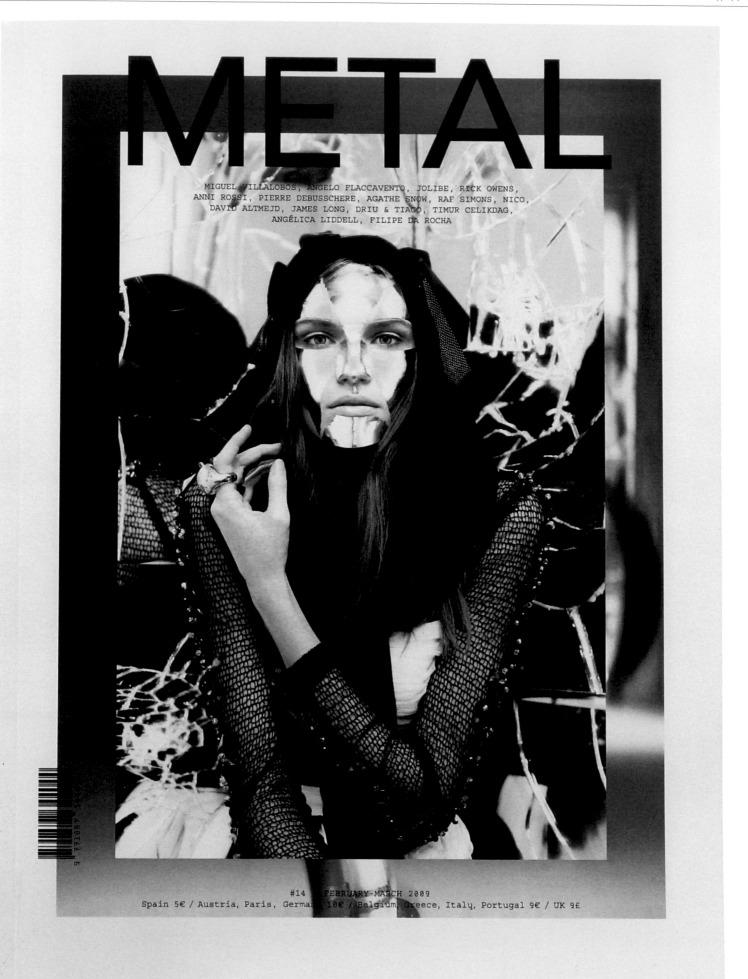

METAL

MIGUEL VILLALOBOS, ANGELO FLACCAVENTO, JOLIBE, RICK OWENS,
ANNI ROSSI, PIERRE DEBUSSCHERE, AGATHE SNOW, RAF SIMONS, NICO,
DAVID ALTMEJD, JAMES LONG, DRIU & TIAGO, TIMUR CELIKDAG,
ANGÉLICA LIDDELL, FILIPE DA ROCHA

#14 — FEBRUARY-MARCH 2009
Spain 5€ / Austria, Paris, Germany 10€ / Belgium, Greece, Italy, Portugal 9€ / UK 9£

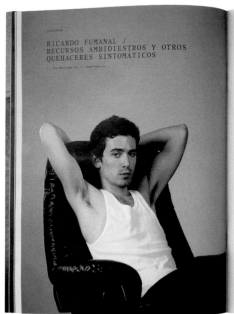

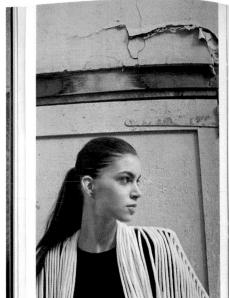

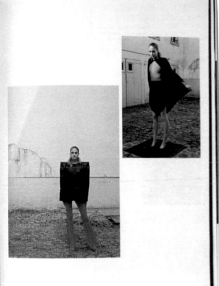

PP 349157/00509

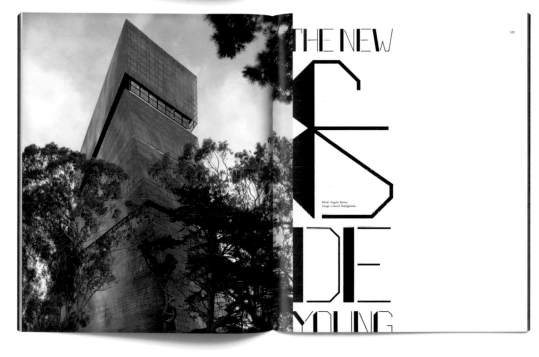

(inside) **Magazine**

The inspiration for *(inside)* magazine was the content featured in the magazine. I was lucky to work with a very talented editor who found some of the most inspiring design projects from around the globe. The magazine was published with a very small team; the editor was based in Sydney and the design was produced in Melbourne. I think this was the magical combination that allowed me to design with a clean canvas each issue. Less moving parts, and no real restrictions from the publishers allowed me to break the mould from issue to issue. The only problem was that I wish I could have produced twelve issues a year; the magazine was a bimonthly.

(inside)
australian design review

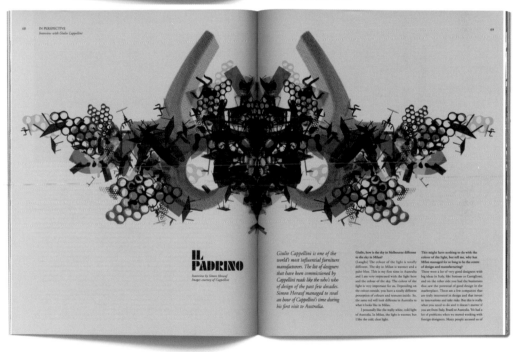

Jeffrey Docherty // New Zealand // www.jeffreydocherty.com

Born in New Zealand, Jeff Docherty, an independent art director, has worked with inspiring studios in New York, Australia, and New Zealand over the last ten years.

Describe your early influences. I really responded to what the Designers Republic was doing. It was very out of the box, and broke away from the safe, straight-edged works being produced at the time. Also I can't forget Josef Muller Brockmann and Herb Lubalin, the "masters."

Do you have a motto for work? It's an oldie but a goodie: keep it simple.

What inspires you? I'm always trying to break my daily routines to find new and untapped creative sparks. These moments can be found everywhere, from a visit to my local coffee shop or simply by stumbling upon a crazy blog or a Google image search.

What guidelines and advice would you give students of graphic design? Study the masters. Surround yourself with good design. Always critique your work after completion. If you can't spot the weaknesses, then you're not progressing.

Where do you find new energy? The energy comes from the work I produce. When I am happy with the direction the project is heading, I get more drive to push and develop it further.

POSTERS

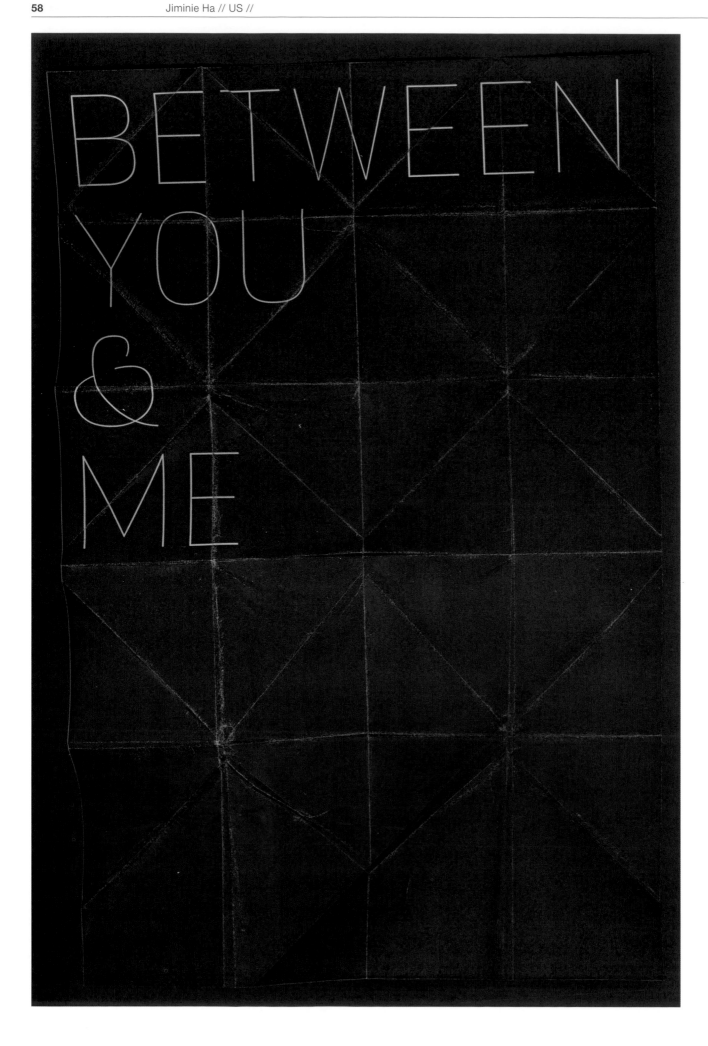

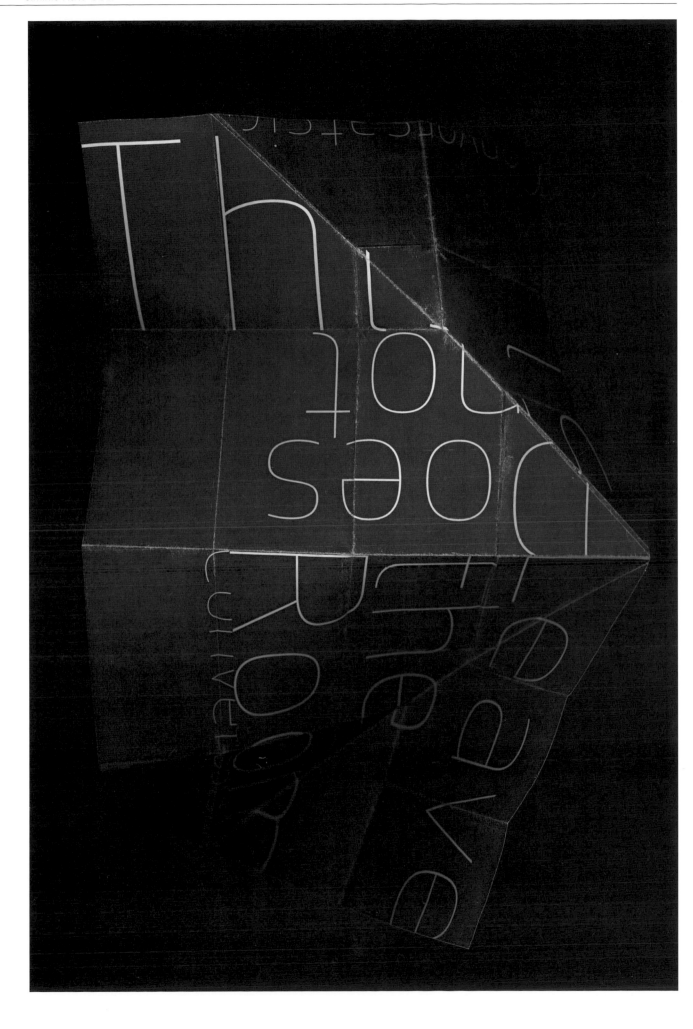

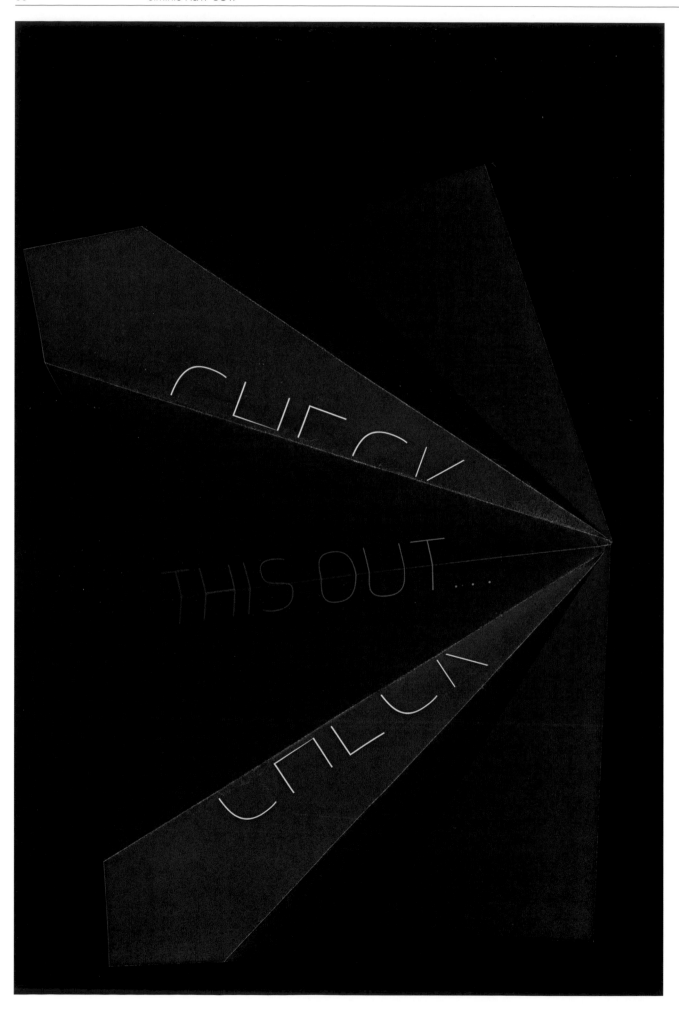

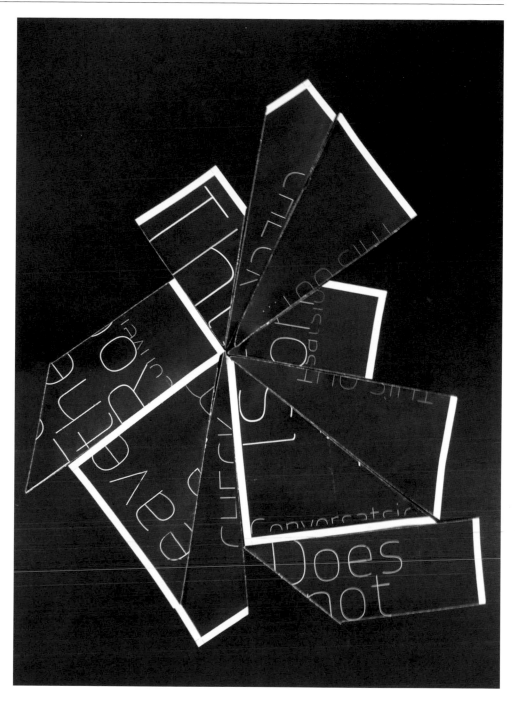

Rumors

This is a poster series that I did while I was in art school getting my M.F.A. at Yale. I was interested in the old folding techniques that we would do to pass notes in class when we were younger. The idea was inspired by rumors, the idea of private information becoming public, and exploding them into posters. I think the entire series really defined my approach to design. There's a time when designers transition from just emulating what they like, to suddenly creating their own voice and ideas on design. I think this project really shaped the way I currently think about design.

Jiminie Ha // New York, USA // www.jiminie.org

Jiminie Ha is a young female art director and graphic designer who is intensively productive. Her works break the borders of the common digital and graphic design attitude.
Which work(s) of yours are you especially happy with and why? The ones you are showing. I think they embody the kind of work I've been developing for a few years now, working within very specific limitations, creating visual work out of very little material.
What do you consider quality in graphic design? I think intelligence in the work, showing a strong concept behind the imagery. You don't need all the bells and whistles in order to make a beautiful piece of graphic design. You can make beautiful things with very little.

What guidelines and advice would you give students of graphic design? I usually just tell them to think outside of what they "think" they have to make, and to make it with whatever they have. I think the more creative solutions occur when you really have nothing to work with. Don't get all-deep into what is going on in graphic design. Too much information can sometimes stunt your process.
What does your working environment look like? It's a loft space with exposed red brick walls. It's one of the oldest buildings in New York City and has original nineteenth-century fixtures, so it's a great place to think and work.

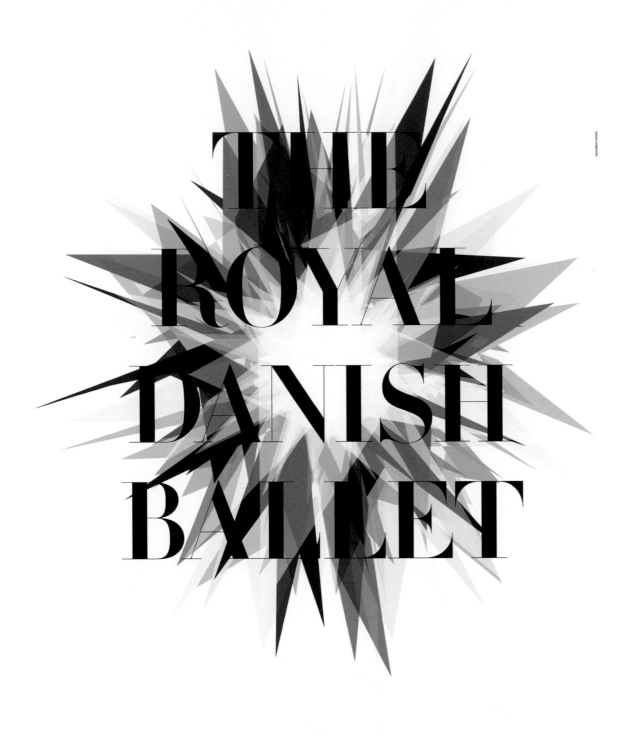

Royal Danish Ballet

The Royal Danish Ballet is one of the oldest ballet companies in Europe. Based in Copenhagen, Denmark, it originates from 1748, when the Royal Danish Theatre was founded, and was finally organized in 1771 in response to the great popularity of French and Italian styles of dance. The Royal Danish Theatre has served as its home since its inception. The most renowned name in Danish ballet is that of August Bournonville (1805–1879), who was known to have created a clearly defined ballet style.

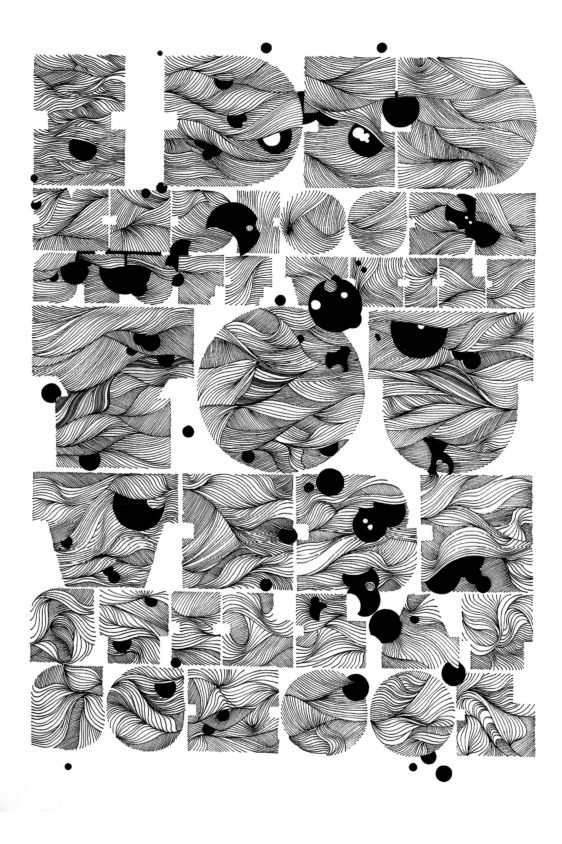

Felt-Tip Poster

This is a one-off poster created for Letraset to showcase their Trio markers. We were asked to create this poster by hand, using a set of markers that they sent us. We decided to hand draw some text using one of our new typefaces, Isambard. The text ("I did mediocre stuff while you were still at school") is something Kjell once said that I jotted down in a notebook for future use/inspiration.

It's probably the only piece that we don't have a copy of, because it's a one-off. It's currently in the possession of *Grafik* magazine (the UK-based independent graphic design publication) as they organized the Felt-Tip event.

We couldn't print anything, so we had to rely entirely on our own abilities at handling an actual pen. Unfortunately, marker pens don't come with the option to "Command Z," so we had to be very careful and think it through beforehand.

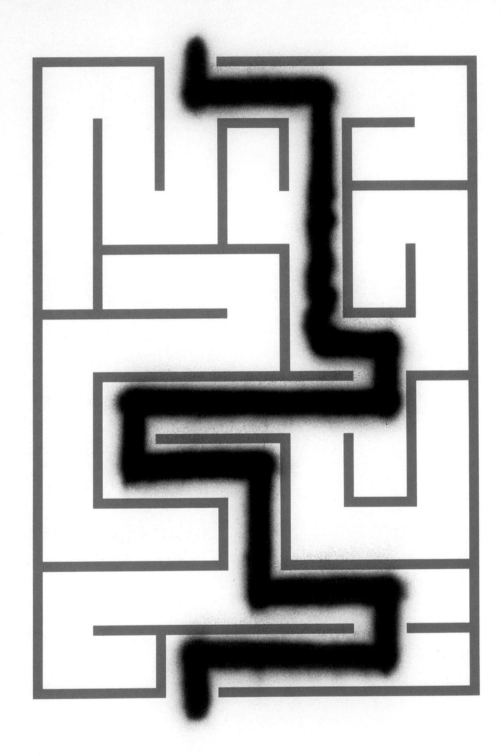

Hektor Games
Maze

Hektor Games
Word Search

Hektor Games
How to Draw

Hektor Games (with Ryan Waller)

This series of posters was created within the context of a workshop by Jürg Lehni and Uli Franke at the Yale School of Art. We created a series of basic learning exercises for their automated drawing machine "Hektor," hoping it would self-realize. We imagined Hektor as a young child and were inspired by basic children games.

Due to the nature of the process, each poster is a one-off. Registering the drawings was the hardest part. An unexpected reaction was that not everyone appreciated the irony of our gesture.

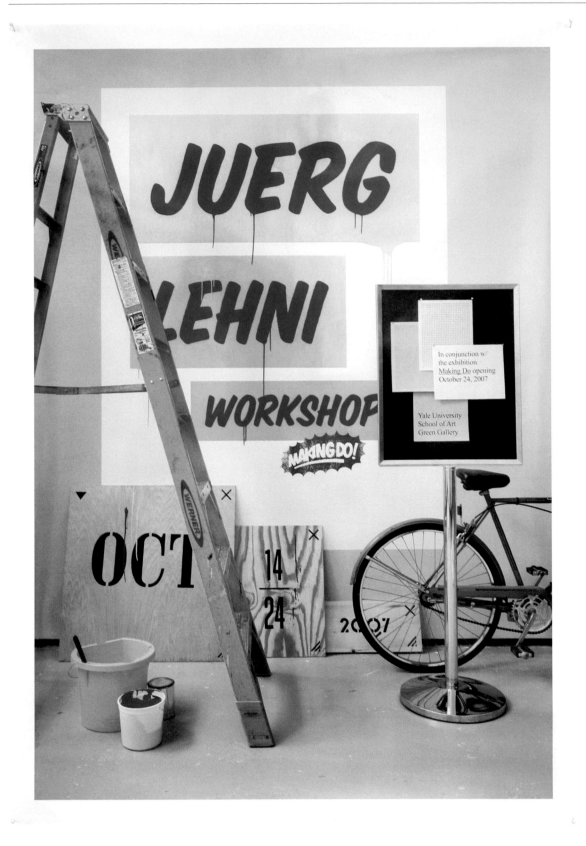

Jürg Lehni Workshop (with Ryan Waller)

Related to the "Hektor Games" poster series, we made this poster to advertise the Jürg Lehni and Uli Franke Workshop at Yale.
At first we didn't know that his collaborator Uli Franke was coming, so only Jürg's name appears on the official poster. We later used Hektor to correct this in a follow-up poster. We were interested in working spatially and playing with elements of illusion, trompe l'oeil, simultaneously creating and flattening space. We enjoyed working with our hands, mixing media, thinking in terms of light and space, and the labor-intensive nature of the process.

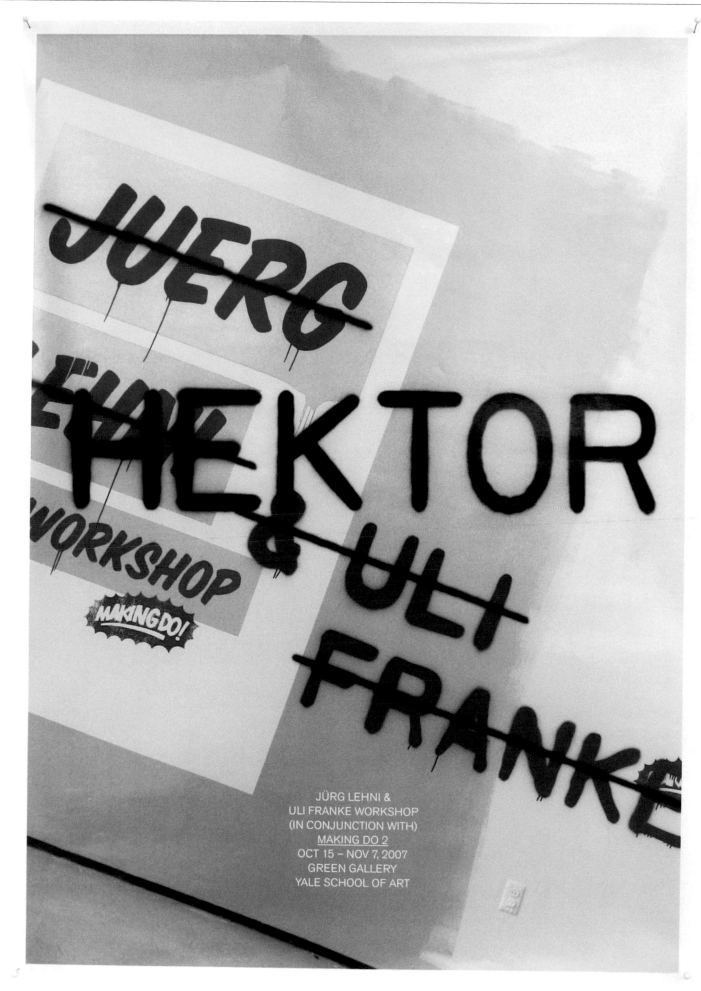

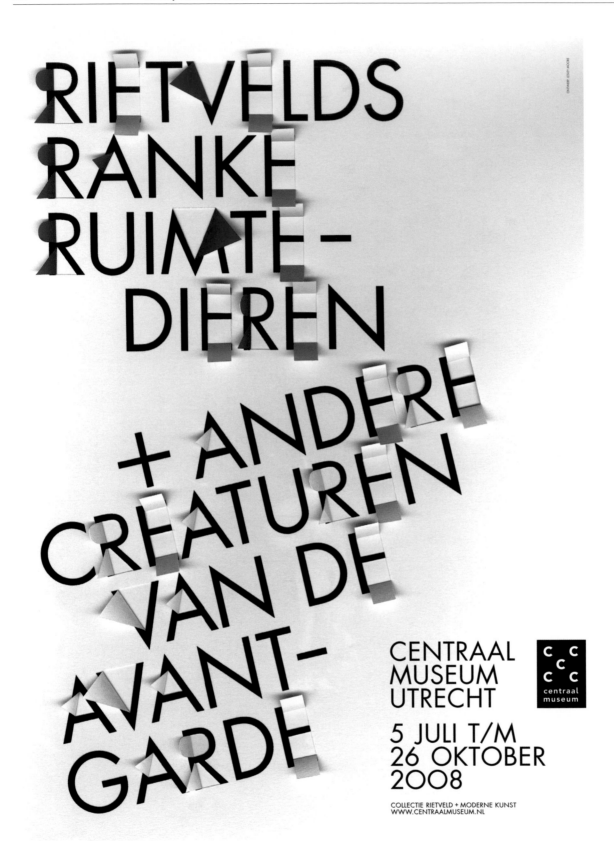

RIETVELDS
RANKE
RUIMTE-
DIEREN

+ ANDERE
CREATUREN
VAN DE
AVANT-
GARDE

CENTRAAL
MUSEUM
UTRECHT

5 JULI T/M
26 OKTOBER
2008

COLLECTIE RIETVELD + MODERNE KUNST
WWW.CENTRAALMUSEUM.NL

Rietvelds Ranke Ruimtedieren

What was your inspiration for this work? Gerrit Rietveld. The poster makes a clear reference to the De Stijl movement without copying it. Rietveld's focus on the spaces "through" and "between" an object is reflected in the emphasis on the "negative" spaces of the letters.

What is special, unusual, or unique about this project? The folding of the pages. The printer had a hard time folding the paper the "wrong" way... People wanted to touch it, to see if it was real or not.

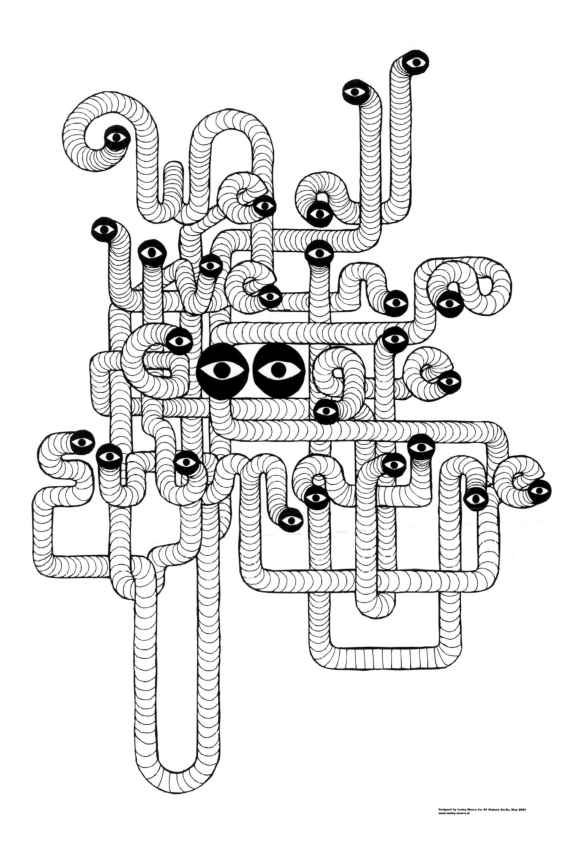

Google Submarine

What was your inspiration for this work? Submarines, worms, monsters. The project (initiated by Berlin designers anschlaege.de) reflects on the fall of the Berlin Wall twenty years ago. Many designers across Europe took part, reflecting on themes associated with the former Communist regime. Our theme was surveillance; we reflected on our own situation today.

Did you run into any specific problems or challenges while creating this work? Legibility. It is a problem that keeps reoccurring in our projects it seems. Some people couldn't tell that it was text.

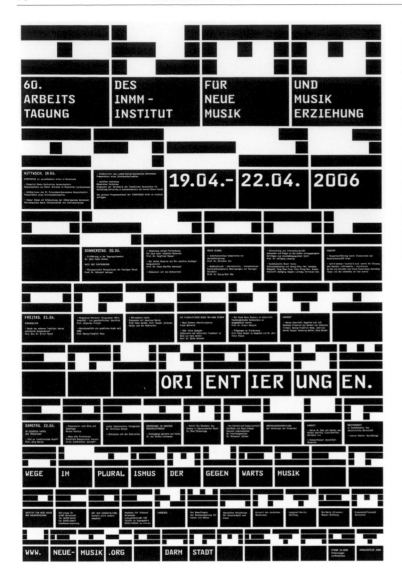

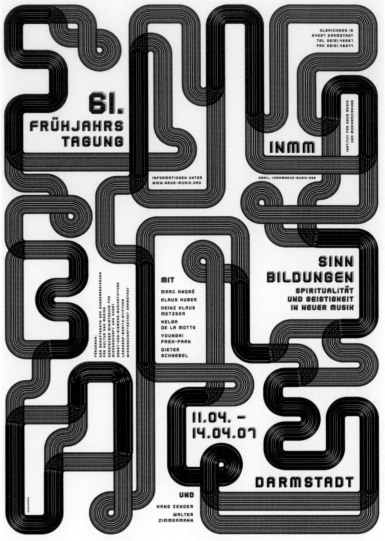

INMM Poster Series

The INMM—Institut for New Music and Education in Music—is one of our first clients. We started to take care of all their printed matter five years ago, when we were students. There was a great amount of reliance in our work from the very beginning. When you start off as a student or/and a young graphic designer this is not common.

As the posters differ a lot and never had the same author, commendation and criticism were never the same.

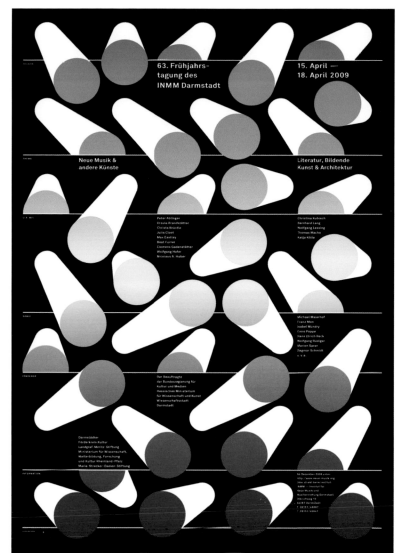

2xGoldstein // Andrew & Jeffrey Goldstein // Karlsruhe, Germany // www.2xgoldstein.de

Andrew and Jeffrey Goldstein are half-Canadian twin brothers, who studied together at the Hochschule für Gestaltung at Karlsruhe. They are co-founders of Versfabrik, an interdisciplinary workshop that deals with literature and graphic design. 2xGoldstein work as an independent graphic design studio for publishers, radio stations, and film studios.

Describe your early influences. Very first influences: a copier and an old typewriter. Distortions made with this copier, overlaps made with copier foils, and typography made with the old typewriter. First influences in design: posters by Gunter Rambow and his attitude toward design and designing.

Do you have a work motto? No, we don't have a motto. (But if we had one, it would be something like: We like it simple, straight, and with very good pay.)

What inspires you? Usually everything that is not design.

What aggravates you? Usually designers who use design as a form of self-fulfillment.

What is your worst nightmare? Usually a designer who considers himself or herself as an artist.

Are you a team worker or a lone fighter? As we are twin brothers the answer is clear.

Tell us the story of the name of your studio. 2xGoldstein. As we run a family business and like it simple and straight: two multiplied by our family name.

What is your dream of happiness? "Makes much more sense to live in the present tense." —P.J. / No code

Tell us five things you are crazy about. Thinking, debate, responsibility, beards, and long hair.

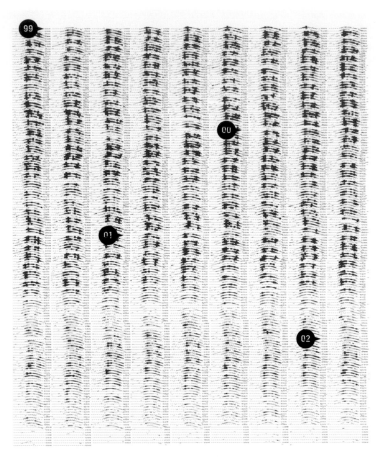

FD-2

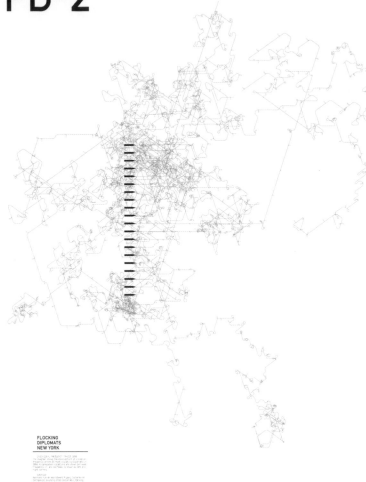

FLOCKING DIPLOMATS NYC 1999–2002

// VIOLATIONS/HOUR

Parking violations by Diplomats / Hour in 1999 to 2002 in New York City. The violations are plotted in relation to the sun-position as seen from Central Park (LATITUDE 40° 47' N / LONGITUDE 73° 58' W).

ANNUAL TOTALS (YEAR: TOTAL (MAX / DATE))

1999: 42.542 (85 / 09-24) — Security Council / Fifty-fourth Year, 4048th Meeting, Small Arms. Friday, 24 September 1999, 9.30 a.m.

2000: 38.338 (62 / 02-24) — Security Council / Fifty-fifth Year, 4104th Meeting, The situation concerning the Democratic Republic of the Congo. Thursday, 24 February 2000, 11.30 a.m.

2001: 25.390 (56 / 02-12) — Security Council / Fifty-sixth Year, 4276th Meeting, The situation along the borders of Guinea, Liberia, Sierra Leone. Monday, 12 February 2001, 3 p.m.

2002: 12.703 (33 / 04-23) — Security Council / Fifty-seventh year, 4517th Meeting, The situation in Angola. Tuesday, 23 April 2002, 10.30 a.m.

SOURCES

– Based on data from Ray Fisman and Edward Miguel, "Corruption, Norms and Legal Enforcement: Evidence from Diplomatic Parking Tickets", forthcoming, December 2007, Journal of Political Economy.
– Daylight Saving Time http://sunearth.gsfc.nasa.gov/eclipse/SEhelp/daylightsaving.html
– Sun-position (method of calculation) http://answers.google.com/answers/threadview?id=792866 (L. Flores)
– Time of sunrise and dawn: http://aa.usno.navy.mil/data/docs/RS_OneYear.php
– New York City Department of Finance

DATA MINING / SCRIPTING / DESIGN

Catalogtree, January 2008

printed at Plaatsmaken, Arnhem

FLOCKING DIPLOMATS NEW YORK

Flocking Diplomats

We designed some infographics for the *New York Times* around the end of 2006. One of these infographics showed the results of research about unlawful behavior and possible relations to the country of origin. The researcher used a database with parking tickets gathered by New York City diplomats to prove his thesis. We liked the idea of these diplomats swarming around Manhattan like a flock of birds, parking at the strangest places, and asked for permission to use the data.

We got it about a year later. Only the names were deleted, but the rest of the information—address, time, country, number plate—was shown. So we decided to design the following series of six silkscreened posters. Because of the amount of data, we had to design our own tools and decided to write our own programs to visualize the data.

FD1: Violations Per Hour
The graphic shows all violations/hour for each hour of 1999 to 2002. The violations are plotted in relation to the sun position as seen from Central Park.

FD2: Individual Frequency Traces
The diagram shows the development of violation frequency of the twenty most violating diplomats in 1999. Accumulated violations are shown per week. Frequency increases and decrease are shown as left and right curves.

FD3: Same Time, Same Place
Parking violations by diplomats in 1999 shown as polar graph. The top twenty addresses with the most violations is shown vertically. The lines connect the address, time, and day of week.

FD4: Same Place, Multiple Times
Parking violations by diplomats in 1999 shown as treemap. The top one hundred addresses with the most violations are used, the surface of the image is related to the number of violations committed at that place. In collaboration with Mikhail Iliatov (photography).

FD5: Time of Violation
The photo consists of about 140,000 clock hands as screen dots showing the exact time of each violation between 1998 and 2005.

FD6: Locations, 1998–2005
Parking violations by diplomats between 1998 and 2005. Of all 143,702 violations, 141,369 were suitable for geocoding, resulting in 16,355 unique locations. In collaboration with Lutz Issler (geocoding and programming).

FD-3

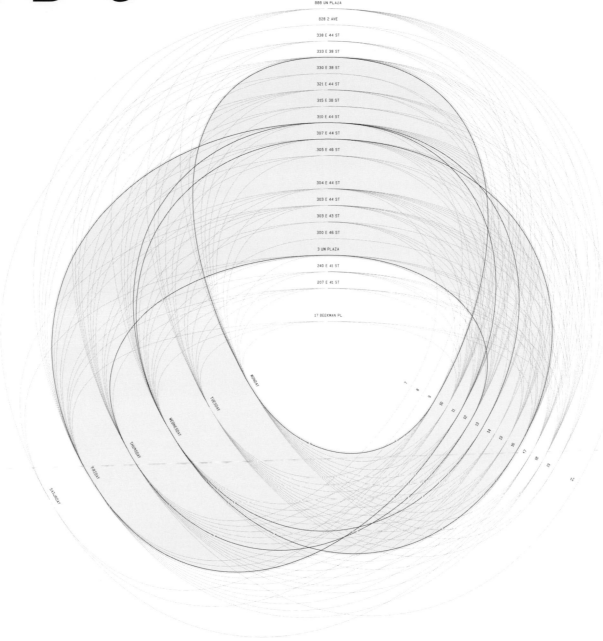

**FLOCKING
DIPLOMATS
NEW YORK**

SAME TIME, SAME PLACE
Parking Violations by Diplomats in 1999 shown as
polar graph. The Top 20 of addresses with most
violations is shown vertically. The lines connect
the address, time and day of week.
Dotted line: 3 to 6 diplomats meeting
Continuous line: 7 to 11 diplomats meeting

SOURCES
Based by kind permission on data from: Ray
Fisman and Edward Miguel, "Corruption, Norms
and Legal Enforcement: Evidence from Diplomatic
Parking Tickets", December 2007, Journal of
Political Economy.

DESIGN
Catalogtree, January 2008

printed by Plaatsmaken, Arnhem, NL.

FD-5

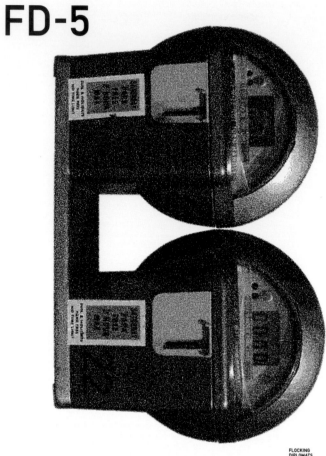

Catalogtree // Daniel Gross, Joris Maltha // Rotterdam, The Netherlands // www.catalogtree.net

Since graduating from Werkplaats Typografie in 2001/2002, Daniel Gross and Joris Maltha have worked together under the name Catalogtree in Rotterdam, The Netherlands.

Do you have a work motto? Form = Behavior. We ask the content to behave in a certain way rather than to tell each word or data point what to do exactly. An infographic should be a data-driven image, not an illustration of data. By behaving in a manner proposed by us, the data shapes itself into an intriguing picture. If possible, we write our own software to generate these images. The processing of data in graphic de-

sign almost demands this approach: because graphic devices, such as size, color, and position hold a quantitative meaning, the graphic designer cannot just use his good taste as guidance. We feel this way of working is refreshing, because it frees us of being virtuoso artists and allows us to tinker.

Tell us the story of the name of your studio. It's a technical term for filing structures—files within folders within folders, etc. We used the name for a Web space we shared with some friends to upload sketches and experiments. We started using it as a name to work under only a few years ago.

FD-6

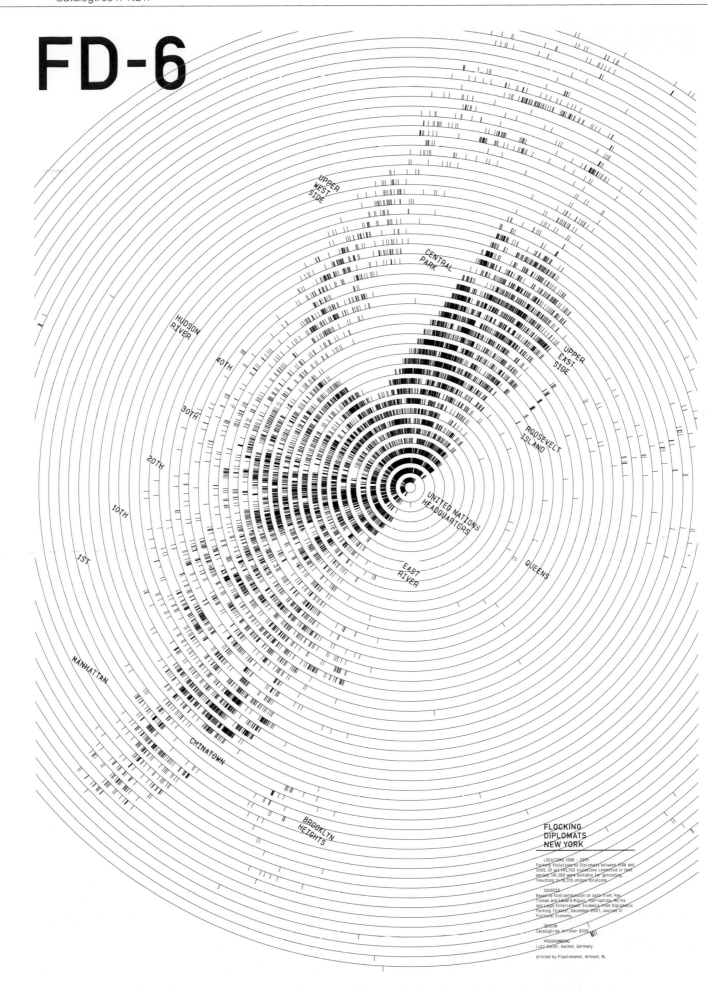

FLOCKING
DIPLOMATS
NEW YORK

LOCATIONS 1998 - 2005
Parking violations by diplomats between 1998 and
2005. Of all 143,702 violations committed in that
period, 141,369 were suitable for geocoding,
resulting in 16,355 unique locations.

SOURCES
Based by kind permission on data from: Ray
Fisman and Edward Miguel, Corruption, Norms
and Legal Enforcement: Evidence from Diplomatic
Parking Tickets, December 2007, Journal of
Political Economy.

DESIGN
Catalogtree, October 2009

PROGRAMMING
Lutz Issler, Aachen, Germany

printed by Plaatsmaken, Arnhem, NL.

Talkshow 03-09-07

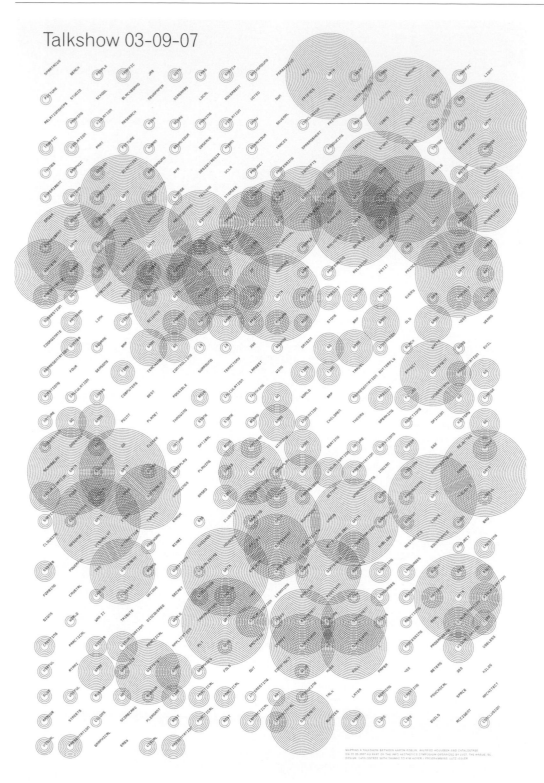

Talkshow

Talkshow, 03–09–07 poster (70 × 100 cm, screenprint) is an automatically generated visualization of a conversation with Aaron Koblin, Wilfried Houjebek, and Catalogtree as part of the Info Aesthetics Symposium organized by LUST, The Hague, and NL. Steno-typing was done by Lutz Issler. We were asked to do an "image battle" with Aaron and Wilfried. We all had one large screen to show images of our work or of in-fo aesthetics in general. The idea was to respond to what the others were showing, both in words and images.

What is special, unusual, or unique about this project? Our discussion was fed into a database by a steno-typist and translated to onscreen visuals in real time. We used the same database to design the poster afterward.

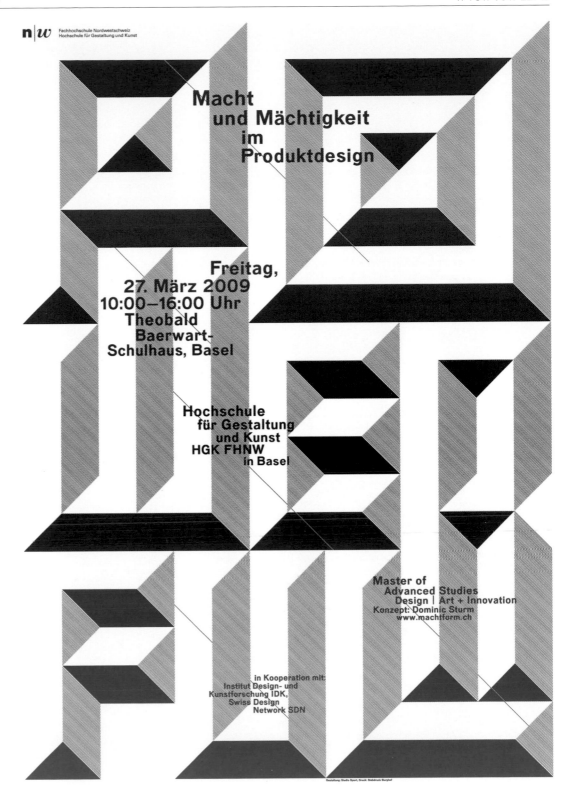

Powerful – Macht und Mächtigkeit im Produktdesign

We developed picture-puzzle-like 3-D letters, inspired by the malicious looks of stealth-boats and bombers. The event, a design conference, took place at the University of Art and Design Basel and was about power and mightiness in the field of product design. The posters and flyers have been screen-printed with two colors in one screen, which makes every product unique.

Thanx Max.
Helvetica 1957–2007

Designed by Ronnie Fueglister, Basel on the occasion of the celebration of «Helvetica, 50 Years» and the European Premiere of «Helvetica, A Documentary Film by Gary Hustwit» in Zürich, on March 24, 2007. An initiative by Lars Müller in collaboration with the Museum of Design Zürich, sponsored by the Swiss Federal Office of Culture. Displayed are all characters of Helvetica Bold (European Mac OS X version), 25 points in size.

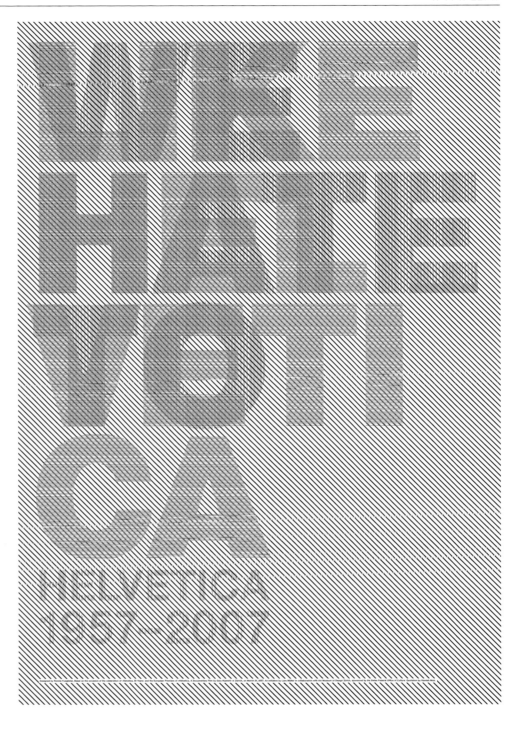

Helvetica – 50 Years

What was your inspiration for this work? The posters were designed for a poster competition organized by Lars Müller Publishers that celebrated the fiftieth birthday of our ultimate love/hate typeface Helvetica.
What is special, unusual, or unique about this project? It was made for a poster competition. No money but fame.
Do you recall unexpected reactions to this work? "We Like" made ninth place, "Thanx Max" was chosen as the jury's favorite.

Studio Sport // Ronnie Fueglister, Martin Stoecklin // Basel, Switzerland // www.studiosport.in

Studio Sport is made up of Ronnie Fueglister and Martin Stoecklin, who describe their work by saying, "Besides having real Swiss last names, we design mostly printed matter, accurate signage systems, bottom-of-the-line typefaces, and, from time to time, even Web sites."
Describe your early influences. Skateboarding, graffiti, and punk rock. Kasimir Malevich, Andy Warhol, and Egon Schiele. Microsoft Paint, NES, and the *Curiosity Show*.
What do you consider quality in graphic design? Thoughtfulness and craft.
Do you have a work motto? Do. Make. Say. Think. In random order.
What does your working environment look like? It's a warehouse. A lot of space; wooden floor; hot in summer and cold in winter.

What aggravates you? Design books.
How do you get new ideas when you are stuck? We discuss.
What is your workout for creativity? Coffee and cigarettes
Where do you find new energy? On the roof of our studio.
Are you a team worker or a lone fighter? We are team workers.
Tell us the story of the name of your studio. No story; we just thought it makes sense.
Tell us five things you are crazy about. Books, music, water, furniture, sports.
Which logo do you like best? The 1972 Renault logo by Victor Vasarely.

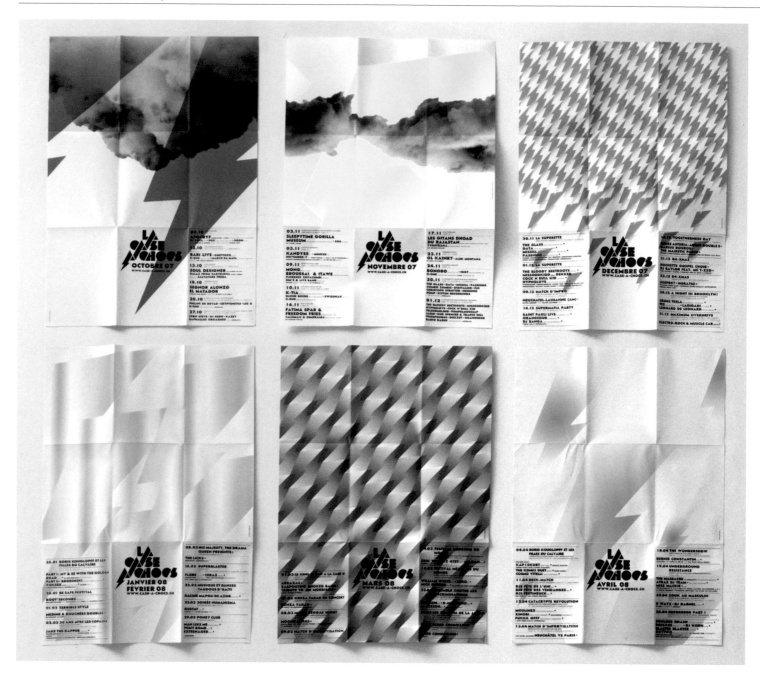

La case a choc

Design of the new logo and monthly flyers for a club in Neuchâtel, Switzerland.
What was your inspiration for this work? Basically, 1980s music visuals.
Did you run into any specific problems or challenges while creating this work? Some troubles with the Web site. Find a good, reliable, programmer. (That's some

good advice for the students.)
Do you recall unexpected reactions to this work? No, but we hope a lot of couples met in the club that year.

Dynamo // Thibaud Tissot, Yassin Baggar // Berlin, Germany // www.dynamo.li

Dynamo is a playground, a structure created by Thibaud Tissot and Yassin Baggar to carry out self-commissioned projects in the editorial and typographical field, in collaboration with diverse people.
Describe your early influences. We were influenced by very diverse people. As students, we were hungry for graphic design, we would look for everything we could, in the library, in bookshops, on the Internet. Of course Swiss graphic design caught our eyes (Emil Ruder, Armin Hoffman, Müller-Brockmann, Weingart). The younger generation, Lineto as well, of course, but we really looked around. There is something interesting everywhere you look.
Which work of yours are you especially happy with? In general, we're not happy for very long. That keeps us going.
What do you consider quality in graphic design? Courage.

What is your worst nightmare? Fear.
What inspires you? Some days, everything. Some days, nothing.
How do you get new ideas when you are stuck? Hopefully the next day will be better.
What guidelines and advice would you give students of graphic design? Get a good hard drive.
Are you a team worker or a lone fighter? We're team fighters.
What is your dream of happiness? When we know what happiness is, we'll be happy to share the information.
If you were not a graphic designer, what would you be? A cat. I think they have it pretty good.

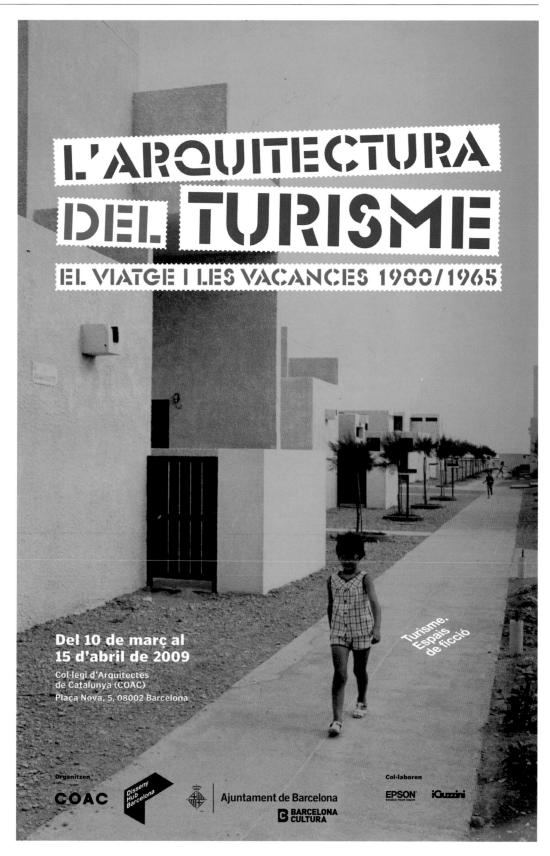

L'arquitectura del turisme. El viatge i les vancances 1900/1965

The exhibition is a journey through the architecture of tourism in the Mediterranean coast, from the early twentieth century travelers to the mass tourism of the 1960s. To evoke the idea of travel, some iconographic elements of the postal service were taken as reference: the serrated edges of a stamp, the red-and-blue edges of an envelope, and the typography of the postmark.

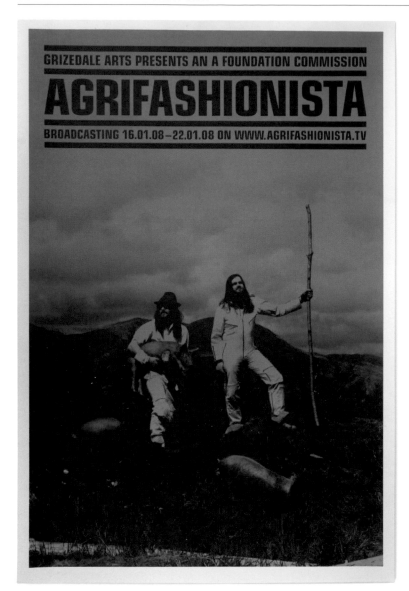

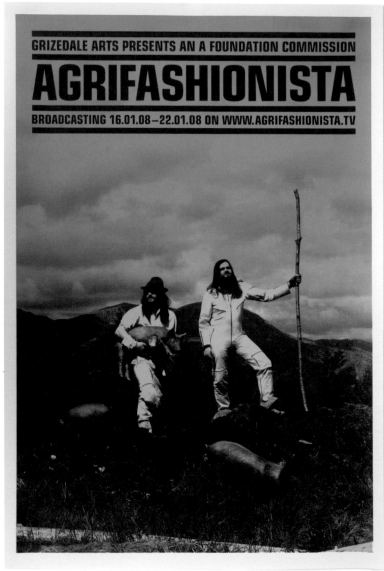

Agrifashionista

These posters reference everything from eighteenth-century agricultural portraiture, to psychedelic poster art to Soviet political propaganda. Because the project was

screen-printed, we had the opportunity to vary the colors used gradually throughout the course of the run. Because of this, every poster is unique.

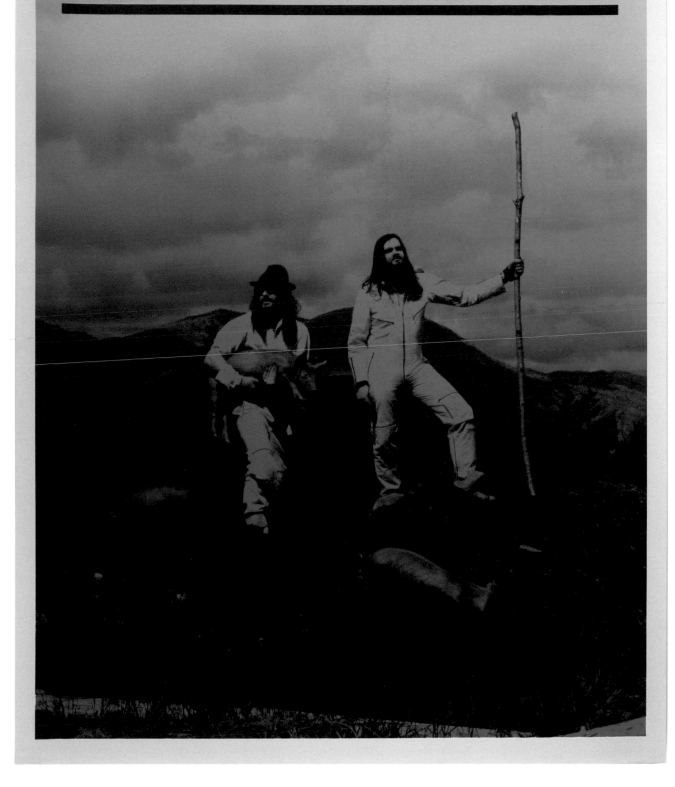

Piet Mondriaan
Compositie No.II
olieverf op doek

vanabbemuseum

Asger Jorn
Le monde perdu
olieverf op doek

vanabbemuseum

Christo
Packed Arm Chair
stoel, textiel, plastic, touw

vanabbemuseum

Campaign Van Abbemuseum

What was your inspiration for this work? The simple idea of showing the collection of the museum to people, whether they are in the museum or outside.
Did you run into any specific problems or challenges while creating this work? No. On the contrary, there are so many great works in the Van Abbemuseum that it's too bad nobody sees them normally.

John Körmeling
HI HA

installatie

vanabbemuseum

A.R. Penck
Torquato Tasso

acrylverf op doek

vanabbemuseum

75B // Robert Beckand, Rens Muis, Pieter Vos // Rotterdam, The Netherlands // www.75b.nl

The Rotterdam-based design collective was founded by Robert Beckand, Rens Muis, and Pieter Vos. During their study they started collaborating on projects for the Art Academy as well as for local youth and music initiatives. After projects became bigger, more complex, and more ambitious, 75B evolved into a more serious, stable, and acknowledged firm that creates innovative and experimental designs for various clients.

What does your working environment look like? We're based in an old garage building or something like that. Plumbers and all kind of chore-men walk in and out repairing something, we don't know what. We have the idea to write a musical about this dynamic scenery and sometimes try to sing some songs about the situation.

Do you have a work motto? We always say *ieder z'n vak*, which means something like everybody should work in his own professional field.

What inspires you? Kids.

Tell us the story of the name of your studio. 75B is a European bra size, which is an average size, so nothing extreme. We're not about extremes.

If you could live in another place for one year, where would that be? Any place that has more sunshine than here in Rotterdam.

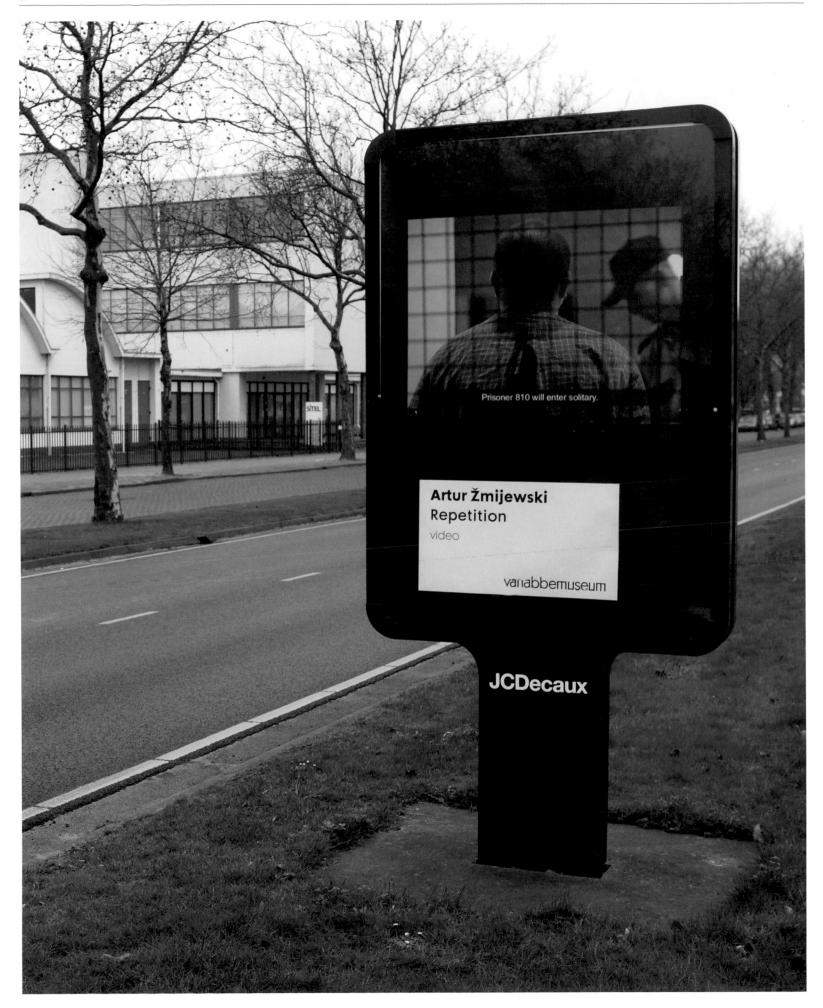

ORIGINAL OUTSIDER
IN ASSOCIATION WITH
LIVE NATION
PRESENT
THE LEA SHORES
LIVE AT THE
100
CLUB
OXFORD STREET W1
100
TUES 15TH
APRIL 2008
WITH EXIT CALM &
KYTE
PLUS
SPECIAL GUEST DJ SETS
£8·00 7.30
UNTIL LATE
ADVANCED TICKETS
FROM WEGOTTICKETS.COM
www.myspace.com/theleashores

LIVE NATION ORIGINALOUTSIDER

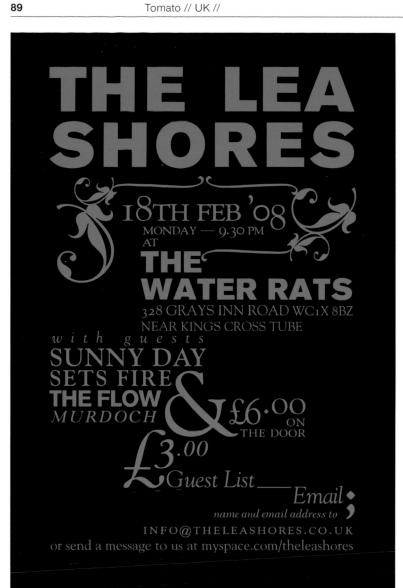

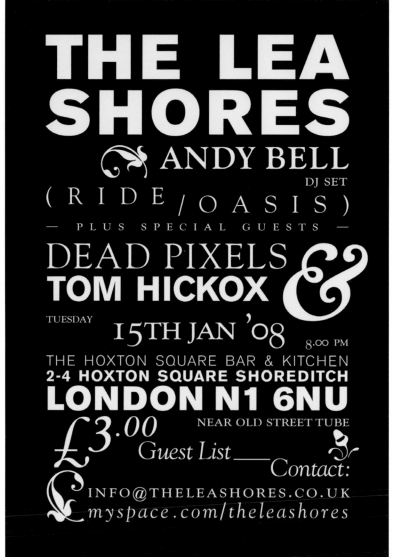

The Lea Shores

Typographic posters and flyers for the band The Lea Shores, formed about four years ago in Peckham, South East London.

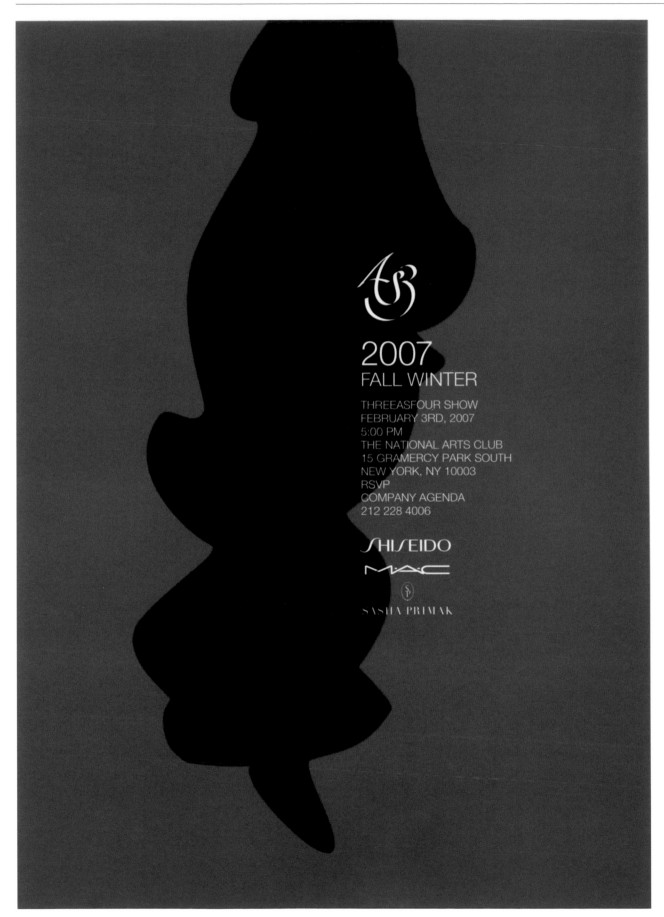

Three ASFOUR FW 2007 Invite

Stiletto wanted the Three ASFOUR FW 2007 invite to be dark, but still readable. The inspiration came from the clothing itself, as Stiletto describes: "Showing its silhouette, the clothing is abstracted as an exterior form. It's hard to tell that it's even clothing."

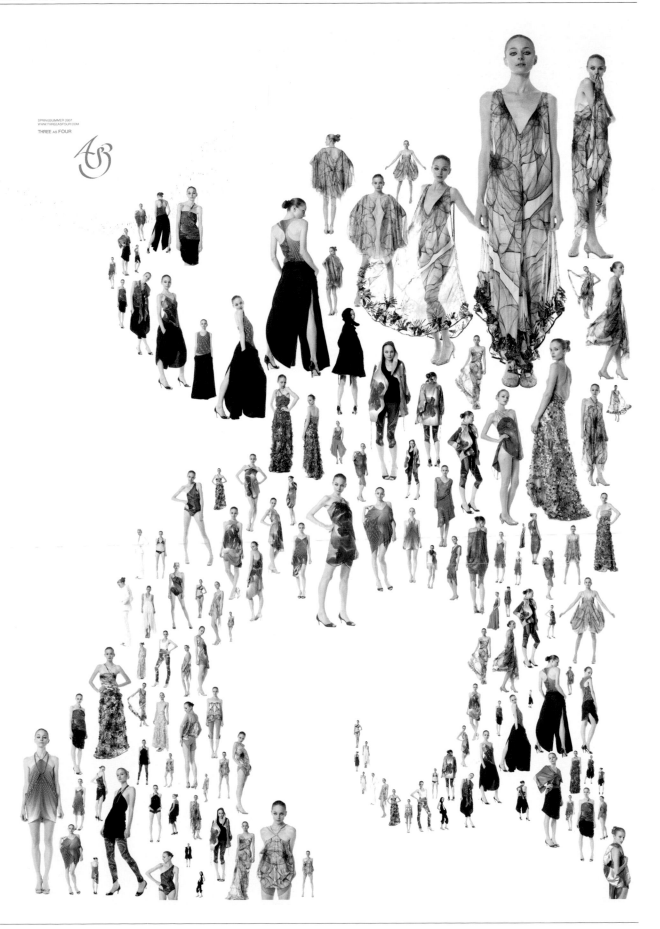

Three ASFOUR SS2008 Lookbook Poster

Rather than create a traditional lookbook, Stiletto designed a poster featuring all of the looks in the collection. They worked closely with ASFOUR to create an overall shape that fit with the fractal patterns that were used for the collection.

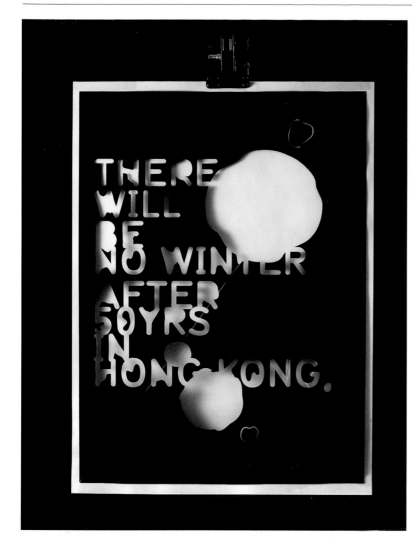

"There Will Be No Winter After 50 Years in Hong Kong."

Global Warming was a creative exhibition in Shenzhen for independent Chinese designers and artists to arouse peoples' attention of our living planet. It was simply inspired from a stunning Hong Kong report I heard while watching the news one day: "There will be no winter in Hong Kong after fifty years." Instead of general offset printing, the poster was created with transparent film, only without paper and ink. It was produced in only one piece for the exhibition, which was a new challenge for me compared to my previous work as a graphic designer.

Milkxhake // Javin Mo, Wilson Tang // Hong Kong, China // www.milkxhake.org

Milkxhake is a young Hong Kong-based design unit co-founded by graphic designer Javin Mo and interactive designer Wilson Tang in 2002 that mainly focuses on graphic and interactive mixtures.
Describe your early influences. Anything "weird" in my home city, Hong Kong.
On a more practical level, what can be found on your desktop? A chaos of paper, ideas, and files (both on my working table and my notebook desktop).
Do you have a work motto? Do good work to "mix it" a better world!
How do you get new ideas when you are stuck? I have a good sleep.
What is your workout for creativity? Leave the place you are quite familiar with.
Where do you find new energy? Go to any other places you aren't familiar with.

Tell us the story of the name of your studio. Milkxhake was the name of my design assignment project in university; you were asked to establish a design studio and a full identity was designed at that moment. Originally named as "milkshake," the new name "milkxhake" embodied the meaning of "mix" and was used since 2005.
What is your dream of happiness? Design can make something better in our life.
If you could live in another place for one year, where would that be? Scandinavian cities, which are, I'm sure, totally different than Asian ones.
Your top five newsletters. Manystuff.org, grafikcache.com, *IDEA* magazine (Japan), *Art&Design* magazine (China), *Design 360°* magazine (China).

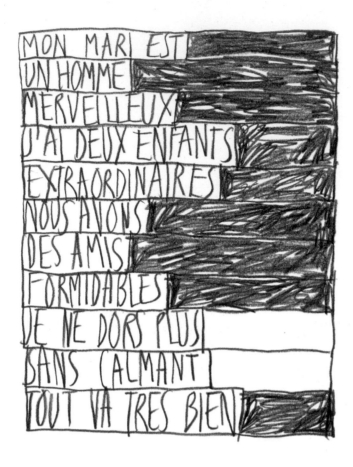

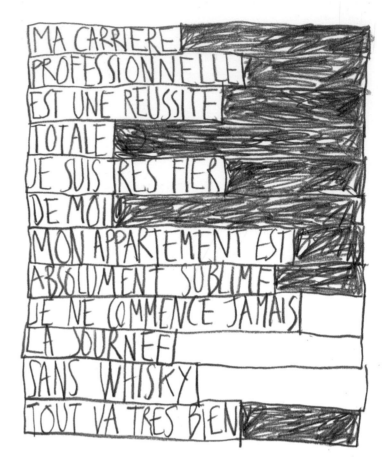

0800
DROGUES 231
INFO 313
SERVICE

de 8H à 2H, gratuit depuis un poste fixe, anonyme et confidentiel

0800
DROGUES 231
INFO 313
SERVICE

de 8H à 2H, gratuit depuis un poste fixe, anonyme et confidentiel

Drogues Info Service

What was your inspiration for this work? Being in someone else's shoes to find a pertinent text but also a right graphic answer. Among other things, the hotline wanted ill people to become aware of their own situation. I enjoyed working on what could be the state of mind of someone that has these kind of matters to deal with, but does not.

Géraldine Roussel // Paris, France // www.geraldineroussel.com

After her studies at ESAG Penninghen, Paris, Géraldine Roussel lives and works in Paris as a freelancer, collaborating within a network of young designers and artists.
Describe your early influences. Tony Ross, Quentin Blake, Rosy… my parents.
What do you consider quality in graphic design? Determination.
What does your working environment look like? White table, white wall. Some colorful pictures I often change.
Do you have a work motto? I try to be intuitive in my work.
What inspires you? I don't think there is a miracle solution to being inspired. I feel creative when I am happy, also sometimes when I'm despaired.

What aggravates you? Doubts.
What guidelines and advice would you give students of graphic design? Staying self-confident.
How do you get new ideas when you are stuck? A change of scenery. I think about something else.
What is your workout for creativity? None. I don't understand where it comes from. It comes and goes.
Where do you find new energy? When I leave Paris.
What is your dream of happiness? We will see.

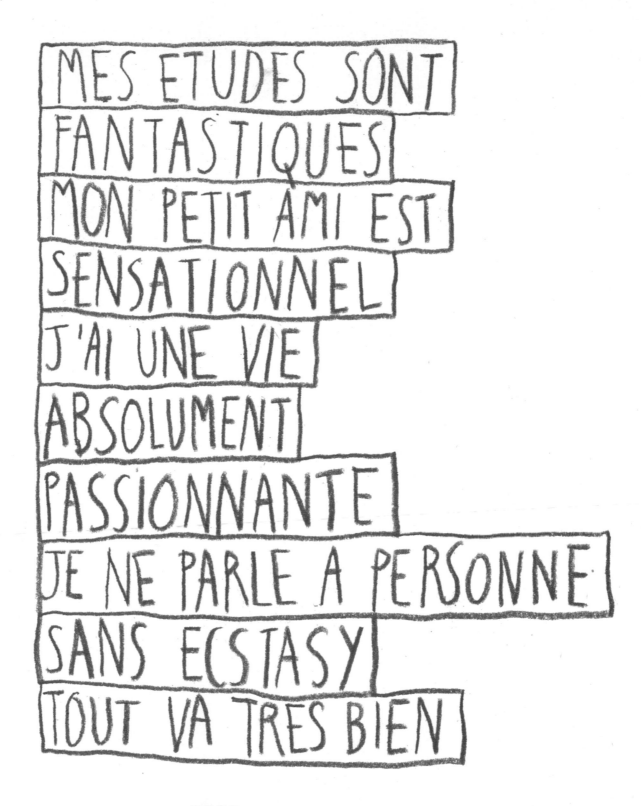

0800
DROGUES 231
INFO 313
SERVICE

de 8H à 2H, gratuit depuis un poste fixe, anonyme et confidentiel

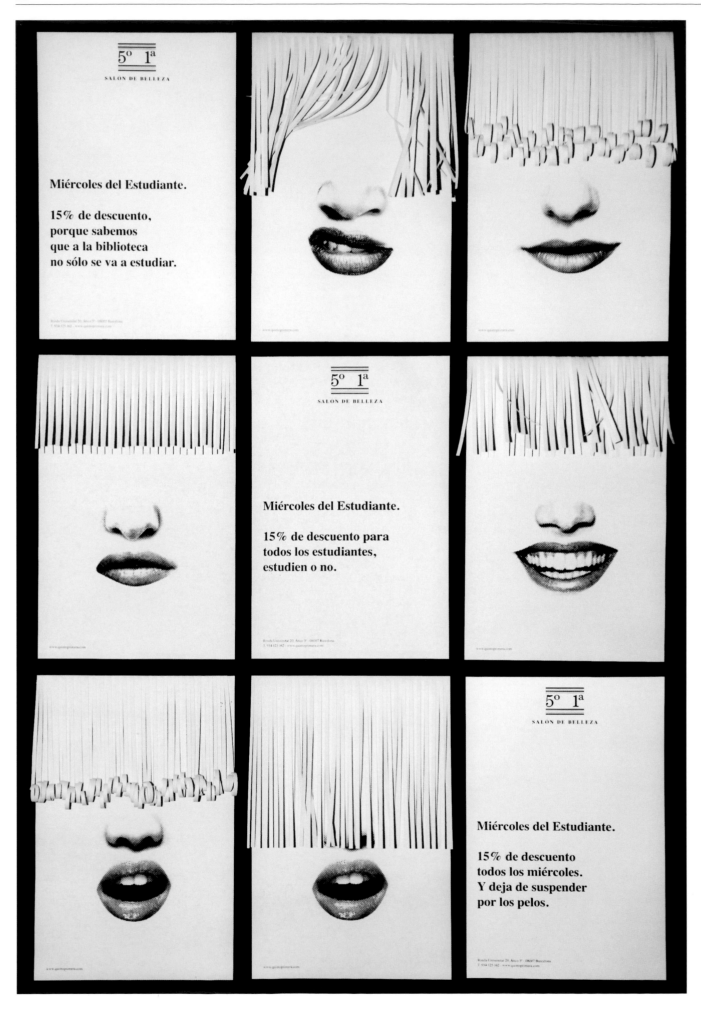

Combed Poster 5º 1ª Hairdressing Salon

What was your inspiration for this work? Strips of wastepaper after using a paper shredder. The special thing is that the posters are combed. It was challenging to get familiar with the shredding process. Just a part of the poster (the hair) had to be torn. What we didn't expect was that people would steal the posters.

New Season Posters – Sabina Moda

Starting this project, we looked for plenty of techniques related to "dressmaking." In the end, it became a textile poster series produced by means of cross-stitching. **Did you run into any specific problems or challenges while creating this work?** We had to learn to cross-stitch.
Do you recall unexpected reactions to this work? Cross-stitching hurts.

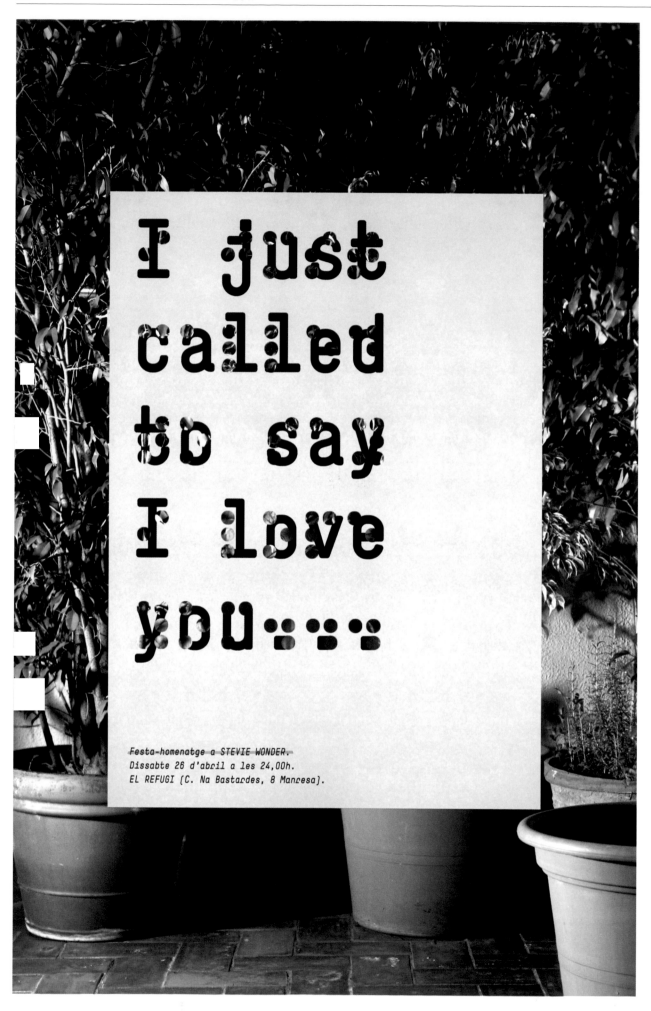

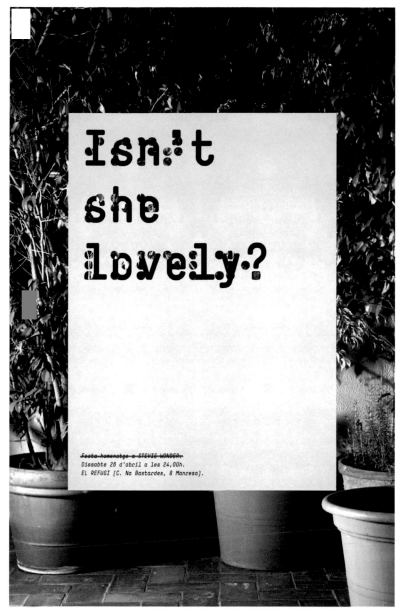

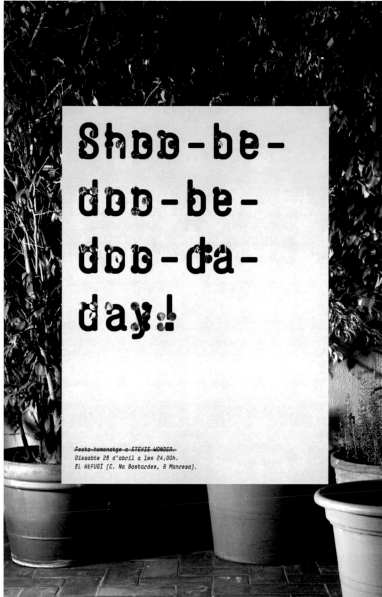

Stevie Wonder Tribute Party – El refugi

Many songs of Stevie Wonder are universally known. The posters combine song ti-
tles with the dual roman/Braille alphabet (print/cut-out) to identify the musician and
create an instant message.

Bendita Gloria // Alba Rosell, Santi Fuster // Barcelona, Spain // www.benditagloria.com

The work of Bendita Gloria shows the fun and joy they have while creating individual
and carefully elaborated peaces of graphic design.
Describe your early influences. We've always loved clever solutions in graphic de-
sign, as in the work of Daniel Eatock or Stefan Sagmeister, for example. We were al-
so influenced by graphic novelists, like Chris Ware or Daniel Clowes and by the early
movies of Peter Greenaway.
What does your working environment look like? Many things hang on the walls of
our small studio. It's located in a penthouse in Barcelona and iTunes is always play-
ing. It's very important for us to keep it nice and orderly.

Do you have a work motto? Everything should be personal and dissimilar. The worst-
case scenario for a client is to go unnoticed.
What guidelines and advice would you give students of graphic design? Don't be
afraid to make mistakes; you'll never be as free as you were in school.
How do you get new ideas when you are stuck? Sharing a chat and a cup of tea.
Tell us the story of the name of your studio. Bendita Gloria means "blessed glory."
We're agnostic, but we want our clients to catch "glory."
If you were not a graphic designer, what would you be? Alba would be a photogra-
pher and Santi would be a musician.

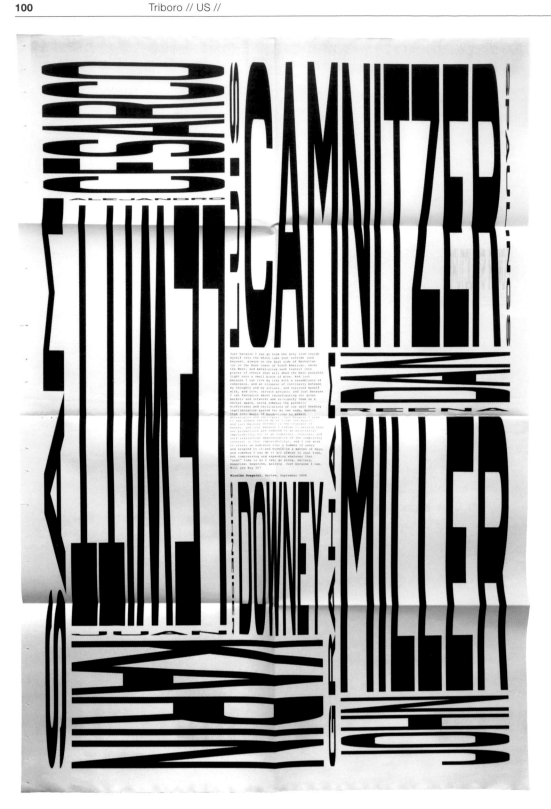

Power Structure

Power Structure is an invitation for a group show at Roth Gallery. There are many different styles of artwork and we must accommodate many different artists' names. Usually we treat all the names consistently so that there is no hierarchy. In this case we went a bit nuts. We created a custom font that naturally could be compressed and extended in extreme ways. We really expected that the artists in the show would have a problem with their names being compressed and extended and set at varying angles. Astonishingly, these issues with readability were never raised.

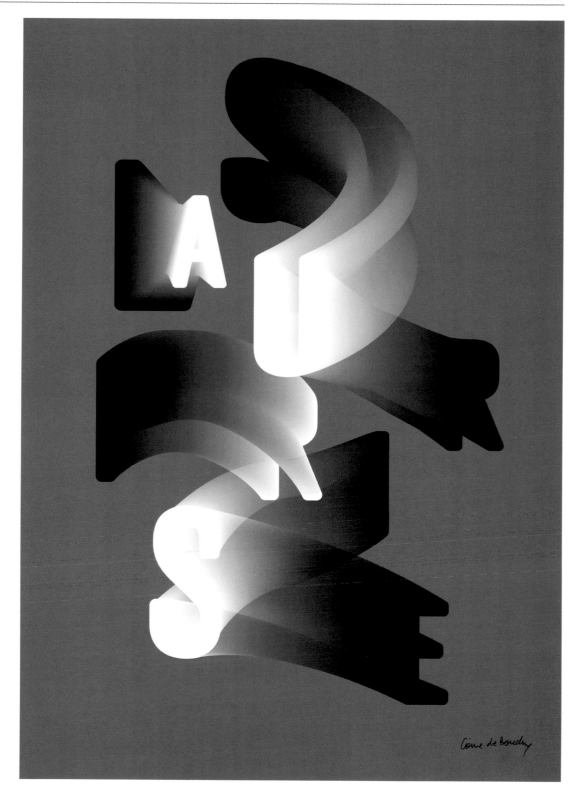

La surprise

Poster celebrating the launch of new Parisian studio, La surprise.

Côme de Bouchony // Paris, France // www.comedebouchony.com

After studying in Paris and Rotterdam, Côme de Bouchony founded his own practice in 2007. He is currently working on an eclectic range of projects, mostly in music and cultural and media areas, including print and animated design.
What inspires you? I think everything can be a source of inspiration. It's really something I don't try to explain myself. Although, I must say, music plays a big role in my life and in my work.

What does your working environment look like? I work at home!
What can be found on your desktop? On my real desktop: pens, magazines, books, papers Post-Its, sunglasses, clothes, food, plants, pretty much everything! On my Mac desktop: lots and lots of images.
Where do you find new energy? I go swimming and take a walk.

international architectural education summit
建築教育国際会議
建築教育と職能の世界標準化をどう考えるか
2009年7月17日(金)〜19日(日)

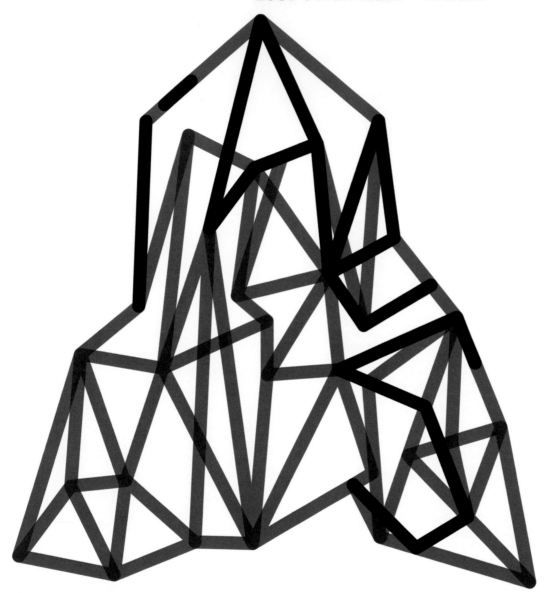

阿部仁史 / **ヘルムート・アンハイア** / **ニールカンス・チャヤ** / **プレストン・スコット・コーエン**
ベアトリズ・コロミナ / **ダナ・カフ** / **オディル・デック** / **古谷誠章** / **伊東豊雄** / **ジョン・キュウ・キム**
隈研吾 / **ラルフ・ラルナー** / **難波和彦** / **小野田泰明** / **ウォルフ・プリックス** / **フェルナンド・ラモス**
ブレット・スティール / **塚本由晴** / **マーク・ウィグリー** / **ウェイグォオ・シュー** / **山本理顕**
アレハンドロ・ザエラ・ポロ / このイベントは、現在の世界的状況に対する初の試み
として、国際的な建築家、教育者、研究者を集め、建築のローカルな実践現場と
国際基準との間に生じる軋轢を議論する。

共催: 東京大学GCOEプログラム 都市空間の持続再生学の展開＋UCLA 建築・都市計画学部

1日目 7月17日(金)午後5時〜7時半　東京大学工学部1号館建築学科製図室　基調講演 および展覧会オープニング
2日目 7月18日(土)午前9時半〜午後6時　東京大学安田講堂　シンポジウム
3日目 7月19日(日)午前10時〜12時　東京大学情報学環福武ホール　ラウンドテーブル

詳細はウェブサイトを御覧下さい。
www.iaes.aud.ucla.edu

助成: 国際交流基金日米センター　後援: 社団法人 日本建築学会、社団法人 日本建築家協会、社団法人 日本建築士会連合会
協賛: 総合資格学院、株式会社 建築資料研究社／日建学院、株式会社 三菱地所設計、株式会社 日建設計、株式会社 日本設計、株式会社 サイマル・インターナショナル
連絡先: design@arch.t.u-tokyo.ac.jp ari.seligmann@aud.ucla.edu

入場無料
当日先着順 (1日目200人、2日目1000人、3日目150人)
同時通訳付き

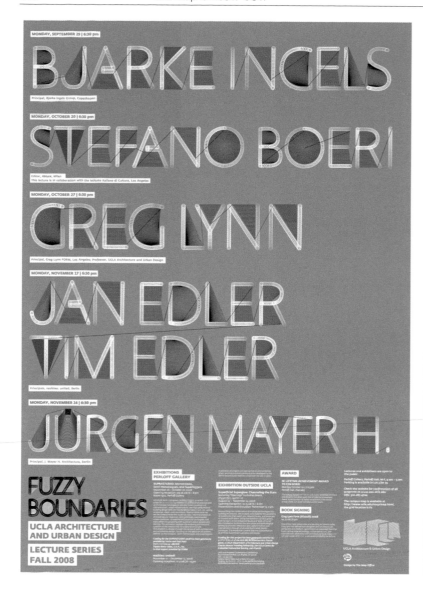

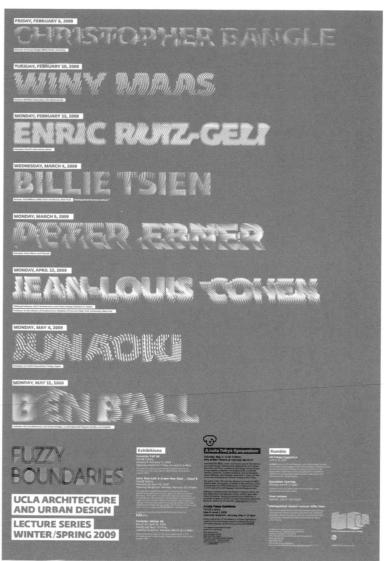

IAES, International Education Architectural Summit, Tokyo

The initial set of ideas for this bilingual produced poster (one for Japanese, and one for English), revolved around the representation of "Education" and "Summit" with an undertone of focus on the text, which described the set-up as a meeting of "internationally respected architects, educators, and scholars to address tensions between local practices and international standards for a globalized architectural profession." It was immediately apparent that we were dealing with simple ideas in a complex setting. The designs involved the use of balance, connection, and the infrastructure of objects. It was from the explorations of infrastructure of type where the abstract shape derives from representing a mountain's summit.

UCLA (poster lecture series Fall '08 & Winter /Spring '09)

Map digitally altered the pixels of Fedra Sans, the typeface of the UCLA Architecture and Urban Design brand, to give birth to typographic styles or mutant forms of the typeface to reflect that the faculty is about freethinking individuality.

Did you run into any specific problems or challenges while creating this work? When you computationally render a lot of points, it's extremely difficult to save the overall composition.
Do you recall unexpected reactions to this work? "Why didn't I think of that?!"

The Map Office // Eddie Opara, George Plesko // New York, Boston, USA // www.themapoffice.com)

Map is a multi-disciplinary design atelier based in New York and Boston. With an extensive experience in all areas of graphic design, it is working with a focus on luxury, art, fashion, and media branding.
Describe your early influences. Part of my early influences was looking at the rough, raw, sporadic work of Cy Twombly and Lazslo Moholy Nagy graphical experiments. Architecture has always been a large influence upon me. I've always had a soft spot for Archigram for their unrelenting hedonistic graphical style.
Do you have a work motto? I'm a Tottenham Hotspur supporter and believe in the motto "To Dare Is To Do"; this is quite fitting for Map.

What aggravates you? Designers who are prima donnas, taking credit when credit is not due, and people who talk too much and don't do anything. Clients who don't listen to designers. Designers that don't listen to clients.
What is your worst nightmare? Losing my ability to design.
How do you get new ideas when you are stuck? I go to church.
How do you get new energy? By listening to music. I sing and dance along.
Five things you are crazy about. I'm crazy about Tottenham Hotspur, Sarah Rosengartner, Supergraphics, and singing incorrect lyrics to songs.

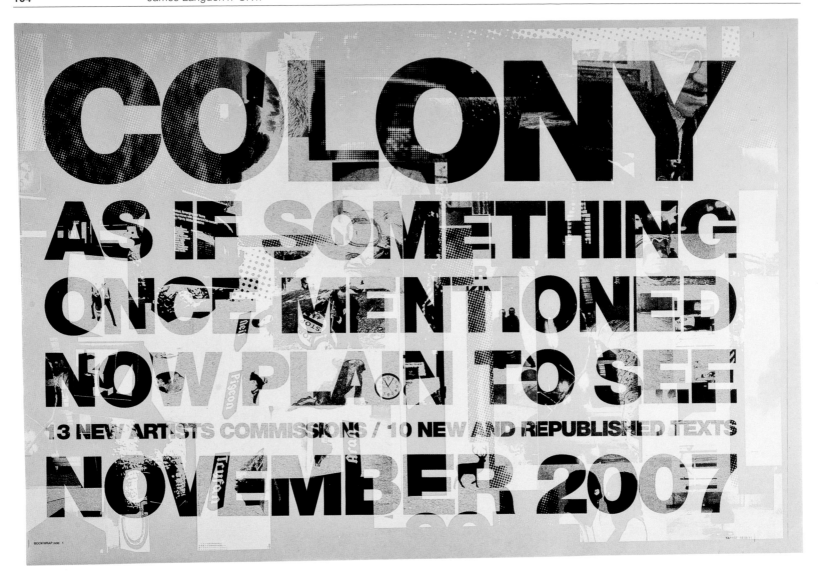

Colony

Commissioned by Colony Gallery, based in Birmingham, UK, and run by Irish artists Mona Casey and Paul McAree, Colony is a nomadic project space that finds venues across Birmingham and beyond as projects' and artists' needs arise. Colony-run projects seek to challenge and negotiate the frameworks of contemporary art practice.

James Langdon // Birmingham, United Kingdom // www.jameslangdonwork.net

James Langdon, based in Birmingham, studied as an artist and now works as an independent designer of books and printed matter with artists and arts organizations. He is also one of the founding directors of Eastside Projects, an artist-run exhibition space in Birmingham, UK.

Which work of yours are you especially happy with? I like the poster for Simon and Tom Bloor's exhibition. It looks like it could have been found on the wall of a 1970s community center.

What inspires you? Discovering the work of other artists and designers—in old books and magazines and online—that has been forgotten

What does your working environment look like? A small room in my house.

If you could live in another place for one year, where would that be? An alpine village.

If you were not a graphic designer what would you be? A printer.

What are your top five newsletters: *Aargauer Kunsthaus* by Elektrosmog. The long-running *Art & Project* bulletin series from Amsterdam. Richard Hollis' work for The Whitechapel in London. Stedelijk Museum Bureau Amsterdam by Mevis and van Deursen.

Tell us five things you are crazy about. Books by Dieter Roth, Helix by Ceal Floyer, cutaway drawings, Remy Zaugg studio by Herzog & De Meuron, anything by Georges Perec.

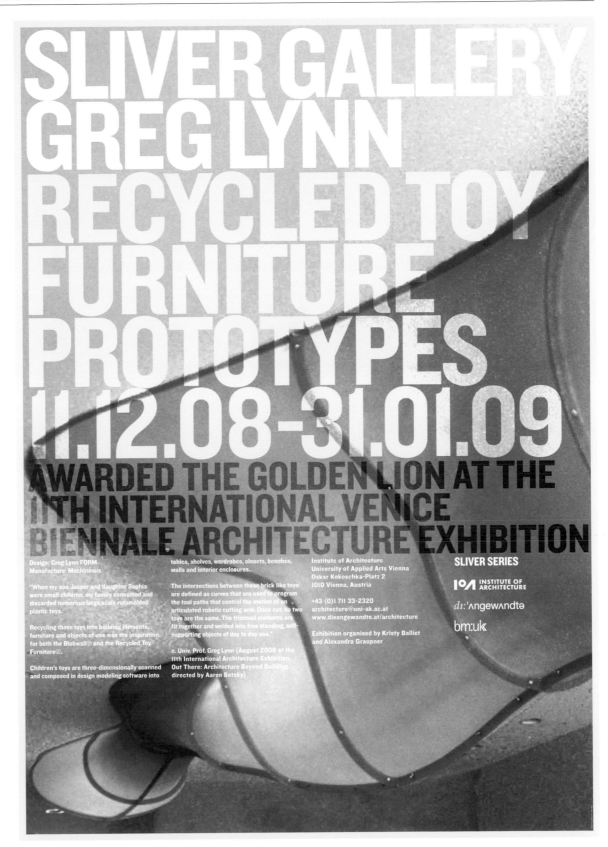

The poster reads:

SLIVER GALLERY
GREG LYNN
RECYCLED TOY
FURNITURE
PROTOTYPES
11.12.08-31.01.09
AWARDED THE GOLDEN LION AT THE
11TH INTERNATIONAL VENICE
BIENNALE ARCHITECTURE EXHIBITION

Design: Greg Lynn FORM
Manufacture: Machineous

"When my son Jasper and daughter Sophia were small children, my family consumed and discarded numerous large scale rotomolded plastic toys.

Recycling these toys into building elements, furniture and objects of use was the inspiration for both the Blobwall® and the Recycled Toy Furniture®.

Children's toys are three-dimensionally scanned and composed in design modeling software into

tables, shelves, wardrobes, closets, benches, walls and interior enclosures.

The intersections between these brick like toys are defined as curves that are used to program the tool paths that control the motion of an articulated robotic cutting arm. Once cut, no two toys are the same. The trimmed elements are fit together and welded into free standing, self-supporting objects of day to day use."

o. Univ. Prof. Greg Lynn (August 2008 at the 11th International Architecture Exhibition, Out There: Architecture Beyond Building, directed by Aaron Betsky)

Institute of Architecture
University of Applied Arts Vienna
Oskar Kokoschka-Platz 2
1010 Vienna, Austria

+43 (0)1 711 33-2320
architecture@uni-ak.ac.at
www.dieangewandte.at/architecture

Exhibition organised by Kristy Balliet and Alexandra Graupner

SLIVER SERIES

I°/ INSTITUTE OF ARCHITECTURE

di:ˈʌngewʌndtə

bm:uk

Sliver Gallery Poster

The Sliver Gallery Poster is based on a harsh typographic hierarchy, which then integrates into or merges with the background image of one of Greg Lynn's pieces of furniture. It is part of a series of posters that we design regularly for the Gallery. Quite early on in this process we decided to work with bold typography and chose the typeface Knockout for the project. The particular cut and the use of uppercase only emphasizes the format of the portrait poster. In this particular instance, it was the tension that we created by the tight margins and large lettering that also reflect the pressure, the molding and deformation process happening in the process of recycling children's plastic toys.

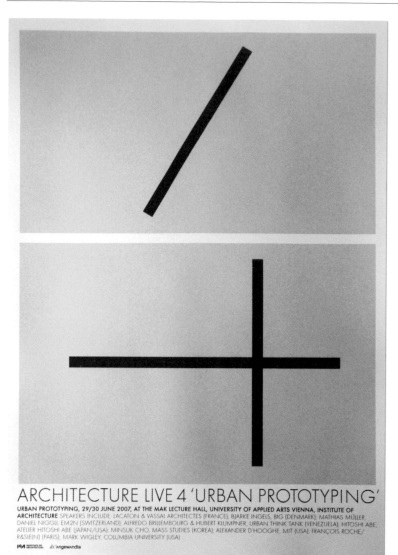

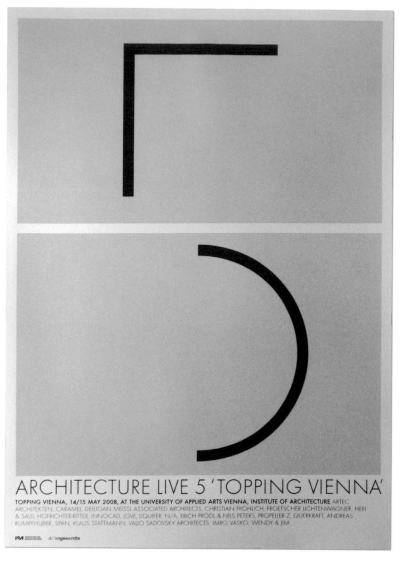

Architecture Live, Limited-Edition Posters

The Architecture Live, limited-edition posters were designed as a thank-you "note" for people running a workshop at the University of Applied Arts Vienna Architecture. This university teaches a lot about deconstructivism and spatial awareness. Since the title always stays the same, I decided to make the numeral the main design feature. The general aesthetic stays the same and establishes the posters as a series, but the deconstructed numerals give the posters their individual signature.

Funnily enough, the boss of the client team hated the poster designs, but we decided to have them printed nevertheless. They became a huge success. It is one of the projects I get most comments on.

Paulus M. Dreibholz // London, United Kingdom // www.dreibholz.com

Paulus M. Dreibholz was born in 1977 in Graz, Austria. After studying at the London College of Printing and the Central Saint Martins College of Art and Design, he founded his own practice with a focus on projects in the field of fine art and architecture. Specializing in all things type-related, his London-based studio has a rigorous output of books, catalogs, corporate identities, and exhibition pieces. Besides his work as an associate lecturer in London and Vienna, he regularly conducts typographic workshops and lectures at colleges and universities across Europe.
What do you consider quality in graphic design? Well-crafted, non-dogmatic, intelligent (sometimes intellectual), questioning, inspiring, and political design. I believe

in the power of form and materials and the conceptual integration of these elements into a project. Typography is about working with the structure of text, the meaning of words and not additional ideas to overlay, disguise, symbolize, or code the content. **Do you have a work motto?** The concept can be raw; the detail needs to be perfect. **What aggravates you?** Stupidity. I can get very upset about snappy arguments or shortsighted views.
What is your worst nightmare? Not the worst, but the most often reoccurring is having to do my A-levels again. Funny, isn't it?

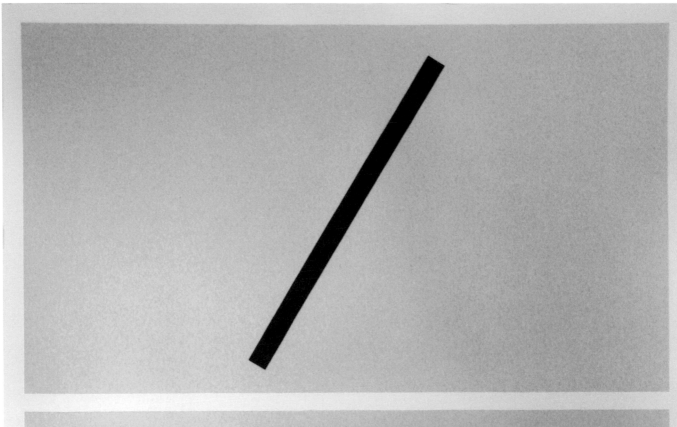

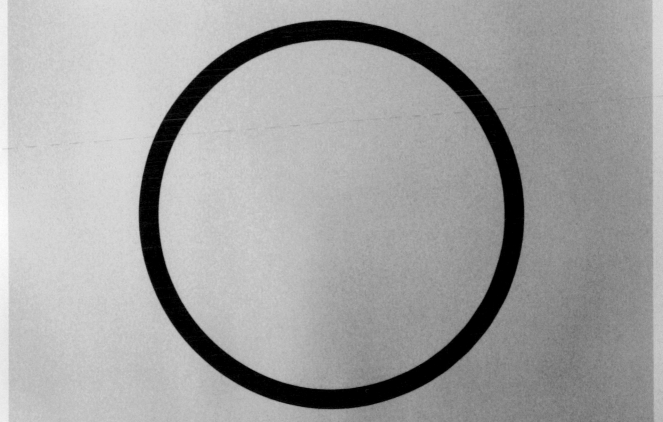

ARCHITECTURE LIVE 6 'ALUMNI'

ALUMNI - NETWORKS REVISITED, 14/15 MAY 2009, AT THE UNIVERSITY OF APPLIED ARTS VIENNA, INSTITUTE OF ARCHITECTURE
HITOSHI ABE, CECIL BALMOND, HERWIG BAUMGARTNER, ERIK BERNHARD, ALFREDO BRILLEMBOURG, IRMGARD FRANK, MARIE THERESE HARNONCOURT, HUBERT HERMANN, BARBARA IMHOF, JEFFREY KIPNIS, HUBERT KLUMPNER, SYLVIA LAVIN, BART LOOTSMA, CAREN ORHALING, MAX RIEDER, WOLFGANG TSCHAPELLER, THOMAS VIZKE, MICHAEL WALRAFF, CARMEN WIEDERIN, SUSANNE ZOTTL

What was your inspiration? We just wanted to use the old letterpress standing in the garage of our printers!

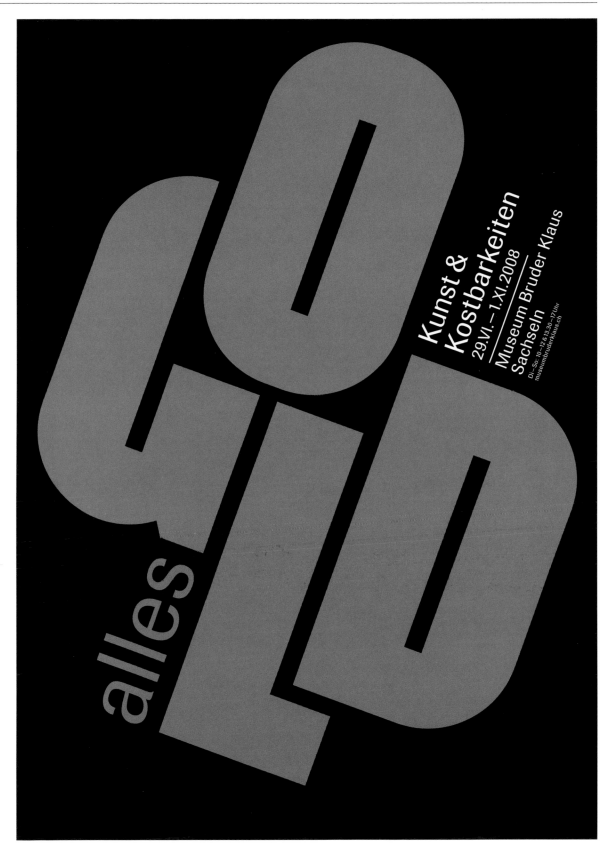

alles Gold

The museum announces its exhibitions on A3-posters only. We wanted to have the biggest impact on the "advertising column" as possible on this format.
Did you run into any specific problems or challenges while creating this work? The poster is printed gold and green on a coated paper, which makes it really delicate to handle. Your fingerprints are everywhere.

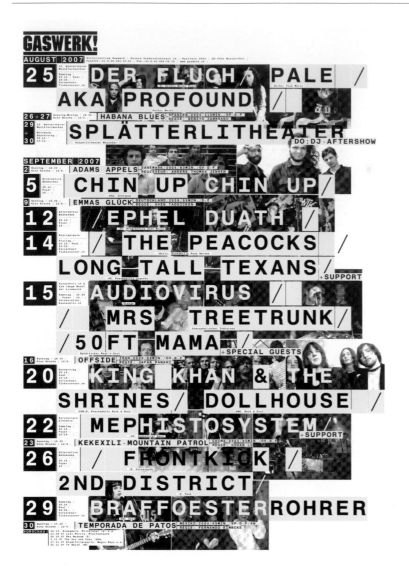

Gaswerk

We were looking for a grid system that allowed us to use different type, pictures, colors or graphics for monthly posters for Kulturzentrum Gaswerk, which created an image with big type instead of having a huge picture for each month in the background.

The grid system is very widely and differently *bespielbar/nutzbar*. That allows us to make very different posters, but ones that are always recognizably linked as a series.

Hi // Megi Zumstein, Claudio Barandun // Luzern, Switzerland // www.hi-web.ch

Megi Zumstein and Claudio Barandun met at the Lucerne School of Art and Design. In 2007, they founded Hi as a design studio specialized in print design with a focus on cultural projects.
What do you consider quality in graphic design? We like designs that touch us—when we see the love that is put in the design, or when designs are made with a humorous spirit. Good composition and love for details attract us.
Do you have a work motto? The bigger the type, the better the poster.
What inspires you? Things laying around you that are supposed to be something else.

Tell us the story of the name of your studio. When we were looking for a name for our studio, we found most of the names boring, unhappy, too serious, too long, too complicated. So we came up with the shortest name we could think of, which was friendly but not too opportunistic, which was a bit humorous but at the same time serious. The only problem we have in Switzerland is that people don't think of "hello," but think it is an abbreviation of something.
If you were not a graphic designer, what would you be? A hairdresser, maybe?

GASWERK!

Februar 2008

6 Rock'n'Roll Soldiers
/ Lombego Surfers /
9 Pornorama /
10 Euphoria
13 Des Ark /
15 Saalschutz /
DJs Wicked Wilma /
Cash-P / Rocko Pop /
17
18 Akiakane /
22 Cowboys from Hell /
5 Pound Pocket
Universe /
Kettenfett /
23 El Thule /
Phased /
Despu Palliton /
24
Absynthe Minded /
28.2. 12.Lichtspieltage
-2.3. Winterthur /

Vorschau:

GASWERK!

MÄRZ 2008

28.2. 12.
-9.3. LICHTSPIELTAGE
WINTERTHUR
GAUMENSICHT
14 G-PLUS
16
19 ZAMARRO /
MOTHER SUPERIOR
20 SPECK
/ FIREBREATHER
22 SURROUNDED /
ASLEEP /
ACAPULCO
STAGE DIVERS
28 RAY DAYTONA &
GOOGOOBOMBOS /
STAGGERS / MONSTERS
/ MARK & SPIES

WHERE THE TRUTH LIES
VORSCHAU:

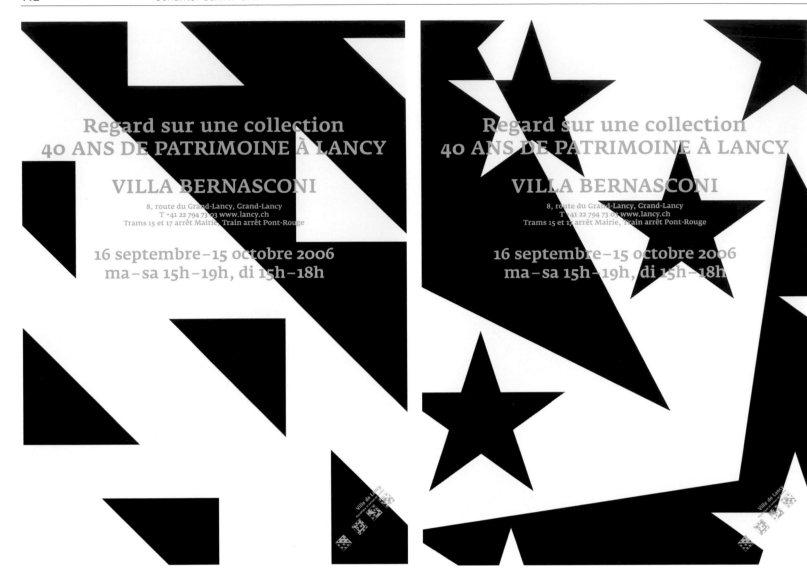

Mai au Parc

Situated in the heart of a beautiful park near Geneva, Switzerland, the Villa Bernasconi, a neoclassical building from 1826, provides the framework for a festival of contemporary art, including stage plays as well as sculpture. Since 1997, the Mai au Parc Festival is held annually and plays an important role in the local art scene.

Schaffter Sahli // Joanna Schaffter, Vincent Sahli // Geneva, Switzerland // www.schaftersahli.com

Schaffter Sahli, a Geneva-based design duo, founded by Joanna Schaffter and Vincent Sahli create identity systems and design strategies for clients from cultural to commercial sectors. Sharing their ambitions with clients and associates, they accomplish a work that is thoughtful, inventive, and distinctive.

Villa Bernasconi

Line [cross the]

Manon Bellet
Rudy Decelière
Anna-Kavata Mbiti
Beat Lippert
Thomas Maisonnasse
Elodie Pong
Ana Strika

Exposition d'art
contemporain
Villa Bernasconi
24.5–6.7.2008

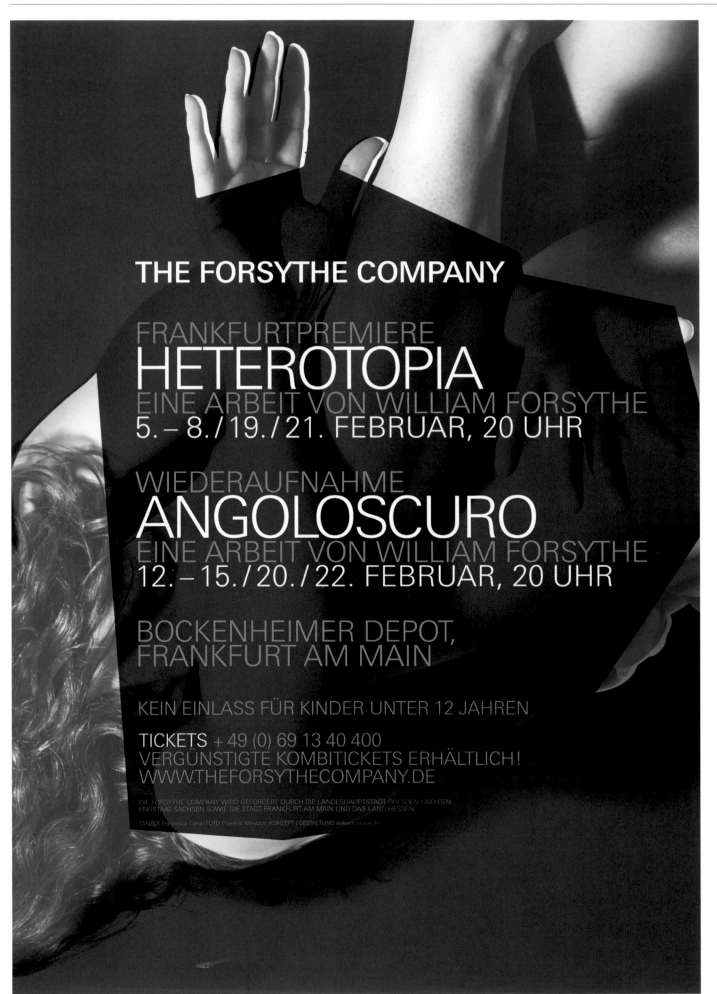

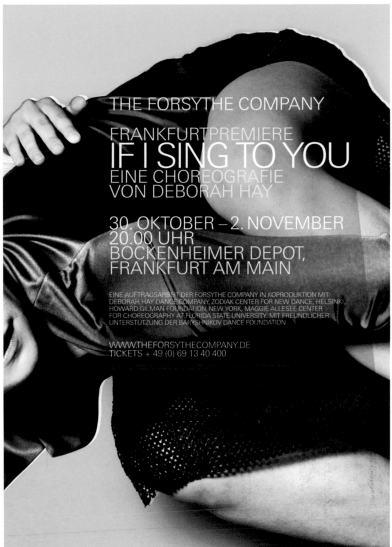

The Forsythe Company

The 2008/2009 campaign for the Forsythe Company displays black-and-white photography with abstract spaces that, due to their transference, emphasize the dynamics of the figure. The graphic composition integrates the typography in the areas with color and photography.

Surface // Markus Weisbeck // Berlin, Frankfurt, Germany // www.surface.de

Surface is a studio for corporate culture design. For more than ten years, Surface has worked almost solely on themes of contemporary and performing arts, architecture, music as well as exhibition contexts. The conceptual design approach is, without exception, dependent on the content of the inquiries, and subjects are developed accordingly, in order to avoid style arbitrariness.

la Biennale di Venezia

52. Esposizione
Internazionale
d'Arte

Partecipazioni nazionali

Isa Genzken
Oil
German Pavilion
Venice Biennale 2007

ifa DW-TV DUMONT Deutsche Bank
 DEUTSCHE WELLE

Isa Genzken – Oil

The campaign for the German pavilion of the fifty-second Venice Biennale illustrates specific excerpts of Venice, similar to Isa Genzken's artistic style in her installation *Oil*. Like the artistic contribution in the pavilion, the image of the campaign is a reference to the cliché of the lagoon city and it quotes that part of the work that uses similar reflections.

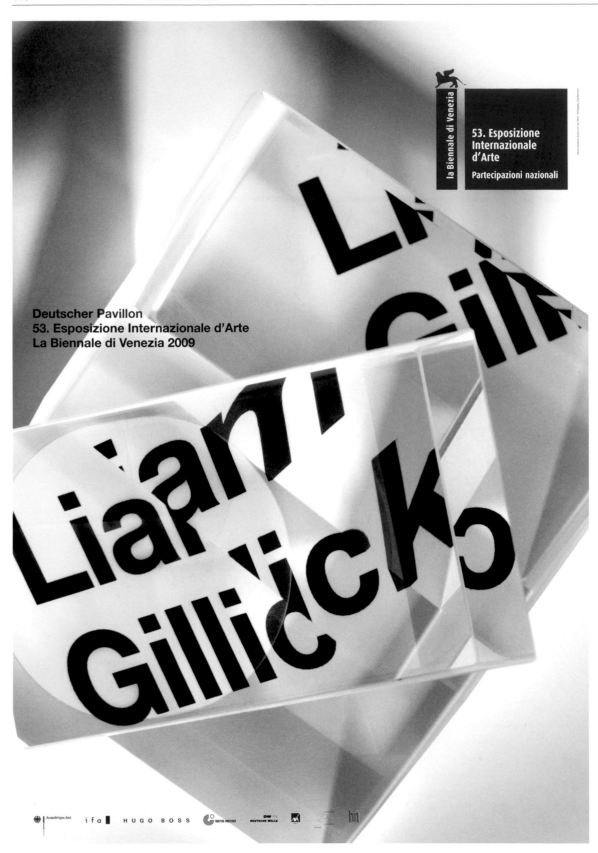

Liam Gillick

The campaign for the German pavilion at the fifty-third Venice Biennale is based on the idea of displaying the artist's name in several orthographical variations. Different refractions through a prism create the key visuals for the poster, invitations, and Web sites.

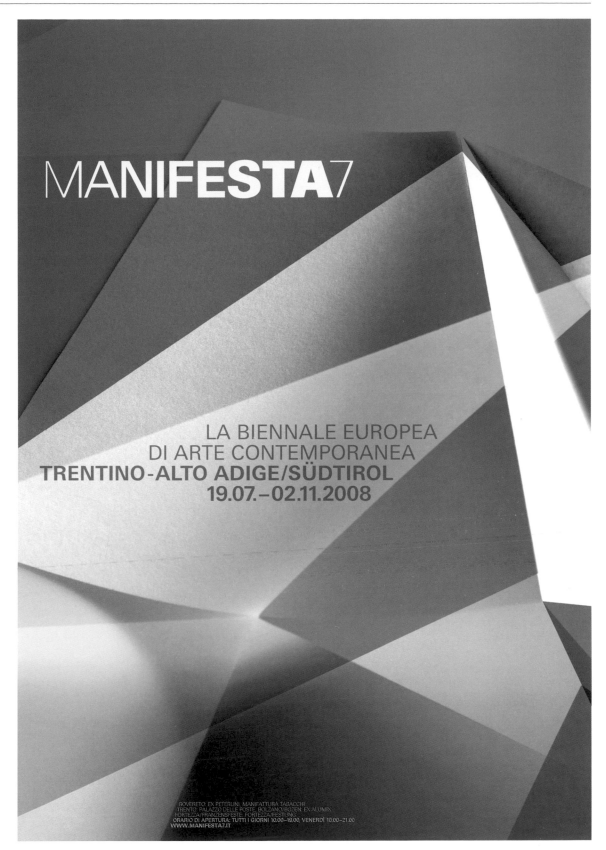

Manifesta7 Biennale

The idea for the key visuals of Manifesta7 changes abstractly between a bricolage and a tourist alpine picture that is further underlined by color selection. The artwork thematically illustrates the movement of the connecting waters between the Italian towns, Franzensfeste and Rovereto.

BOOKS

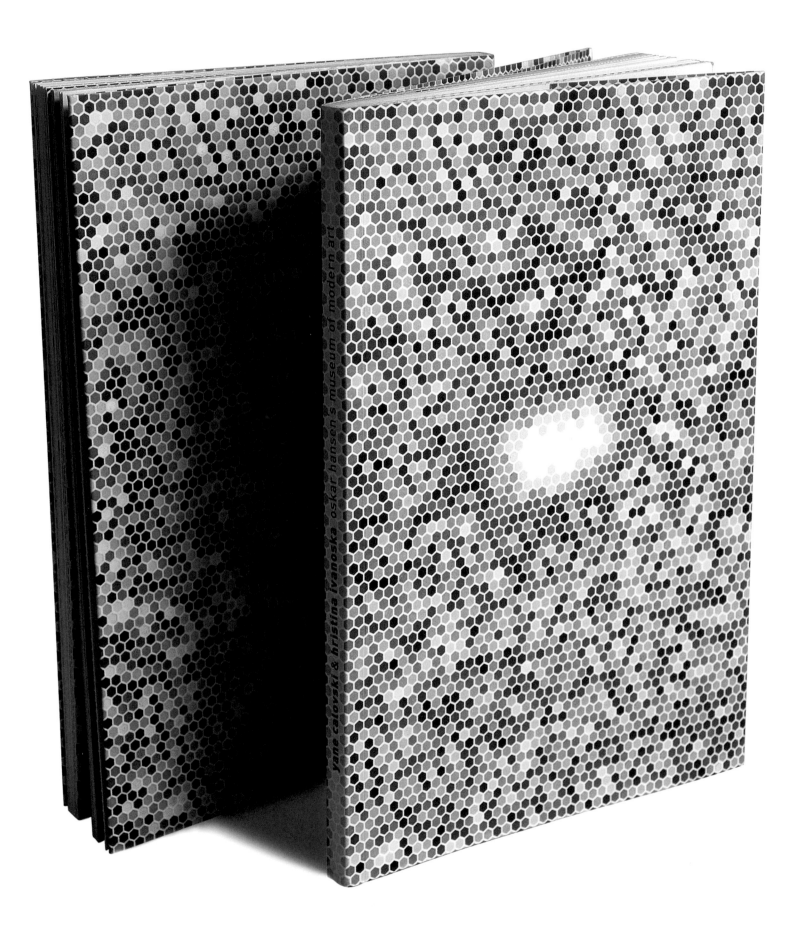

yane calovski & hristina ivanoska oskar hansen's museum of modern art

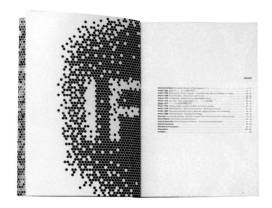

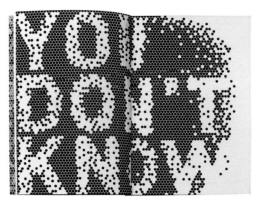

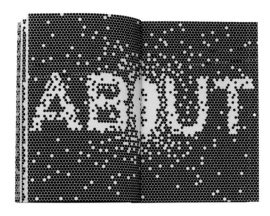

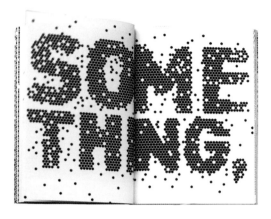

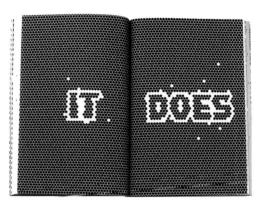

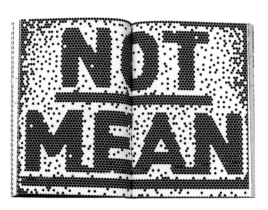

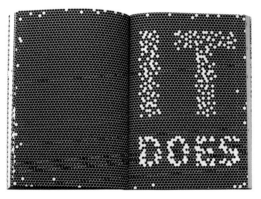

Oskar Hansen's MOMA Catalog

Catalog/book design for Yane Calovski and Hristina Ivanoska's work on the architect Oskar Hansen. The hexagon shape was part of a module-like suggestion for the building of the museum of contemporary art in Skopje, Macedonia in the 1960s.
What is special, unusual or unique about this project? A cover without text, an interview quote that is spread out through the whole book.
Did you run into any specific challenges while creating this work? Sometimes my eyesight started flickering because of the graphic black-and-white pattern.

Ariane Spanier // Berlin, Germany // www.arianespanier.com

Ariane Spanier studied visual communication at Berlin Weissensee School of Art. After working in Stefan Sagmeister's New York office from 2004 to 2005, she began her freelance career on her return to Berlin. Spanier works largely for clients in the fields of culture, galleries, artists, publishers, and architects.
Which work of yours are you especially happy with? The one shown here, Oskar Hansen's MOMA catalog, because it was a nice collaboration with the artists Yane Calovski and Hristina Ivanoska and curator Sebastian Cichocki. We all were happy with the result, it came together very well and was a nice process. The *Fukt* magazine cover, because it's a personal project and there is a lot of freedom for me designing it, so it is usually fun doing it. I am quite happy with the things I do.
Do you have a work motto? To contribute something to our visual environment and to strive to improve it for a moment.
How do you get new ideas when you are stuck? I lay down and pretend to fall asleep, but I don't, and then my head works on its own. It often helps.
What is your dream of happiness? To be able to do what I want to do. A productive life, love… and nice weather.

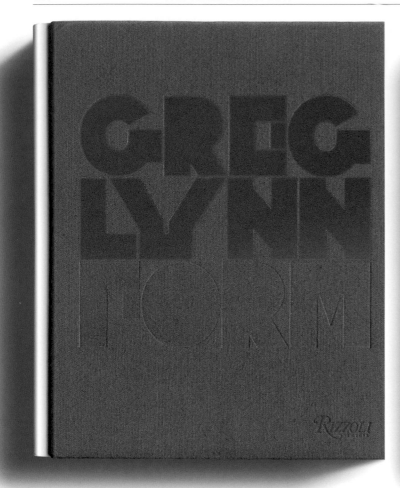

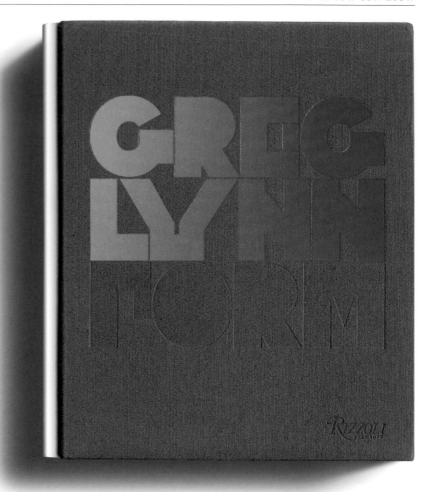

Greg Lynn Form

Rather than a simple retrospective of Greg Lynn Form's work compiled in chronological order, this book contained visual and written essays from writers, architects, photographers, and other commentators, with individual projects cropping up throughout the book. The challenge was to create a visual framework for this disparate collection of work that would tie it all together coherently. We were, therefore, directly inspired by the constraints on the material itself.

It's unusual and special for us because this is one of only a very small number of complete books that we've designed. Although the production budget didn't quite stretch to include all of the specifications we would have liked, we're very happy with the mixture of materials, from the uncoated and glossy papers, to the foil stamped cloth used on the book cover itself.

5900 Wilshire Boulevard
Restaurant and Trellis
Pavilion
-
June 2006—present
-
Model of building exterior
from above without the trellis
shade structure

038
-
Massing
-
039

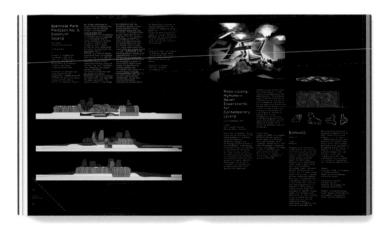

Non-Format // Kjell Ekhorn, Jon Forss // Oslo, Norway // Minneapolis, USA // www.non-format.com

Founded in 2000, Kjell Ekhorn and Jon Forss work under the name of Non-Format on a range of projects including art direction, design, illustration, and custom typography for the arts, culture, and music industries as well as fashion and advertising clients. **Describe your early influences.** Jon: I'm pretty sure my father is my earliest influence. He's a furniture designer and was trained as a sculptor. He certainly nurtured any creative ability and introduced me to the glory of the Letraset catalog. Kjell: David Bowie's *Low* and *Heroes* album covers, Andy Warhol's portraits, and copies of Italian *Vogue* made me dream of a career in the visual arts long before I knew what it meant to be a graphic designer. My first proper graphic design hero was Makoto Saito. **What guidelines and advice would you give students of graphic design?**
1. Don't be afraid to make mistakes.

2. Don't look too closely at other people's work.
3. Avoid the lure of Photoshop filters.
4. Make your PDF portfolios landscape rather than portrait. Computer monitors are landscape.
5. Embrace restrictions.
6. Hierarchy is king.
7. If you're not sure a design is working, look at it in the mirror.
8. Opposites attract.
9. Creating your own type can be easier than working with someone else's.
10. Make your own rules. Then break them.

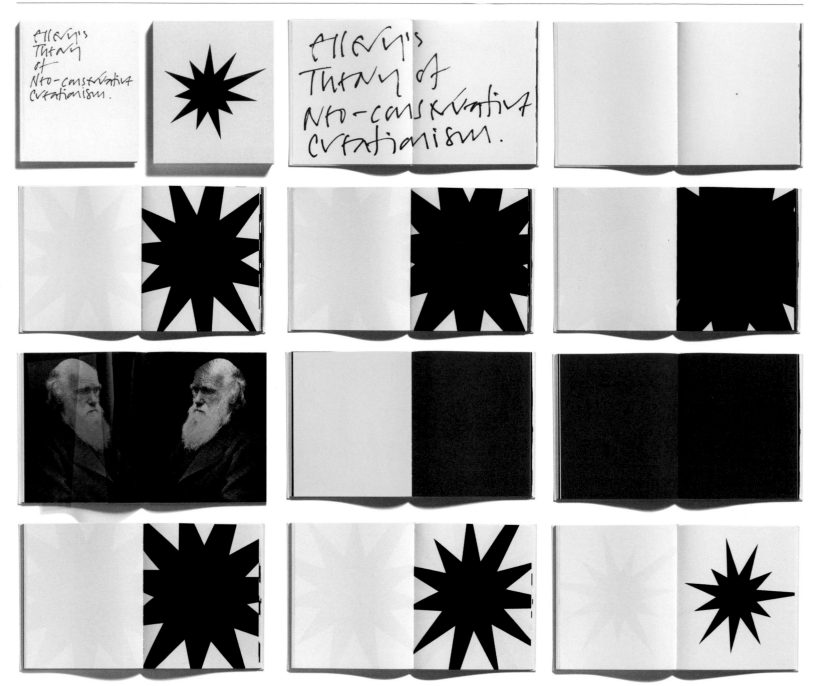

Ellery's Theory of Neo-conservative Creationism

The neo-conservatives aren't very keen on the Big Bang scientists; the Big Bang scientists aren't very keen on the Creationists; the Creationists aren't very keen on Darwin; Darwin's not too happy with the Catholics; and the Catholics don't seem to be too happy with anyone. With this conceptual book, Jonathan Ellery is drawn to this battleground, mischievously sticking his oar in and adding to the friction, offering up if anything more questions.

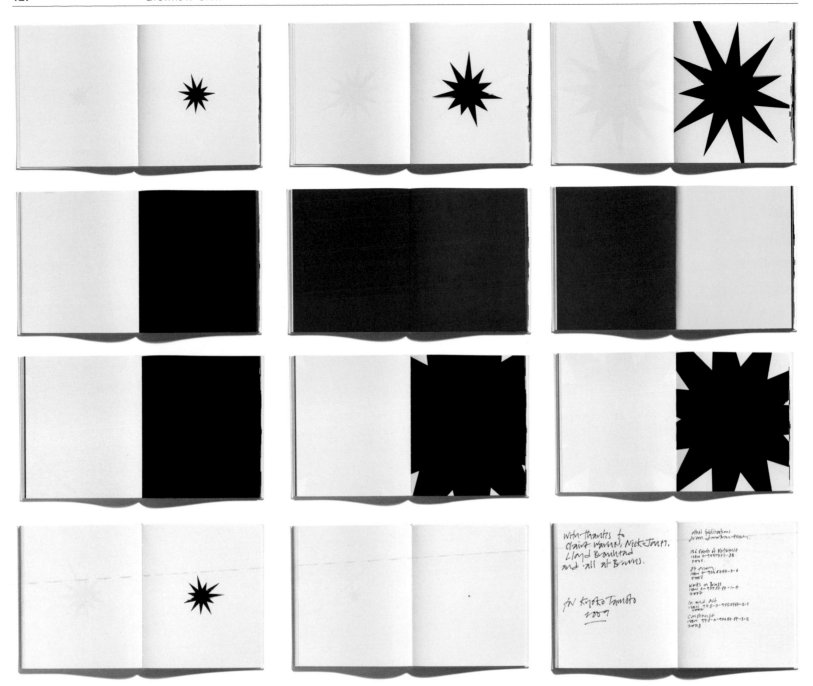

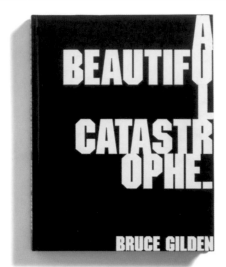

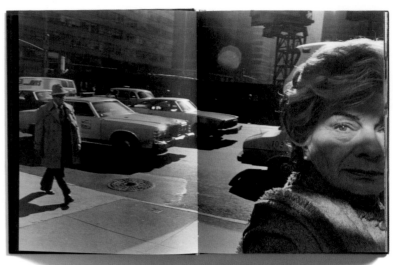

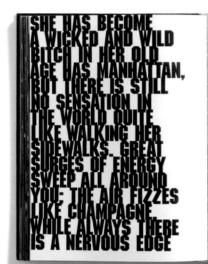

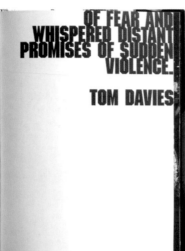

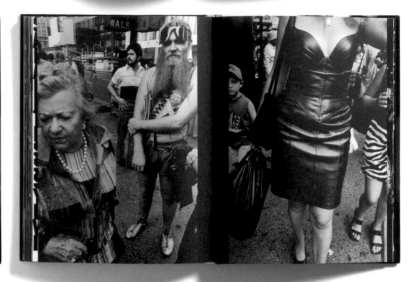

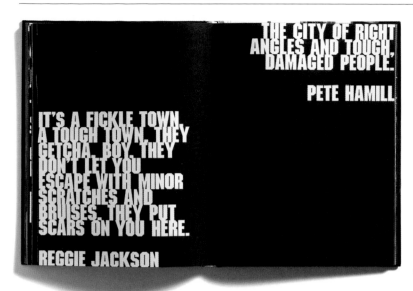

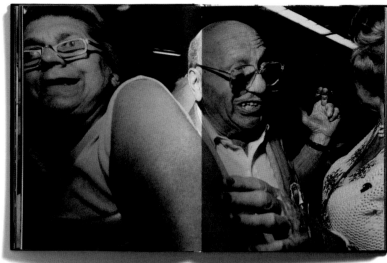

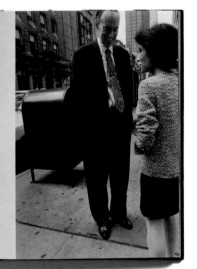

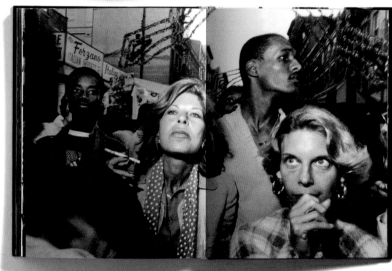

A Beautiful Catastrophe

Inspired by the photography of Bruce Gilden and the claustrophobic aggression of NYC, this poster series was invented to promote the launch of the book *A Beautiful Catastrophe* for Bruce Gilden/Magnum.

Browns // Jonathan Ellery // London, United Kingdom // www.brownsdesign.com

Set up in 1998 by graphic designer and artist Jonathan Ellery, Browns is a London-based, creative consultancy with an international reputation for elegant, powerful, and distinctive communications. Jonathan Ellery playfully works across a wide range of media, from sculpture to performance, film to photography. The medium of book art is also central to his work, molding paper, fonts, and images as he would any other medium, to create tactile, hand-numbered objects of art.
Describe your early influences. Five years ago I produced a book entitled *136 Points*

of Reference, which was an insight into mine and the studio's influences.
What can be found on your desktop? A photograph I took showing the visual complexities of a supermarket in Tokyo.
What does your working environment look like? The studio is a converted industrial tin can factory where jellied eels were canned. Built in 1886.
If you could live in another place for one year, where would that be? Paris.
Do you have a work motto? "Bagsy not make the tea!"

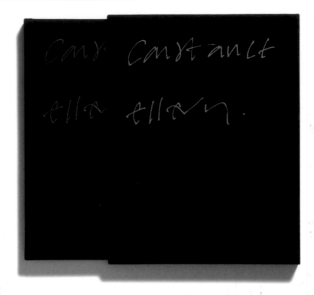 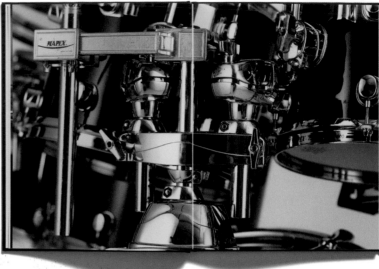

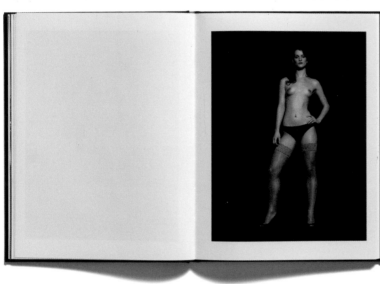 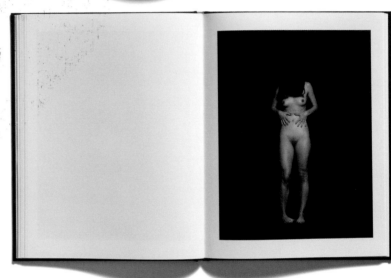

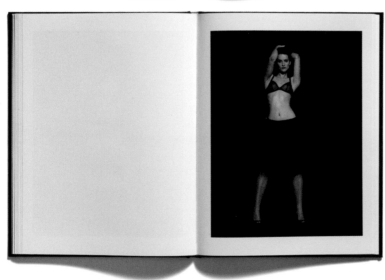 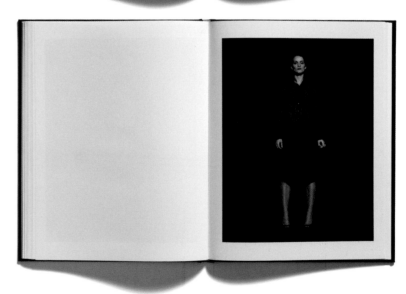

Constance

Constance marries Ellery's art, his relationship with women, and his love affair with drums into a psychological study of social discomfort, power, frailty, and sexuality.

The book was produced to accompany a live performance piece first exhibited at the Wapping Project/London in May of 2008.

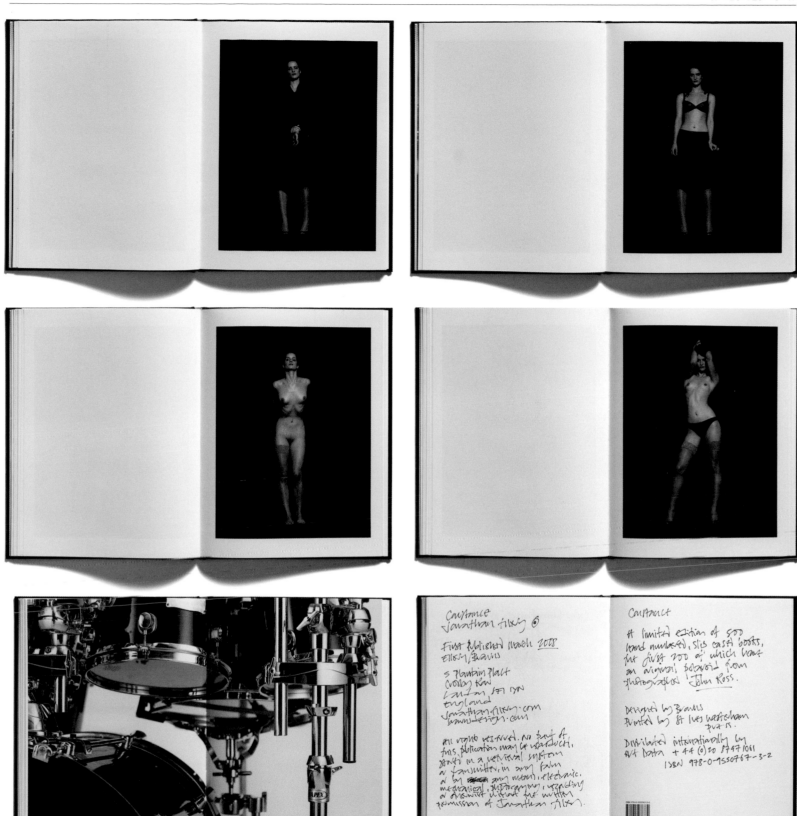

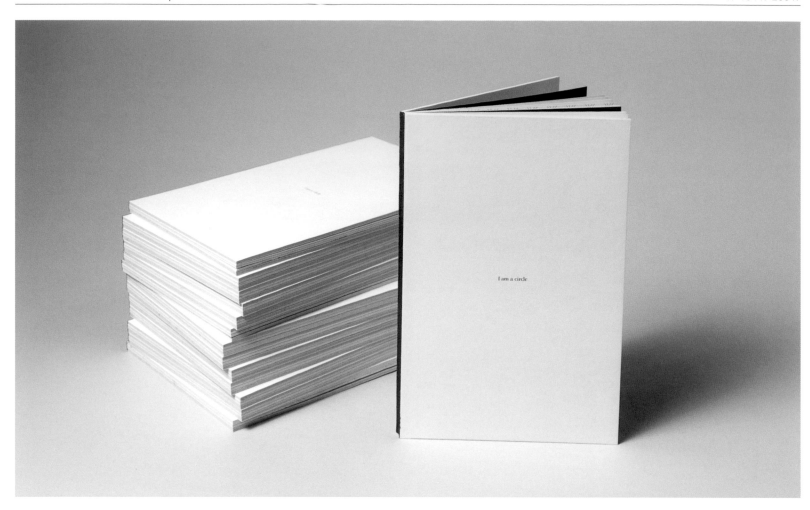

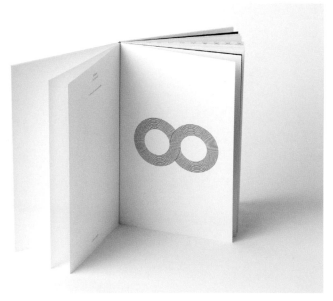

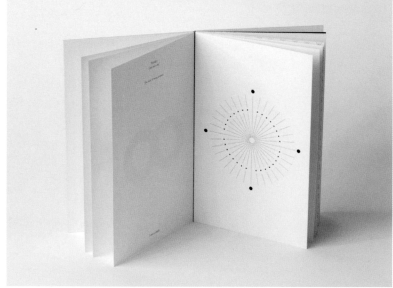

I Am a Circle

I Am a Circle is the first in a self-initiated series of three small books that explore the versatility of basic shapes—circle, square, and triangle.

For the past few years I have been interested in the power of the basic geometric shape both in terms of its visual impact and its ability to communicate. The book presents thirteen distinct characteristics of the circle: simple, infinite, totality, space, precise, united, harmonious, community, pure, eternal, inclusive, continuous, and centered. Each characteristic is supported with a visual representation. The book is padded so that individual pages can be torn out as stand-alone pieces.

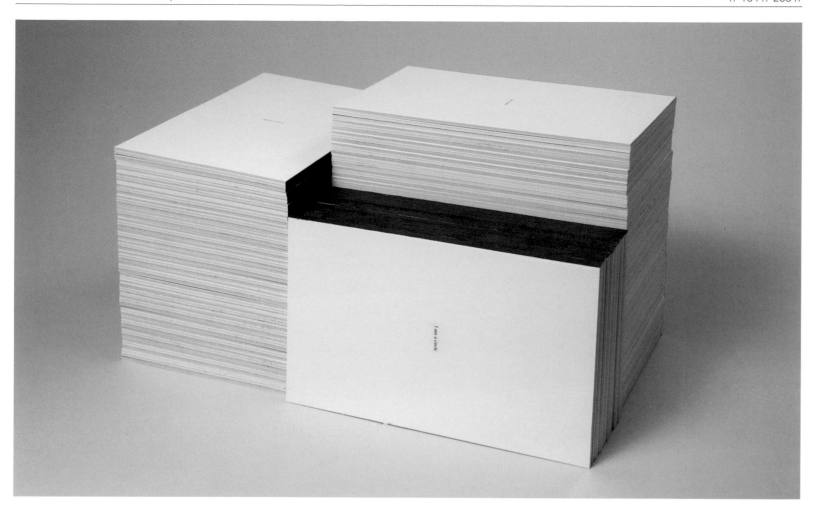

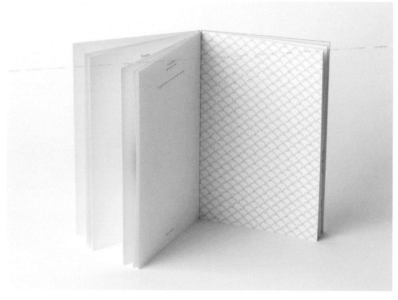

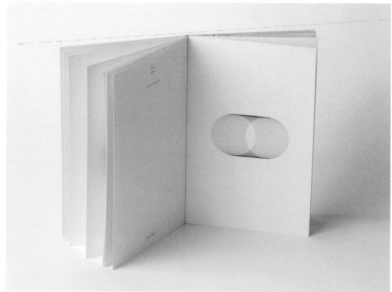

Coöp // Paul Fuog, Dan Honey // Melbourne, Australia // www.co-oponline.net.au

Coöp was established in 2004 by Paul Fuog and Dan Honey with a shared vision of creating a space where creatives could fluidly and dynamically work together. The result is a communal and energetic studio environment where order and disorder converge as ideas are explored with freedom.

What do you consider quality in graphic design? Interesting, thought-provoking, and inspiring work that looks good. Also, work that generates an emotional reaction—preferably a laugh.

What does your working environment look like? We are on the fifth floor of an old building in Melbourne CBD. The building is called Curtin House and it is described as a vertical laneway. It has Cookie, one of Melbourne's best bars on the first floor;

Toff in Town, just voted Melbourne's best bar on the second floor, and Rooftop, every Melburnians favorite bar, on the top floor. As a result, our working environment often looks a little fuzzy.

Do you have a work motto? Stay positive!

What inspires you? Positivity and open-mindedness.

What aggravates you? Negativity and close mindedness.

What is your workout for creativity? Keeping a sketchpad of personal ideas and personal experiments.

What is your dream of happiness? A life full of excitement, love, wonder, joy, and exploration.

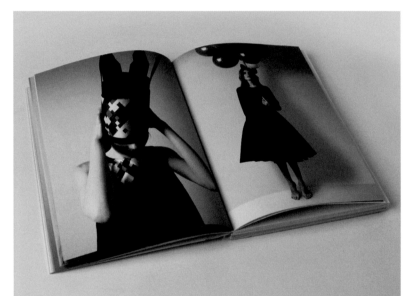

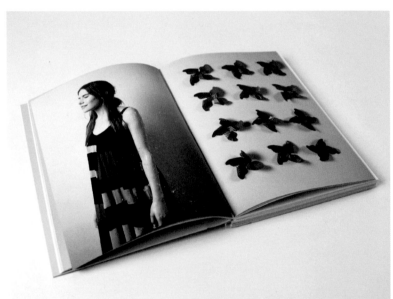

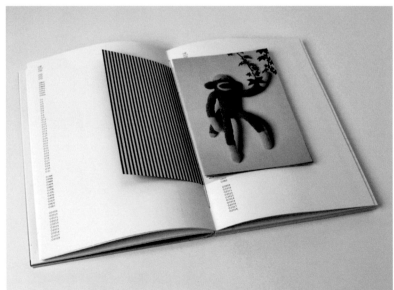

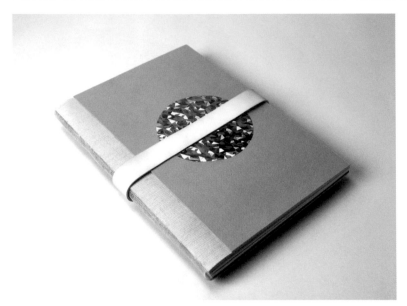

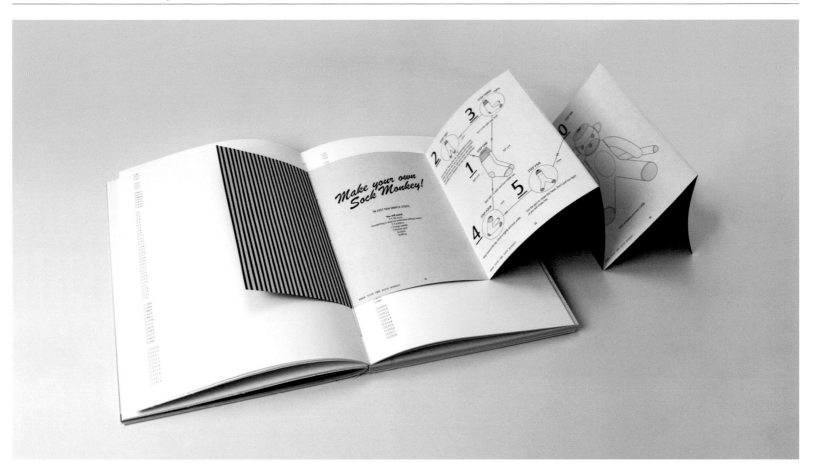

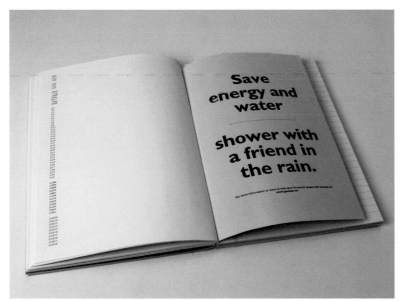

Gorman – 10 Year Diary

In Australia, Gorman is held in high esteem and is seen as a local pioneer of sustainable fashion through its commitment to timeless design, high-quality finishes, carbon-reducing process, and organic production. We conceived and created a comprehensive book designed to educate customers on the merits of "slow fashion" versus "disposable pop fashion" and to make a clear statement that Gorman fashion is enduring. In a reaction against throw-away design, the book was created to become more valuable over time and extends a lifespan of twenty years, reflecting in a photographic series ten years to the past and projecting ten years to the future.

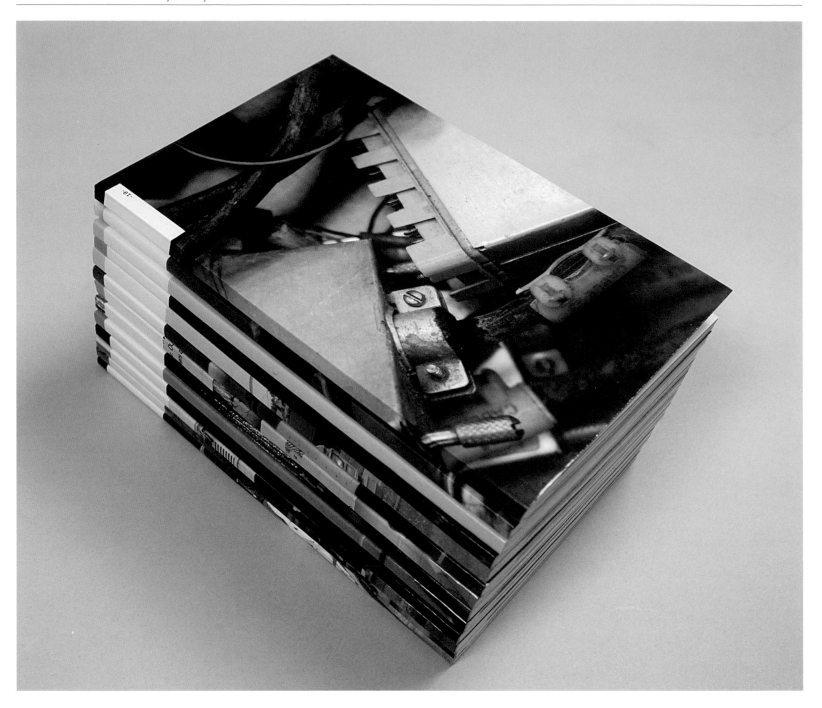

Art in General Book Series

Art in General, a long-running alternative space in New York, commissioned Project Projects to develop a print-on-demand book series to document the artists' projects produced in its New Commissions Program. While the books share a standard format, partially based upon parameters required by the print-on-demand vendor, the design of every volume varies to address substantial differences in each project's content, complexity, scale, and media.

What is special, unusual or unique about this project? The means of production (print-on-demand) requires the careful testing of constraints and possibilities.

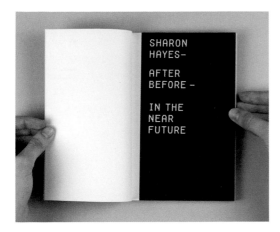
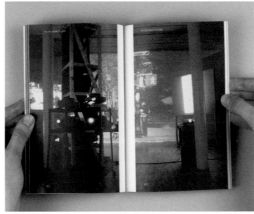
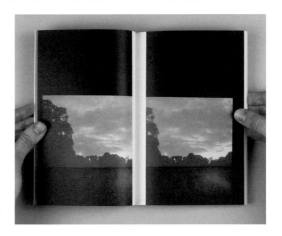

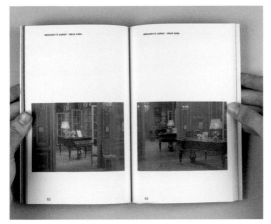
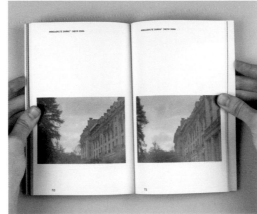
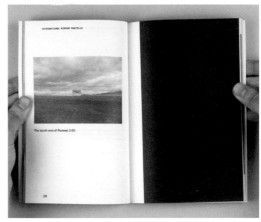

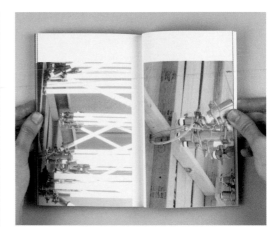

Project Projects // Prem Krishnamurthy, Adam Michaels // New York, USA // www.projectprojects.com

Founded in 2004, Project Projects is a design studio focusing on print, exhibition, and interactive work with clients in the worlds of art and architecture. In addition to client-based work, the studio initiates and produces independent curatorial and publishing projects.

Describe your early influences. Punk rock, role-playing games, Max Bill, Jan Tschichold, Knut Hamsun.

Which works of yours are you especially happy with and why? Projects that involve a strong degree of complexity, conceptual thinking, and involvement in the content.

What do you consider quality in graphic design? Context-specificity, ethical value, and fine craft.

What does your working environment look like? An open-studio with eight desks, overloaded bookshelves, and music.

Do you have a work motto? Don't do it twice when you can do it thrice.

What inspires you? Literature, movies, music, and politics.

What aggravates you? People who don't listen.

What guidelines and advice would you give students of graphic design? Figure out what you want to make, and then pursue it with focus.

How do you get new ideas when you are stuck? Coffee, late nights, then a break, and a new start.

If you were not a graphic designer, what would you be? Furniture maker, musician, curator, writer, bar owner.

Tell us five things you are crazy about. Nachos, Paper Monument, Montreal, X, Kevin Wade Shaw.

TOP
OF
CENTRAL
SWITZERLAND

**KUNSTMUSEUM
LUZERN**

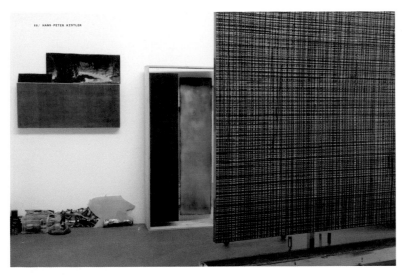

Top of Central Switzerland

The slogan of the Jungfrau Railways is "Top of Europe," which describes the Matterhorn, located in southwest Switzerland. The name of the exhibition plays with this concept. We wanted to reference the mountain of all mountains, which is not in Central Switzerland at all, but the slogan was too nice to refuse. This catalog is made of two separate books. The smaller textbook is glued on top of the bigger image part, and only together they form the whole image. The binding was not easy at all.

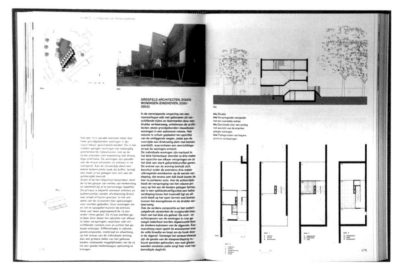

Het ontwerpen van woningen

This book uses lots of examples to introduce a theory about the design of dwellings. It was my intention to clearly distinguish the theory from the examples using a color code system. All general theory texts and diagrams are printed in coppery orange metallic color whereas all the examples are printed in black. The combination of a metallic ink on smooth, uncoated paper stock creates a coppery kind of effect.

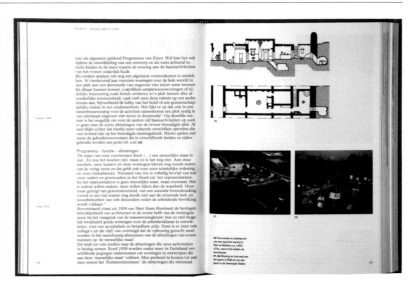

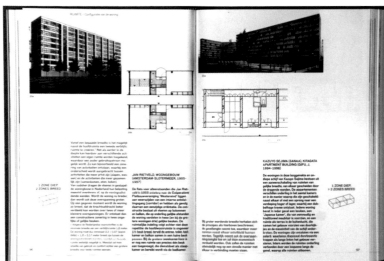

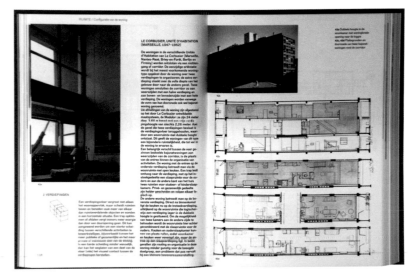

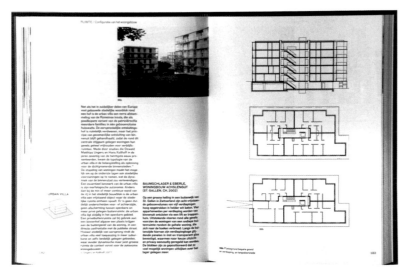

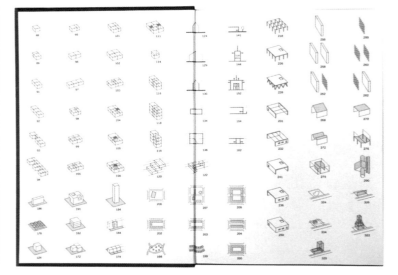

142 Joost Grootens // NL // // 140 //

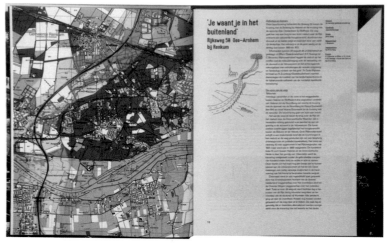

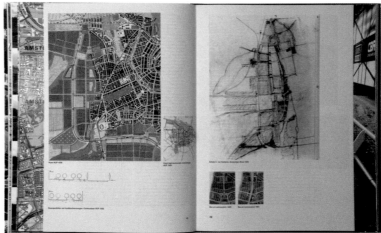

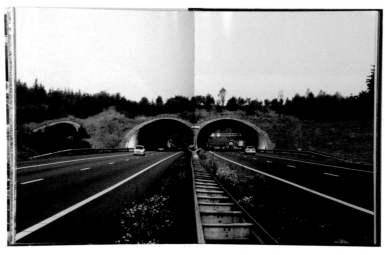

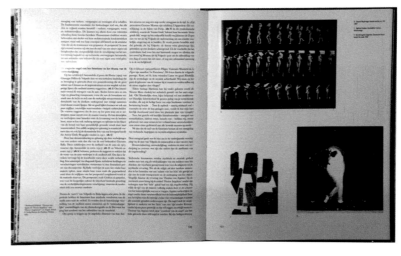

De diabolische snelweg

I wanted two types of books to meet: a more technical engineering kind of book (A4, uncoated, black and white) and photography book (240 x 297 mmm, gloss, color). II always thought this was the best way to show the two sides the authors look at the subject (the design of highways): precise engineering next to visual fascinations, and I was convinced that it would make the book stronger to separate these stories.

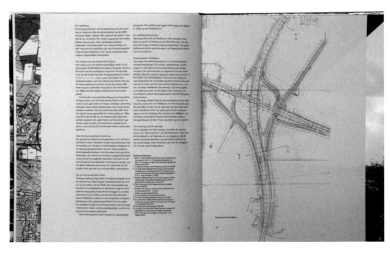
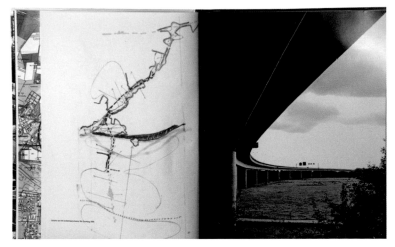
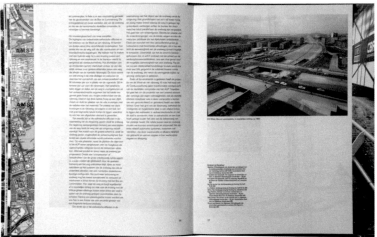
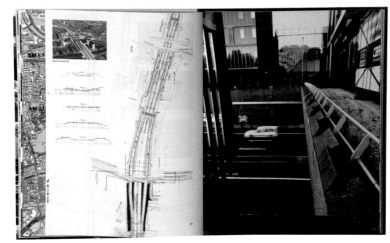

Joost Grootens // Amsterdam, The Netherlands // www.grootens.nl

The Amsterdam-based studio was founded in 1995. Since 2000, Joost Grootens has almost exclusively designed books specializing in the fields of architecture, urban space, and art. In recent years, he has worked on atlas projects, designing both the maps and the books themselves. Grootens has won numerous prizes for his designs. He is a lecturer of the master's program at the Design Academy Eindhoven. He has also lectured at various schools in The Netherlands, such as the Berlage Institute Rotterdam. Additionally, he has conducted workshops at institutions in England, Japan, China, and Taiwan.
Quality in graphic design? I don't want to be too present in my designs. I am a strong believer in the power of absence.

What aggravates me? Designers who are trying to outsmart the author or the reader.
What guidelines and advice do I give students of graphic design? First try becoming a reader and only then start becoming an author.
My workout for creativity? I don't believe in creativity as waiting for inspiration. Creativity is a craft. It is working, reworking, processing ideas.
My worst nightmare? Not having any work.
My dream of happiness? Not having to rush, no deadlines.

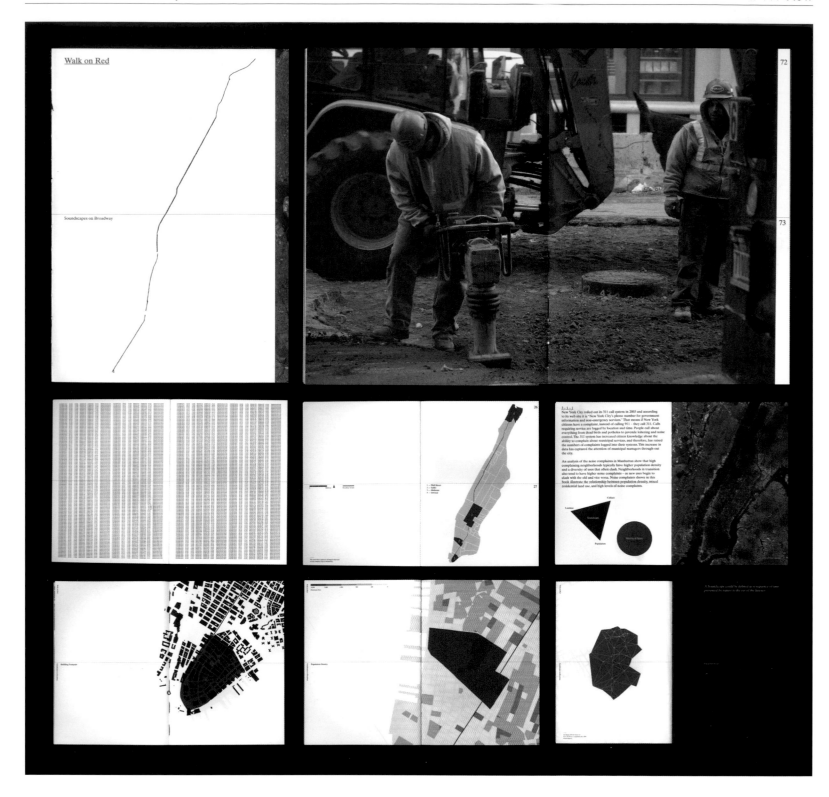

Walk on Red

Walk on Red is a unique portrait of New York City. The graphic artist develops maps of the neighborhoods of SoHo, Wall Street, Midtown, and Inwood, whose varying frequency of noise complaints reflect their different population densities and mixed residential land usages.

As almost all visual identities of areas and regions around the world are too vague,

subjective, or similar having common themes like being green, fresh, or interactive. Using mathematical data for areas is a new equitable manner in building identities. Striking graphic imagery is accompanied by photographs, satellite images, and documentary data.

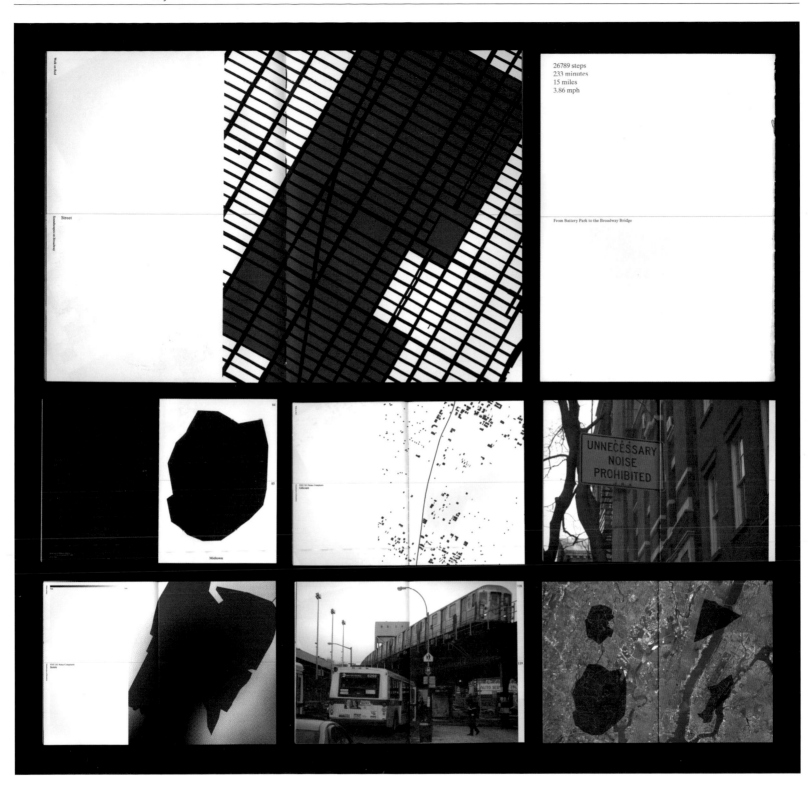

Visible Noise/Invisible Lights

Visible Noise/Invisible Lights is a study of the white noise produced by lights. Hoon Kim, the graphic artist explored relationships between twenty-five kinds of lights at the studio using a Spirograph, which produces mathematical curves known as hypotrochoids and epitrochoids. He listened to all of the lights for several days to verify how much noise they emitted, photographed all of the lights, and recorded their sound while they were turned off and on. The artist then analyzed differences, such as repetition pattern, volume, and frequency between waves of the lights' sounds. Spirographs have many wheels and plates, each making different patterns. He matched the density and edge quality of these Spirograph patterns to qualities of sound—like volume and pitch—to make correspondences. He explains his discoveries, saying, "This book contains both the process and outcomes of the project. From research levels and considerations on various methods to figure out, readers can involve, face, and solve problems together."

The Paper Speaks

One day, I saw various papers in the "used paper" box in my studio. This suddenly made me think about what paper sounds like. Crumbling papers cause two reactions: noise and patterns/traces on the paper. The noise happens when the paper cracks, and the trace becomes the form of a sum of crack spots. All the spots are connected through the folding lines, so the combination of spots and lines creates a classification of numerous triangles. The shape reflects the quality of paper: thickness, weights, firmness, and types. In other words, a pattern on a paper is an abstract identity of the paper.

In *Book One*, each page is real paper that's been perforated, inviting the reader to create his or her own sound experiences from his visual recordings. *Book Two* illustrates, in thirty-six images, the results of my experiences crumbling, folding, and handling paper.

Why Not Smile // Hoon Kim // New York, USA // www.whynotsmile.com

Why Not Smile was founded by Hoon Kim as an independent graphic design work-shop based in New York City. Why Not Smile focuses on design for art, architecture, and cultural clients across various media: printed matter, branding, exhibition de-sign, motion graphics, and Web sites. Participating in diverse exhibitions dealing with space and sound in New York, London, Lausanne, and Seoul, their current research attempts to visualize soundscapes in the public sphere to the printed space, in order to bridge the gap between the personal space and the public space.

Do you have a work motto? Keep calm and carry on. It is a famous British poster from World War II. When I first saw this poster, I strongly felt this should be my life slogan as a graphic designer. To find the intersection and balance between the time of finishing a project and the quality of the design, I just need to "keep calm and carry on."
What is your workout for creativity? Taking photographs of everyday life keeps me creative. The important thing, however, is not the quality of the images, but what I am focusing on and how I crop, as well as capture the subject matter.

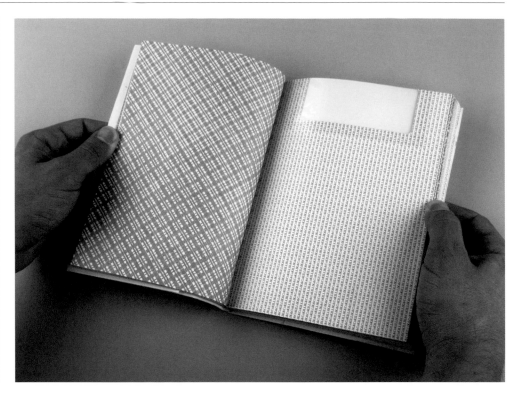

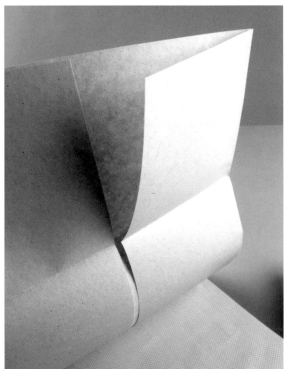

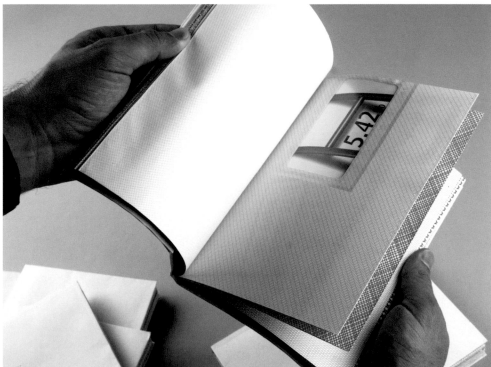

Inside Out

Recycled from discarded bills, forgotten letters, and scraps of other people's lives, these limited-edition, hand-bound notebooks are made from inverted envelopes. The designer explains, "I was always fascinated with the variation of patterns inside the envelopes so I decided to start a typology project based on that. Each notebook is completely different and made out of envelopes from around the world. It started as a small, personal project, and in the end it was sold in different stores and museums around the world, which for me was an unexpected reaction to this work."

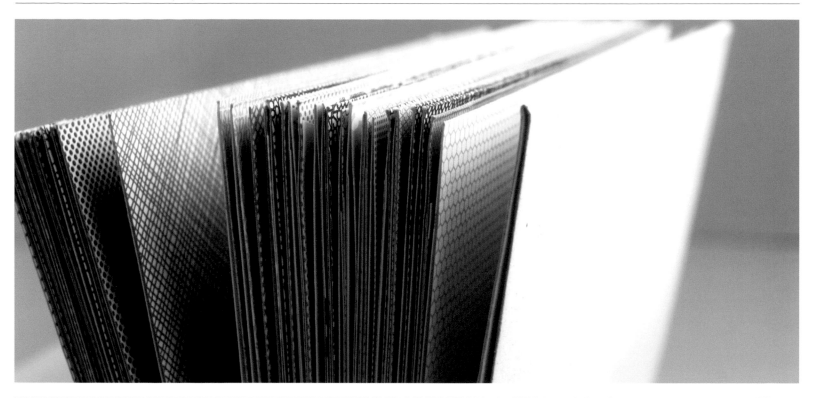

Foolproof Guide to Cooking a Steak

Mamiko Otsubo

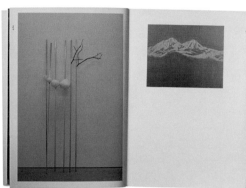

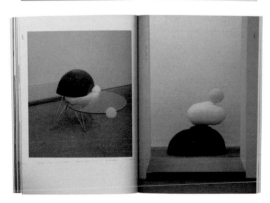
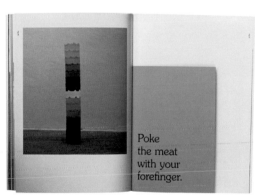
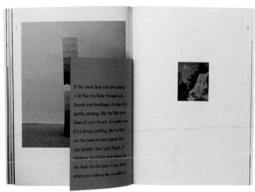

Mamiko Otsubo Catalog

The Mamiko Otsubo catalog represents two books mashed into each other.
What was your inspiration for this work? One trait of Mamiko's work that I'm drawn to is the friendly tension between familiar objects and an invader.
What is special and unusual about this project? Artist's statements are usually set in tiny type and in the front somewhere. Mamiko's artist statement is a major element in the book. Every sixteen pages, the catalog is interrupted with a line from the statement that frames the work—sort of… it's a recipe for how to cook a steak.

Office of Jeff // Jeffrey Lai // New York, USA // www.jeffreylai.info

Office of Jeff is a multidisciplinary design office based in New York City. The office is comprised of Jeffrey Lai and a network of talented writers, designers, artists, editors, photographers, and programmers who are frequent collaborators.
Describe your early influences. Engineering drawings for buildings, bridges, and submarines.
Which work of yours are you especially happy with? The USA invasion of Iraq was imminent. I was in school at the time. A teacher thought assigning another graphic design project seemed a bit pointless given the circumstances. Instead he told us to stop the war. We all made protest posters to use in a demonstration in New York. The poster didn't stop the war, but I learned there are different ways to measure success.
What do you consider quality in graphic design? A thoughtful meeting of content and presentation.
What inspires you? Boldness. Authenticity.
What aggravates you? Being too cool for school.
Are you a team worker or lone fighter? Somewhere in the middle.
Tell us the story of the name of your studio. My name is Jeff. I have an office.
What is your dream of happiness? Continually get better at my job but never believe I am done getting better. Raise a happy family.

Written All Over Us

Written All Over Us constitutes the first book of poems by art critic, artist, musician, and curator Dominic Eichler and features illustrations by Nairy Baghramian, Julian Göthe, Shahryar Nashat, Henrik Olesen, and Danh Vo.

The lap dog desire never shut up
even when the scraps fleeing
the smorgasbord were paltry
Rather than standing
around with imaginary paws
held to the chest
below a whining face
up you get, off to bed!

A voice called Gerry reminded me:
If it gets abject just take it home.

Julian Göthe
Why Does It Hurt When My Heart Misses A Beat, 2009

A Lap Dog Learns Discipline

Imagine the surprise
as you sat across my thighs
One night unexpected
if long hoped for

Then despite your
protestations that you
are a spanner not a nut
lowered yourself

The silver box chain
Around your neck
Swung with our heaving

Lost
You thought I pilfered
or swallowed it
when it was just lying
instead of me under covers

On a rerun
a stupid remark
About the lousiness
Of your commitment
To the position

I was just
Afraid of feeling
But not of being a smart arse

Surprise Position

Henrik Olesen

Shahryar Nashat
Pied de table, 2009

My bed is not broken
but it spoke when the wooden frame grated
as you bent dreaming
and as we swapped places like bookends for autobiographies
or when I selfishly hoped
you hadn't finished our sentence
then bitterly wept

The first time we veered in this bed
our heads were where feet are expected
Did I tell you it was because I recalled a monologue
in a novel mined by an artist?
—a lover paid the compliment
of first bedding her by a river
not in a marital bed

The liquid was ours
we swam like boys
Now I know you don't like getting wet
nor apples, bananas, or coffee

This evening I screwed the bed
together accepting
the future will be mute
about the folding of arms
entering in and out of one or another

Broken B
ed

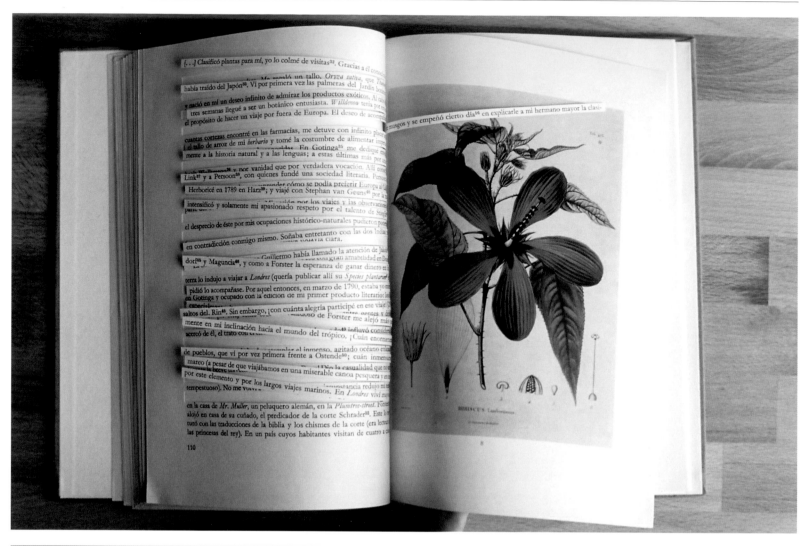

Urban Jealousy – Humboldt, *Between the Lines*

The book, *Between the Lines*, is a unique piece made exclusively for the first International Roaming Biennial of Tehran (Iran).
What was your inspiration for this work? A *jalousie*, which is a French word for a sun-blind that one can see through but not be seen.
Did you run into any specific challenges while creating this work? We had to realize the book within one day.

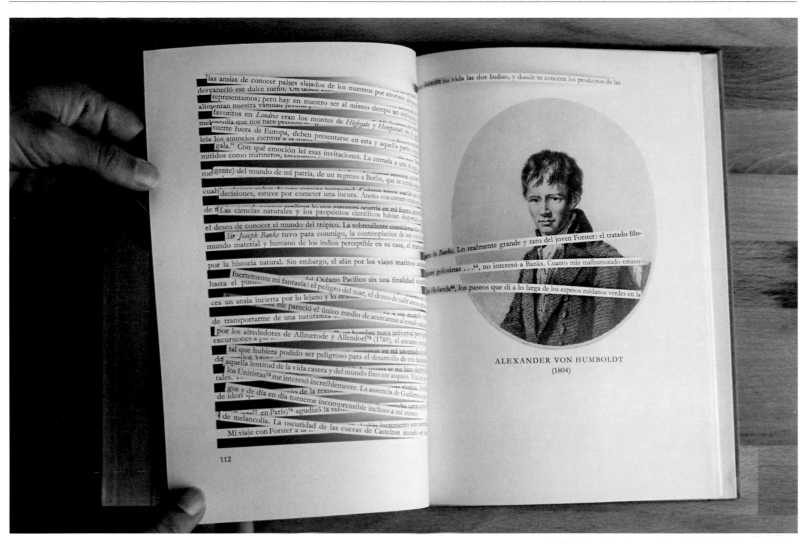

ALEXANDER VON HUMBOLDT
(1804)

GREAT 🐧🐧 LOVES

LEO TOLSTOY
—
THE KREUTZER SONATA

GREAT 🐧🐧 LOVES

FRANÇOISE SAGAN
—
BONJOUR TRISTESSE

GREAT 🐧🐧 LOVES

JAMES BALDWIN
—
GIOVANNI'S ROOM

Great Loves, Penguin Books

As with the previous Great Ideas, this series makes use of a seriously reduced palette to ensure a recognizable, coherent look across all twenty titles.

Design for books on this subject can often appear cliché-ridden and hackneyed, so we decided on a more abstract, symbolic approach, using botany as the chief source of inspiration. I wanted the images to be as evocative as possible, so I considered more traditional printing methods such as screen-printing or lino cutting. However, the time and budget constraints were such that this wasn't a realistic option, so I began to look for ways to create similar effects at a reduced cost. As with any series, the main challenge was keeping the ideas looking fresh across a range of titles (and not slipping too far into chocolate-box territory). I think I have Sigmund Freud to thank for this!

GREAT LOVES

IVAN TURGENEV
—
FIRST LOVE

GREAT LOVES

VLADIMIR NABOKOV
—
MARY

GREAT LOVES

SØREN KIERKEGAARD
—
THE SEDUCER'S DIARY

GREAT LOVES

ANTON CHEKHOV
—
A RUSSIAN AFFAIR

GREAT LOVES

STENDHAL
—
CURES FOR LOVE

GREAT LOVES

ANAIS NIN
—
EROS UNBOUND

Great Ideas, Penguin Books

Penguin Books was founded in 1935. The vision of its founder, Allen Lane, was that the publisher existed to educate and to popularize. Book buying was no longer the preserve of the privileged classes. For the first time, the ordinary man or woman in the street was able to buy a pocket-sized paperback for the price of a packet of cigarettes. In 2004, Simon Winder (a commissioning editor for Penguin Press) began to develop an idea for a miniseries that was to be modest in both pagination and price: the Great Ideas books.

"As a junior designer at Penguin, I was given the task of designing the covers. Early in the process, illustration was suggested to me as a possible solution, but owing to the subjective nature of the writing it felt like a mistake to dress the covers in imagery that might simply mislead. My intention was to situate the writing in its historical and geographical place through typography. Type-only covers had become increasingly rare in publishing, but I remember feeling confident that my solution was "on brand," as Penguin has a rich history of distinctive, type-driven jackets. Also, my feeling was that the cumulative effect of the covers would give them sufficient presence when displayed. The debossing of type tips a nod to letterpress printing, while the choice of an uncoated, off-white stock reinforces the link with traditional printing."

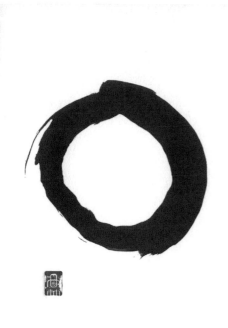

Éditions Zulma

Éditions Zulma developed a book series of contemporary French literature with typo-
graphic, pattern-led covers that invite the reader to fill them with meaning.

David Pearson // London, United Kingdom // www.davidpearsondesign.com

David Pearson is a London-based designer working in all areas of print, specifically in book design and branding.

Describe your early influences. I remember a number- and color-coded Penguin short stories box set from my childhood (designed by David Pelham). I used it as a toy, removing and replacing the colored "blocks" in the correct order. This experience has inspired most of my work to date and has also made me an avid collector (and organizer) of books.

What does your working environment look like? Unsurprisingly, it's covered in books. The by-product of designing series books is that you amass hundreds of reference copies, so you soon run out of shelf space. My floor looks more like a miniature cityscape and so I generally have to hop my way around the studio.

What inspires you? In the broadest and most predictable, sense, my inspiration comes from old book covers (specifically those of Penguin Books) and printed ephemera, such as matchbox labels (particularly from Czechoslovakia and Latvia c. 1960). Because of their size, their creators had to work very hard to produce eloquent, memorable motifs using a highly reductive visual language. They are great lessons/models for any would-be book designer.

What is your workout for creativity? I must admit that coffee plays an increasingly important role.

If you were not a graphic designer, what would you be? A window cleaner. There's something hypnotic about the snaking action of an active squeegee.

SONNETS AND POEMS
WILLIAM SHAKESPEARE

EMMA
JANE AUSTEN

TREASURE ISLAND
ROBERT LOUIS STEVENSON

WUTHERING HEIGHTS
EMILY BRONTË

PRIDE AND PREJUDICE
JANE AUSTEN

SHERLOCK HOLMES
ARTHUR CONAN DOYLE

White's Books

White's Books is the result of a collaboration between David Pearson and Jonathan Jackson, the publisher of White's Books. The bright, colorful covers are the handiwork of some legendary contemporary illustrators, including Radiohead cover artist Stanley Donwood, textile designer and Hockney muse Celia Birtwell, and Pearson's own editions. The covers are composed of non-repeating patterns that have a certain narrative flow. All covers are elaborated with traditional methods like paper cut illustrations, scraperboard, or lino.

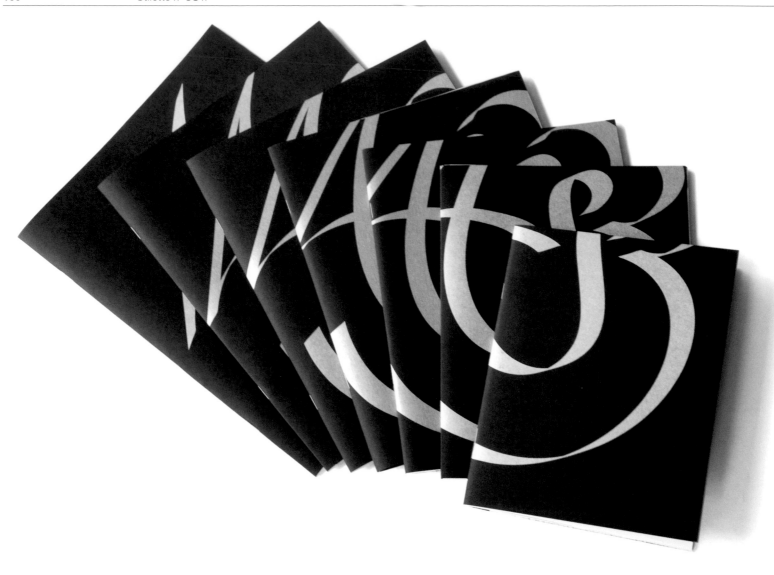

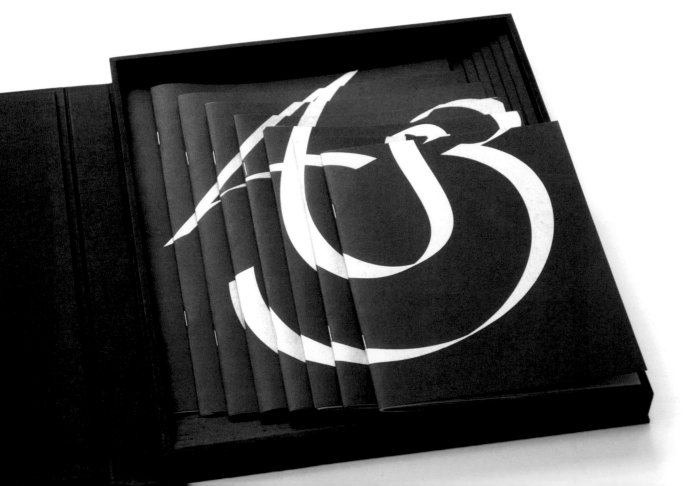

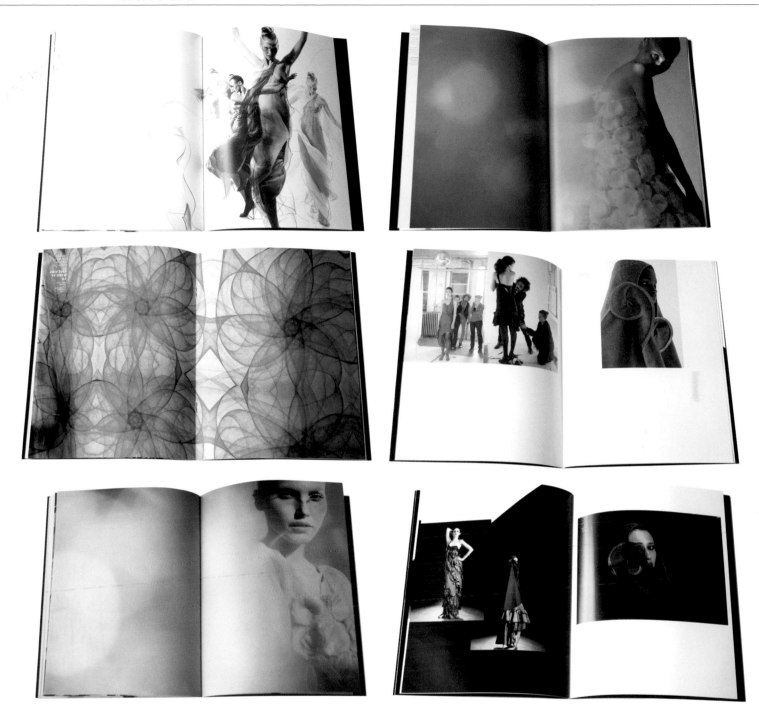

Three ASFOUR, 2008

A series of eight booklets enclosed in a specially made linen-covered box were created for the fashion collective Three ASFOUR. Each booklet represents one of their collections. The covers were screen printed. When seen together, they form the logo.

Stiletto // Stefanie Barth, Julie Hirschfeld // New York, USA // www.stilettonyc.com

Co-founded by Stefanie Barth and Julie Hirschfeld, Stiletto, NYC, is a design studio based in New York City and Milan, Italy, that specializes in art direction and design for print and video.

What do you consider quality in graphic design? Idea-based thoughtful design and well-crafted results.

What aggravates you? Trendiness, clichés, mainstream ideas, and attitude.

What does your working environment look like? It's a real work studio. It's the kind of place where you're not afraid to make a mess. It fills many needs—lunch space, photo studio, arts-and-crafts lab.

What guidelines and advice would you give students of graphic design? Be really experimental. You have your whole career to do safe projects. Leave your computer and go to the labs and workshops.

How do you get new ideas when you are stuck? Try to look at something unexpected. Get away from the computer. Go and see an exhibition, a film, walk around the city.

Tell us the story of the name of your studio. Stiletto has the double meaning of ladies shoe and knife. We like that ambiguity.

If you were not a graphic designer, what would you be? Stefanie: A florist. Julie: A doctor.

Carlos Amorales, *Dark Mirror*

What was your inspiration for this work? The fragile laser paper cuts and the paintings of moths by Carlos Amorales.

What is special, unusual, or unique about this project? The printing on the inside pages of the Japanese binding to make a passé-partout.

Did you run into any specific problems or challenges while creating this work? A lot. It was an experiment because we tried out something new and had to find out how to do it.

Do you recall unexpected reactions to this work? The printer really loved the idea even though it was very difficult to print.

Male

The book is a selection from writer/curator Vince Aletti's personal collection of photos and drawings of men. A gatefold in the center of the book shows Aletti's personal collection in situ, literally overwhelming his New York City apartment. Working closely with the publisher, we created sequences of images that are hopefully seductive, beautiful, and surprising. The book is composed of a series of separate sequences (or chapters). Each sequence begins with a photo on the right-hand page and a yellow field—that mirrors the size and placement of the image—on the left page. The front and back cover function in a similar way.

Triboro // David Heasty, Stefanie Weigler // New York, USA // www.triborodesign.com

New York-based design studio Triboro creates design solutions for clients in publishing, art, fashion, and music, and for cultural institutions. The studio excels both in building inspiring brands from the ground-up and in shepherding established brands into new territories.

Describe your early influences. Our fathers were both artistic. Our mothers kicked our asses.

What inspires you? New York City.

What aggravates you? Ignorance mixed with greed, a dangerous combination. Also tofu.

What guidelines and advice would you give students of graphic design? Never think you are too good to do something. Be eager. You can learn from any experience. It's a small world so try not to piss people off. Try to find a mentor.

Where do you find new energy? Good food, weekend getaways, naps on the couch.

Tell us the story of the name of your studio. In New York, businesses with Triboro in the name tend to be wholesale carpet distributors or industrial shelving manufacturers. We liked the idea that as the businesses in our neighborhood were shifting from an industrial output to a creative output, that the new creative company names might keep some link with the past.

Tell us five things you are crazy about. Kauai, a good pizza from Lucali's in Brooklyn, skiing, the Donut Plant, rooftop parties.

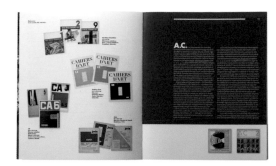

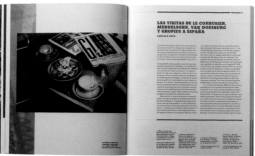

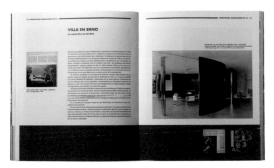
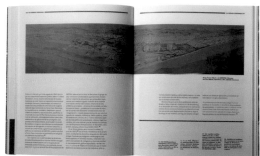

A.C. La revista del GATEPAC 1931–1937

What was your inspiration for this work? The *A.C.* magazine and others magazines of this time. *A.C.* represented new, open-minded ideas in architecture, art, and society… and all was destroyed or blocked with the Spanish Civil War. For this project there were four curators and two coordinators: too many opinions. First I thought this would be a problem but in the end everything was okay, because they were friends and they trusted and respected each other, and also respected us. The bad news was that we had a lot of technical problems with the computer.

Salon de Thé // Rosa Lladó, Roser Cerdà // Barcelona, Spain // www.salondethe.net

Founded in 2007, Salon de Thé is a graphic design studio that specializes in publishing and graphic design, corporate image projects and exhibition graphics.
What does your working environment look like? Our studio is small and full of books; it's very cluttered. We also have lots of light; the studio is on the eighth floor and we have a big window and a door to the terrace.
Are you a team worker or a lone fighter? Rosa: I could be a lone fighter but it's really more enriching to be a team worker. I believe in brainstorming—to share ideas and solutions for a new project. Salon de Thé tries to do this.
Tell us the story of the name of your studio. Rosa: Salon de Thé is a readymade "sign" of a French shop. I bought these letters in the antique street market in La Roche Blanche (France). The idea that "Salon de Thé" transmits is also good for me —a group of people or friends around a table talking about things in a relaxed way… I really would like to work like this with my clients.
If you were not a graphic designer, what would you be? Rosa: My hobby is the study of symbols… something in connection with that… philosopher? I don't know. I also like writing stories… storyteller could be a good job. Roser: Ilustrator, photographer, set designer… even a chef!

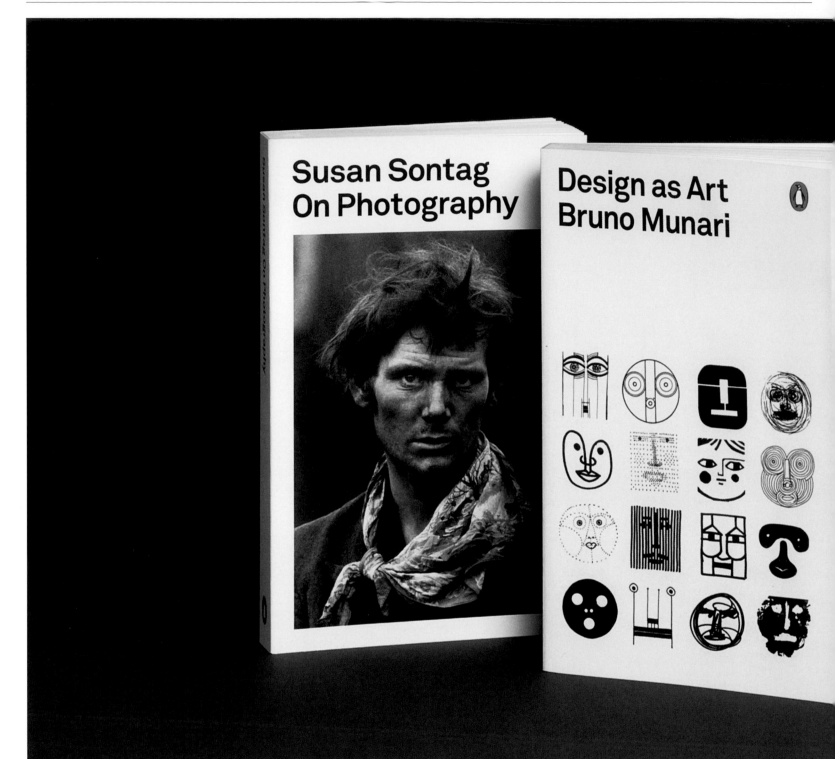

Penguin Design Series

YES was commissioned to redesign the covers of these four seminal titles. The covers fit in with Penguin's rich heritage of cover design and should be seen as both contemporary and classic. Title typography is modernist and restrained, an uncoated cover material was specified, and no pure whites were used in the color palette, to subtly signify the historical aspect of the books.

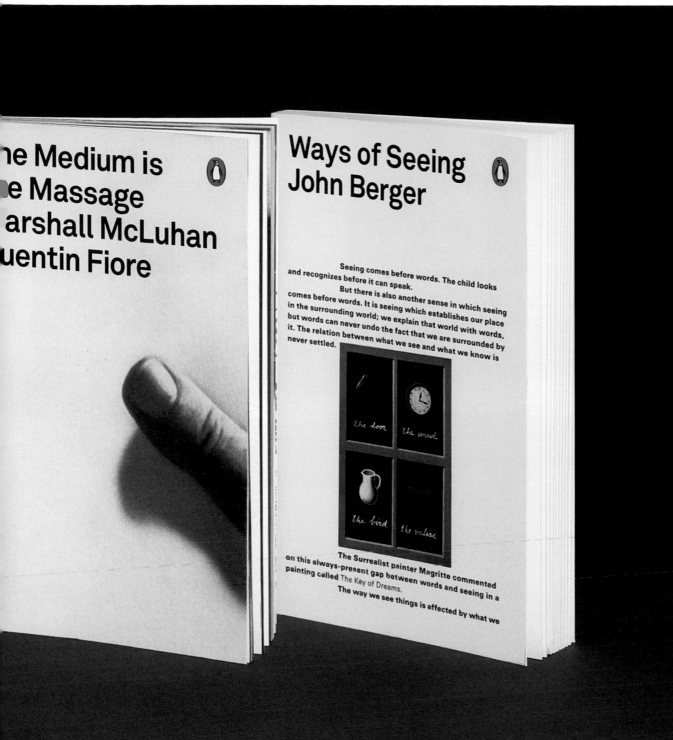

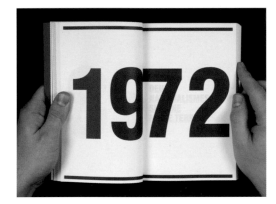

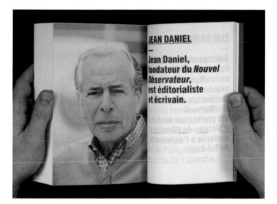

Éditions Galaade

The inspiration for the whole Galaade project is the type itself. All the identity is based on the use of ATTriumvirate. It's quite unusual to work with a client that understands so well what you want to do and trusts you enough to break the established rules of classic book design. The challenge is the really low budget for printing, but we like to work with this kind of constraint.

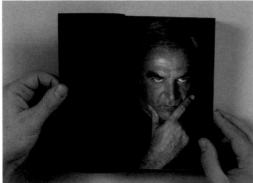

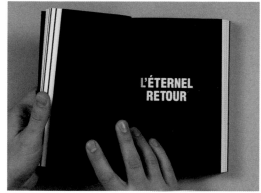

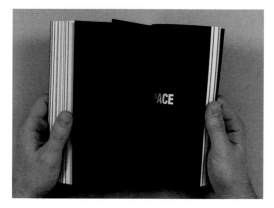

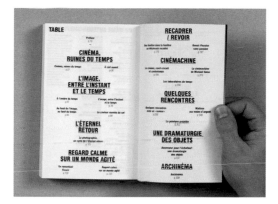

Hey Ho // Julien Hourcade, Thomas Petitjean // Paris, France // www.heyho.fr

Founded in Paris in 2007, the studio specializes in print design. Hey Ho mainly produces books, magazines, posters, and corporate identity.
Which work of yours are you especially happy with? The Galaade project, because it is always on the move, and it involves a lot of different material.
What do you consider quality in graphic design? Efficiency and clarity of the message.
What does your working environment look like? Like a warehouse, with two desks and a Ping-Pong table.
Do you have a work motto? Strength & Order!
What inspires you? Everyday life.

What aggravates you? Everyday surrounding mediocrity.
How do you get new ideas when you are stuck? Playing Ping-Pong.
Are you a team worker or a lone fighter? We are a team of two lone fighters.
Tell us the story of the name of your studio. It come from the Ramones' lyrics, "Hey Ho, Let's Go." We liked it because it doesn't mean anything; it's just a sound.
Which logo do you like best? Centre Georges Pompidou by Jean Widmer, Woolmark by Francesco Saroglia, V&A by Alan Fletcher, Renault by Vassarely, CBS by Bill Golden.
What is your workout for creativity? God.
Where do you find new energy? Devil.

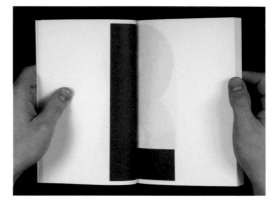

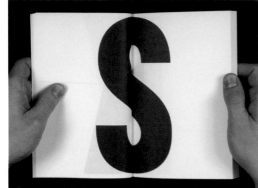

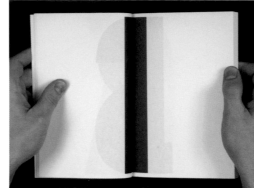

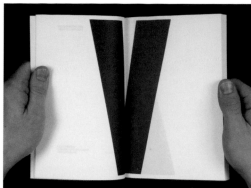

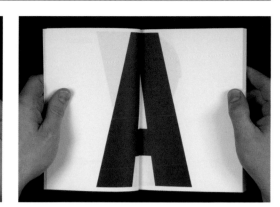

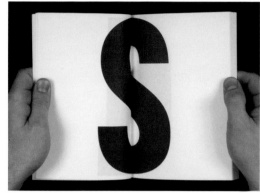

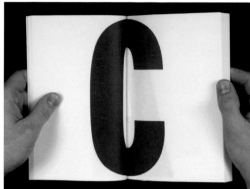

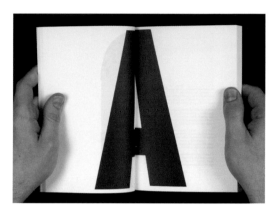

MUSIC

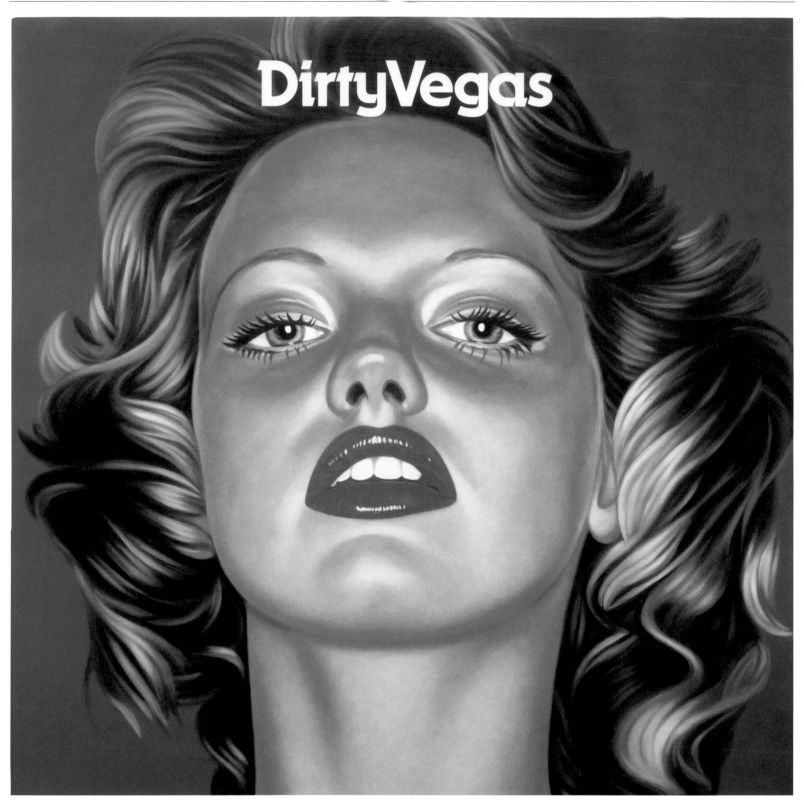

Dirty Vegas

Album campaign for Parlophone band Dirty Vegas. The series of sleeves features paintings by New York artist Richard Phillips. Using magazine ads and gentlemen's magazines as his source material, Phillips created a series of large format paintings, which bring to mind hand-painted murals and billboard art. A number of images were selected that seemed to sum up the idea of Dirty Vegas.

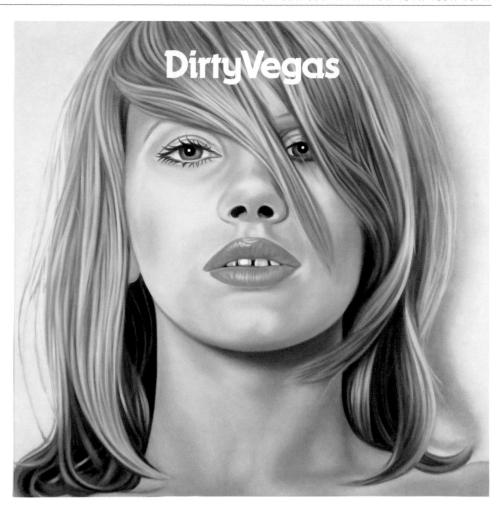

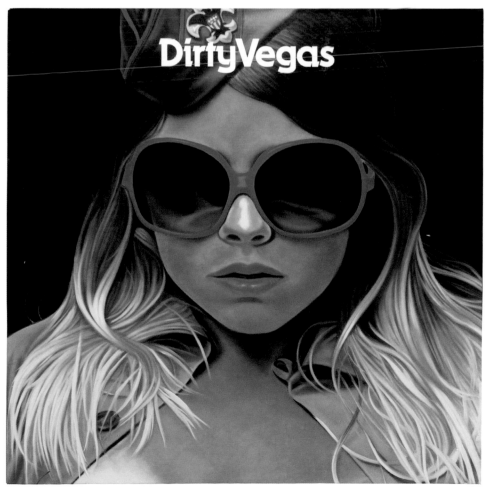

TheStands
HorseFabulous

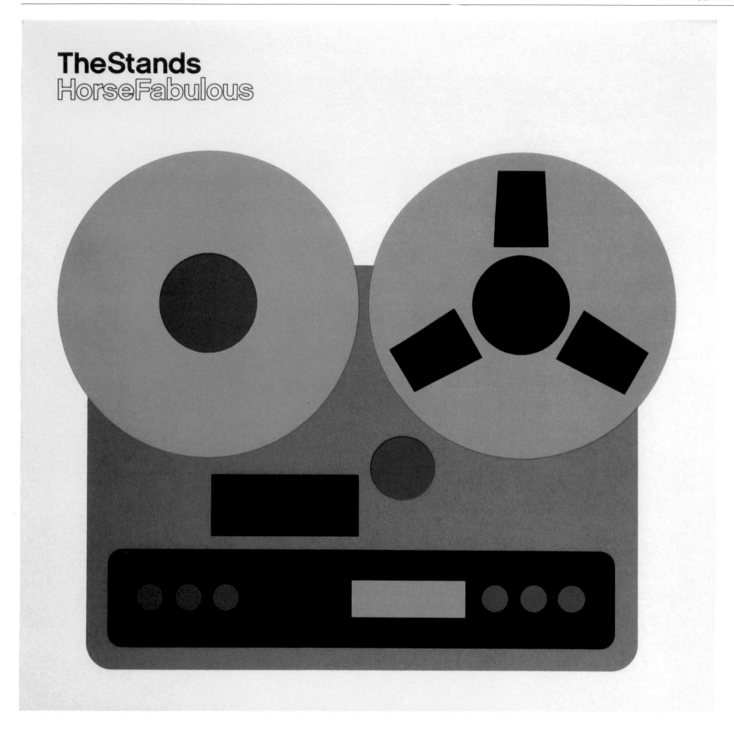

The Stands

Artwork created for the UK band. Inspiration came in the form of pre-1980s analogue hi-fi equipment. Using a reductive graphic approach, multiple designs were created, colors were mixed by hand, and large-format prints were produced at K2 Screen, London. The resulting artwork was then re-photographed and used as the basis for a sleeve and poster campaign.

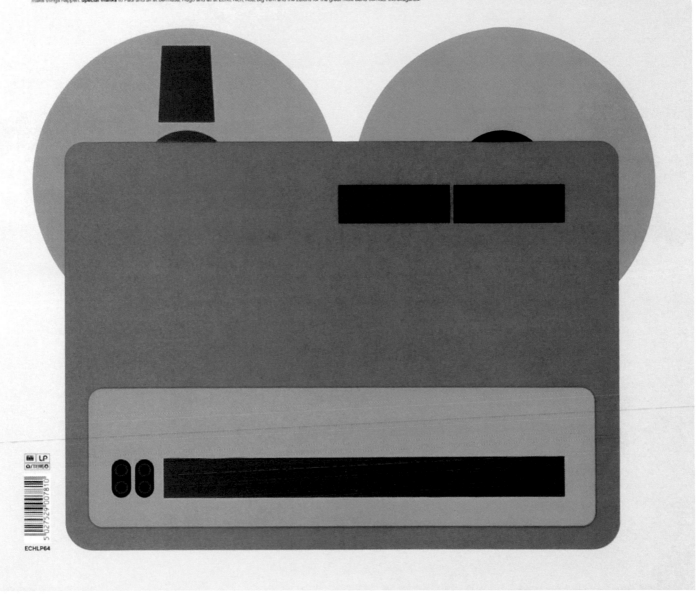

A1 TurnTheWorldAround A2 SoonCome A3 JustEnoughLove A4 IWillJourneyHome
A5 BackToYou A6 MountainsBlueAndTheWorldThroughMyWindow B1 NearerThanGreen
B2 WhenTheNightFallsIn B3 BluerThanBlue B4 DoItLikeYouLike B5 YouSaid

Written by Howie Payne. Produced by Tom Rothrock. Mixed by Tom Rothrock & John Paterno. Engineered by John Paterno. Strings and horns arranged by Suzie Katayama & Howie Payne. Additional backing vocals Sharon Celani & Gia Ciambotti. Horns: The Los Angeles Hollywood Horns. Strings: The Los Angeles Hollywood Strings. Saxophone on 'Just Enough Love' by Jeff Turmes. Published by BMG Music Publishing Ltd. All tracks ℗ & © 2005 The Echo Label. The copyright in the artwork and sound recording is owned by The Echo Label. The Echo Label is part of the Chrysalis Group PLC. Made in the UK. Distributed in the UK by Pinnacle. Artwork & Design: YES. **Many thanks** to everyone who helped in the making of this record. Friends family and everyone who makes and continues to make things happen. **Special thanks** to Paul and all at Bermuda, Hugo and all at Echo, Rich, Rob, Big Vern and the Zutons for the great multi band corridor extravaganza.

ECHLP64

YES // London, United Kingdom // www.yesstudio.co.uk

YES is a London-based commercial art studio founded in 2004. A distinctive approach to typography and image making has earned the studio a reputation for engaging, well-crafted work. The studio's diverse output includes projects for publishing, music, art, fashion, and broadcasting clients.
What do you consider quality in graphic design? What we try to achieve in everything we do is a level of refinement. To us, the process of design is about crafting something in a very pure and honest way. That's for us quality in graphic design.
Do you have a work motto? If you enjoy what you do, it never feels like work.
How do you get new ideas when you are stuck? Libraries and bookshops are always great places for bumping into something that might give a new perspective.

More and more, we use blogs and similar image-based repositories for the same effect. Our own blog is www.magicrealism.net.
What is your workout for creativity? We find the key to keeping ideas flowing is to allow each project to inform the next. We usually have about ten to fifteen projects going on at any given time, and everyone in the studio gets a chance for their input. Working this way helps us keep things fresh.
Tell us the story of the name of the studio: We wanted something short, positive, and unpretentious. The name was partly inspired by Yoko Ono's *Ceiling Painting (Yes Painting)*, 1966.

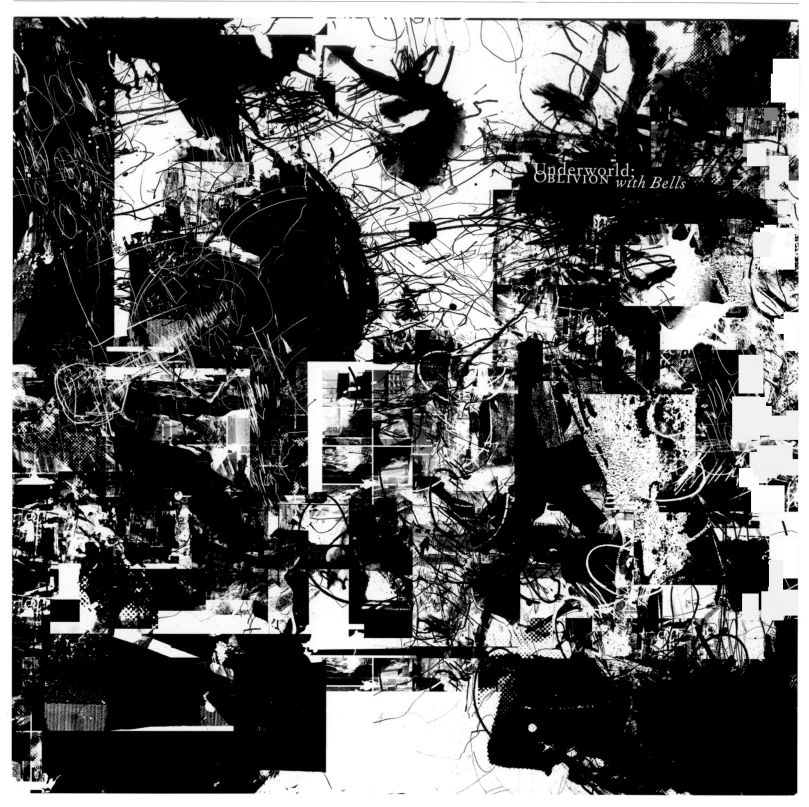

Underworld, *Oblivion with Bells*

Design and art direction for twelve-inch vinyl double album *Oblivion with Bells* in a gatefold sleeve, plus inner sleeves.

Tomato // London, United Kingdom // www.tomato.co.uk

Tomato is a collective founded in London in 1991. The members work together without any hierarchy and experiment with many different media in various fields, including music, film, fashion, architecture, installations, and many more. Though spread all across the world, Tomato's work lives from constant conversation and never-ending interchange of ideas.

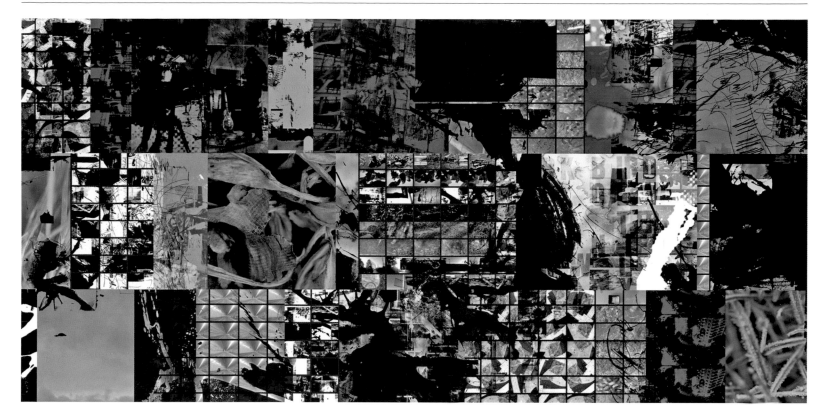

Lindstrøm & Prins Thomas Compilation Album

The L&PT album imagery came about from the fact the band is Norwegian. The Beatles' song "Norwegian Wood" is a reference point for the wooden images. The decision to use animals on the covers was due to the fact that, like most Nordic countries, Nor-way has lots of forests. So I thought about it and asked the guys to pick a few forest creatures, of which they chose frog, squirrel, owl, salmon, and butterfly. Not the typical moose or reindeer.

Chris Bolton // Helsinki, Finland // www.chrisbolton.org

Chris Bolton is a British/Canadian-educated graphic designer, based in Helsinki, Finland. He works on music, retail, fashion, architecture, advertising, and publishing projects worldwide. His thought-provoking work delivers a clear and relevant result, regardless of scale or budget.

What do you consider quality in graphic design? A well-thought out idea and execution. The way you can see the passion of the designer in the final product. And leaving me the feeling of "damn, I wish I could have done that."

Do you have a work motto? Work is called work for a reason. If it was easy, it wouldn't be worth doing.

What guidelines and advice would you give students of graphic design? Find what your personal interests are within graphic design—the field of business is quite vast. Focus on what you are good at and stick with it. Then push yourself with every project/brief/client. There is no such thing as a dream project; each project is an opportunity.

If you could live in another place for one year, where would that be? Tokyo / New York City.

Tell us five things you are crazy about: Memphis furniture (Ettore Sottsass), Oiva Toikka, Kenojuak Ashevak, ice hockey, everything about Japan.

If you were not a graphic designer, what would you be? Gardener.

Lindstrom & Prins Thomas
Turkish Delight

Lindstrom & Prins Thomas
Mighty Girl

Lindstrom & Prins Thomas
Boney M Down

Lindstrom & Prins Thomas
Nummer Fire Ep

Reverso 68

The solution came straight from the name of the FIN group itself. I thought somehow it was such a strong name and wanted to express it typographically. The use of the symbols/arrows forming the outlines of the letters was a result of this. It happened by shear luck that there was an even amount of characters in the name to form a 3 x 3 grid of letters/numbers. The backside of the sleeve shows a more simplified version of the main cover typography. These graphic letters make up the names of the tracks and which side they can be found. The image that is used is an idea based upon reflection or reversed image seen in a mirror, and the fact that two guys make up the group.

REVERSO**68**

Brandt Brauer Frick, *Iron Man*

What was your inspiration for this work? The music itself, and the title specifically. I had been working for a long time, exploring a tiling technique called "girih." This is a reoccurring technique in my work. It can be tiled both periodically and in aperiodic fashion. This pattern, in specific, is a clash of these two methods, starting off with eight symmetric cores. An aperiodic "virus" was then built up between the cores, which "ate" off them when necessary, until the symmetric cores were fully surrounded and left half "eaten" within. This was all done manually by so-called local displacement. It was a very laborious trial-and-error process, and required an Iron Man effort, so to speak.

Emperor of Antarctica // Christian Zander // Copenhagen, Denmark // www.emperorofantarctica.com

Graphic designer, art director, and artist Christian Zander founded his own practice ten years ago in Copenhagen, Denmark. As the "Emperor of Antarctica," he works specializing in all things type-related with a focus on music.

What do you consider quality in graphic design? Design, be it graphic or otherwise, is to me merely the opposite of accident.

What inspires you? I don't believe in inspiration. Or at least I believe too much emphasis is being put on it. It's a romantic notion and a magic word. Like the word "love," it means everything and nothing at the same time. As such, there isn't any specific thing, activity, or person that "inspires me." I sometimes wish it were that

easy. My ideas appear as a result of the continuously evolving relationship between the world and me, spontaneously and thankfully unpredictably.

What guidelines and advice would you give students of graphic design? To dig deep into the history and theory. And then to dig deep into yourself. If you engage deeply with both these aspects, and you have the talent for it, then something interesting is bound to pop up at some point.

What is your workout for creativity? Working.

Where do you find new energy? In bed.

Filur, In Retrospect

I created the pattern about three years before the Filur job came around. Which is a very normal occurrence. It's very simple, made up of packed equilateral triangles occurring in random, within a set range of colors, creating a mesh of different polygon shapes, from same-color triangles that appear next to each other.

What is special, unusual, or unique about this project? It's not really unique, but I always enjoy it when material finds a home with the right jobs.

HUMANS BEING

01. COPS AND ROBBERS
02. PIGS DO FLY
03. EXTREME
04. NME
05. PLUG INTO THE MACHINE
06. ROLLERCOASTER
07. LONDON OUT THERE
08. BOY/GIRL
09. STAND OUT
10. SIMON SAYS
11. A LIST
12. WAIT
13. I GOT WHAT YOU NEED

ALL TRACKS PRODUCED BY DAVE
MCCRACKEN EXCEPT LONDON OUT THERE
PRODUCED AND MIXED BY DAN SWIFT,
AND STAND OUT PRODUCED BY MAX HEYES

ALL TRACKS MIXED BY CHRIS SHELDON
EXCEPT ROLLERCOASTER MIXED BY STEVE
FITZMAURICE AND STAND OUT MIXED
BY ADRIAN HALL

ALL TRACKS WRITTEN BY PIET BEZ
AND KEVIN FLOYD

PRESS.
OWEN PLACKARD @ HERO PR

RADIO PLUGGERS.
PAUL KENNEDY @ GET INVOLVED

NATIONAL PRESS.
RACHEL@HEROPR.COM
+44(0)1635 868 385

REGIONAL PRESS.
WARREN@CHUFFMEDIA.COM
+44(0)208 830 0330

RADIO.
AIDEN@GETINVOLVEDLTD.COM
+44(0)207 604 2944

BOOKINGS.
PHYLLIS@ITB.CO.UK
+44(0)7725757824

LABEL.
JASON@ATHOLESTILL.CO.UK
+44(0)7711240283

MANAGEMENT.
MARK@ATHOLESTILL.CO.UK
+44(0)7771681179

DESIGN.
WWW.COMPANY-LONDON.COM

WWW.DORP.CO.UK
WWW.MYSPACE.COM/DORP

Dorp, *Humans Being*

South African band Dorp asked us to design the artwork for their forthcoming debut album, *Humans Being*. Since the album explores different aspects of human relationships and behavior, our concept was to create a unique portrait of humanity by splicing together images of a random selection of people that we photographed in our studio.

This collage of different identities morphed into a coherent whole. The back cover uses the same technique to show the rear view. We opened our studio for a whole day and invited people to come in and have their picture taken. It was a challenge since we didn't know any of them. We felt like we worked in a little shop.

I GOT YOU ON TAPE 2
remixes

A

Somersault (Money Your Love remix)

Prophet Rock (Context remix)

33 rpm

B

Somersault (MHM One & Larry's Coffee And Biscuits mix)

Prophet Rock (Snöleoparden remix)

33 rpm

I Got You on Tape 2

I Got You on Tape 2 is the first record cover of graphic designer Lasse Andersen. Looking for inspiration, I stumbled upon an old Penguin cover with some quirky wireframe graphics and thought the idea would fit for this project. The idea was to make a darker graphic remix of the original album cover, since the tunes were all electronic remixes of melodic indie songs. I wanted some sort of randomness and distortion within my structures, so I started to break the wireframes apart in different shapes after it was done, and the whole color layer was put on by intuition, instead of my normal "colormatching" process. I imagined that the final work would be a solid structure slightly split apart and with a lot of different colors on top of it—just like the remixes on the album.

Same Same Visuals // Lasse Andersen // Copenhagen, Denmark // www.samesamevisuals.dk

Lasse Andersen has been doing visuals for the past six years in Europe. As a graphic designer, his style is inspired by old animations. His love for movies from the 1980s also informs a lot of his graphic style.

Describe your early influences. Looking back, I think the covers of my dad's record collection combined with the music had a huge impact. My dad bought an IBM in 1983 and I have always been a huge fan (and former collector) of consoles, so the whole wireframe/1980s look will always have a special place in my heart combined with the feeling of being in another universe.

What inspires you? My own childhood, travels—what a gift!—the different interpretations people have on things, movies, music, and places, the stories of old things, and all the great people in my life.

What guidelines and advice would you give students of graphic design? You only get better by trying, not by talking.

If you were not a graphic designer, what would you be? I would work with kids.

Electric Wire Hustle

Creation of a unique image and logo for the first Electric Wire Hustle EP, released out of Japan. If you look closely at this project, it's the basic shape of a stylized fighter jet. The color palette adds a layer of funk. The project was a collaboration between myself and a trio based in New Zealand. I find working online is getting easier and easier; the time-zone differences help as I can have concepts back to the group the following day.

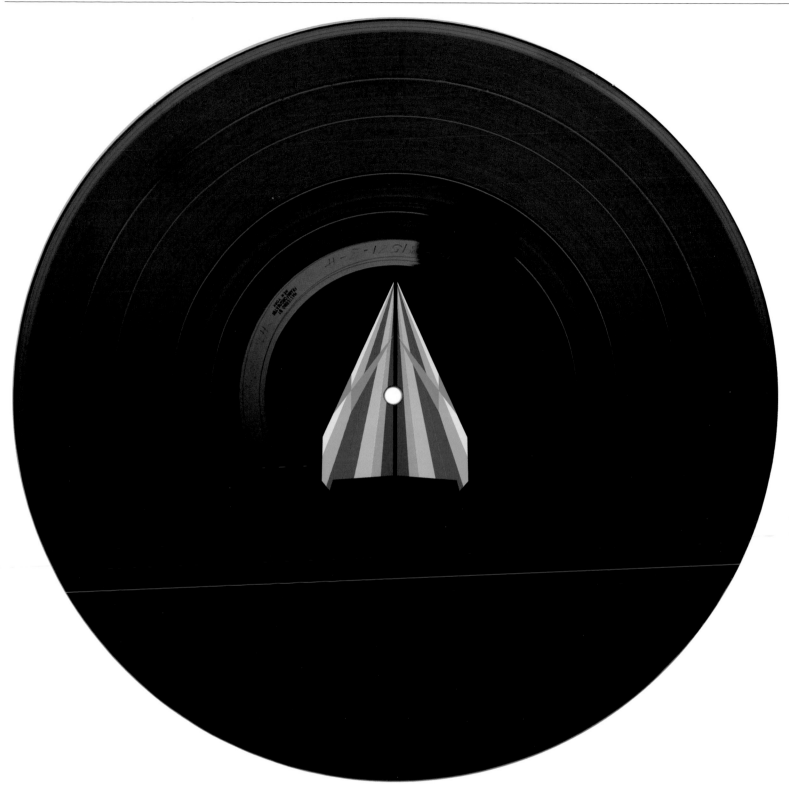

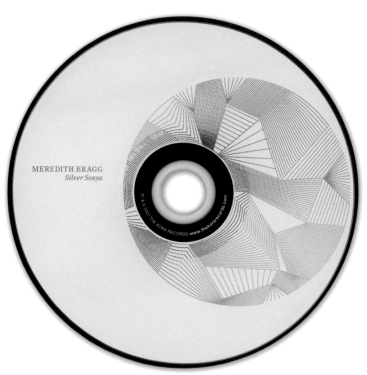

The LK vs. The Snow

Album artwork for the U.S. release of LK's second album.
I love working in vector, and with this project I had a vision from the get-go that I would try to illustrate snow in a new unique way. The cover illustration is basically my abstract view of snow falling. I wanted to print this package using letterpress tech-nique, but with letterpress you can't print large block colors. We ended up printing the sleeve using a spot color; this wasn't my first choice, but once I had the printed job in my hand I was surprised by how great it looked.

Meredith Bragg

It was Meredith's first solo album; he was recording all the instruments separately and then mixing the elements together at Silver Sonya Studios. This was my inspi-ration for the project: many inputs coming together to form a single whole. The il-lustration on the cover was time-consuming. I remember being halfway through creating it and thinking, "I hope this works," as I had already invested a lot of time in the alignments of the lines, etc. This project seems to pop up a lot on design blogs. It makes me happy to see my clients' work being featured, as it helps raise the pro-file of the band.

Hanne Hukkelberg
Rykestraße 68

Hanne Hukkelberg, *Rykestraße 68*

Rykestraße 68 is the second album from the Norwegian singer-songwriter Hanne Hukkelberg. The six-page CD is illustrated by Loveworn. The original typography is made by Non-Format.

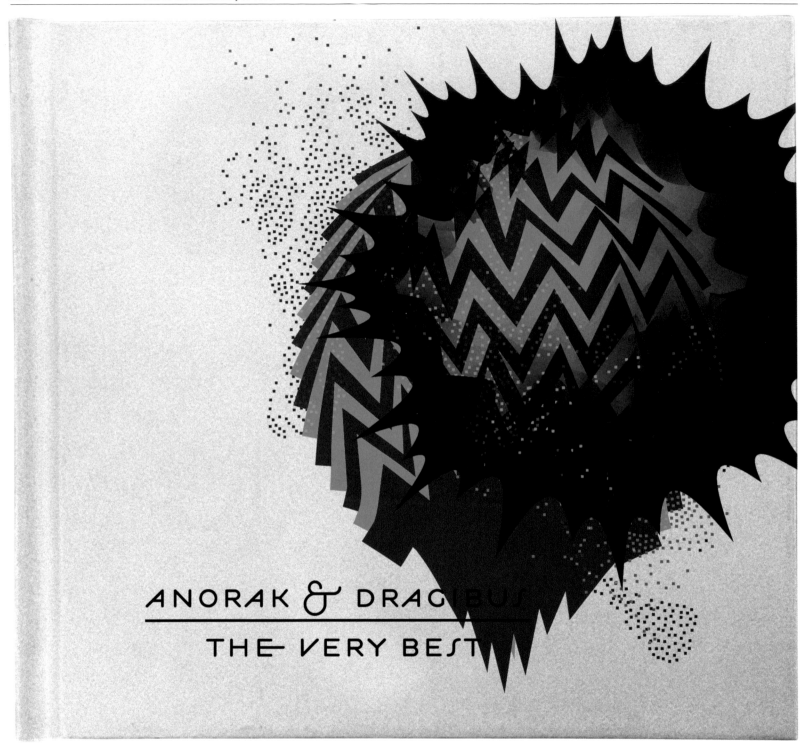

Anorak & Dragibus

Sleeve design for the ONcovered project initiated by Ontwerpatelier. Anorak & Dragibus is an intergalactic Afro-Pop band. The series consists of three albums with three different covers. The sleeve design for *The Very Best of Anorak & Dragibus* album is the superposition of the three previous covers.

ANORAK & DRAGIBUS
KOMPHIPI

ANORAK & DRAGIBUS
SUPER CHIKONDI

ANORAK & DRAGIBUS
FUNA FUNA

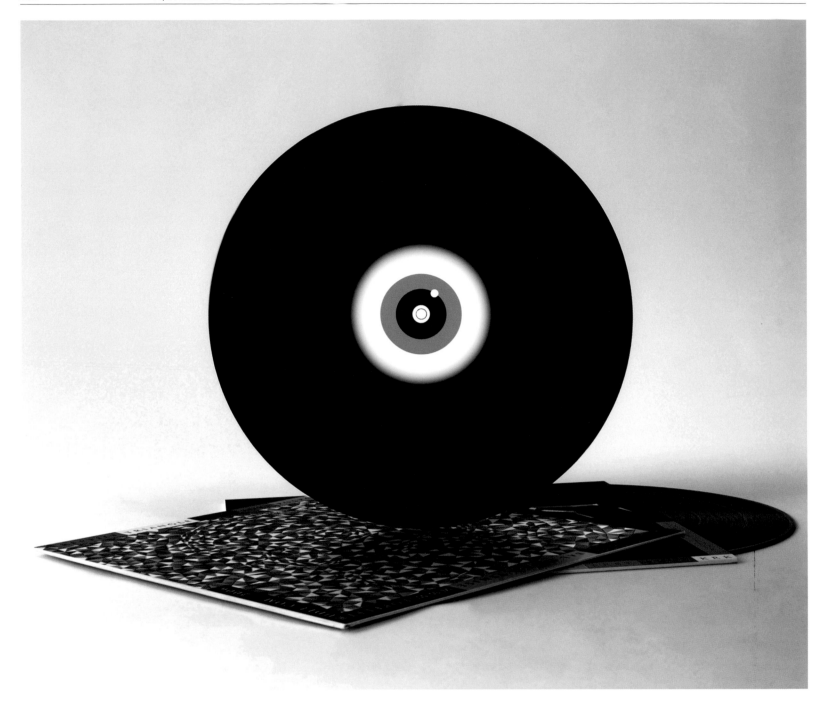

Popelstrudel

This series of covers was for an electronic metal band, so the inspiration comes from hard rock lexicon (skull, snake, spider, etc) and a contemporary way to see it (colors and facets). This band contains four members, so there is a cover for each member.

Pipi Parade // Alain Rodriguez, Raphaël Garnier // Paris, France // www.pipiparade.com

Pipi Parade is a Paris-based graphic design studio directed by Alain Rodriguez and Raphaël Garnier. Their work has an independent and innovative style. It is irritating and appealing at the same time.

Describe your early influences. Our first influences were nature and architecture.

Which work of yours are you especially happy with? A series of portraits made with pieces of other portraits. We like it because it gives the impression that you are seeing the images for the first time.

What do you consider quality in graphic design? Sobriety and a small dose of humor.

Do you have a work motto? Do something new. Do something smart. Smile.

What inspires you? All the things that deserve to be seen.

What aggravates you? Whatever wastes our time.

What guidelines and advice would you give students of graphic design? Make what you feel; sometimes it works.

How do you get new ideas when you are stuck? We visit the library or enjoy a good bottle of wine.

Tell us the story of the name of your studio. We really wanted a typical French word, but something that sounds good in any language.

Tell us five things you are crazy about. To touch, see, hear, smell, taste.

Cuicui Music

As many different rhythms characterize the music of each artist, in this project we were interested in working with patterns. We tried to draw vibration. It's an image that we are listening to.

Une véritable histoire
Audrey

A
01 ce matin là 3.45 min
02 le vide 3.28 min
03 j'allume ma cigarette 3.05 min

B
01 splatch 1.14 min
02 je colle et tu décales 2.38 min
03 trois petits cochons 5.12 min

All tracks produced, recorded and mixed by A Prudhomme
CCM 12 004. (P) & (C) 2006 CUICUI MUSIC
info : cuicui.music@hotmail.fr
Graphic design : www.raphaelgarnier.com

UMTKZT
mobile

A
01 one dollar 3.33 min
02 multicouches 2.42 min
03 par la fenêtre 4.00 min

B
01 haverboardshoe 2.50 min
02 professional cd recorder 7.04 min

All tracks produced, recorded, mixed and vocals by A Pape
CCM 12 004. (P) & (C) 2006 CUICUI MUSIC
info : cuicui.music@hotmail.fr
Graphic design : www.raphaelgarnier.com

Frequenza, *Frequenza Limited*

What was your inspiration for this work? I got my inspiration from different sources— amazing work by other people, friends, simple things I see every day. For Frequenza, I had to create a series, which is almost a challenge. I had to design a simple layout and a kind of illustration style that is repeatable for every record, but different at the same time. The artwork for Frequenza Limited is based on the idea of keeping the main sleeve for every release the same but to change the color of specific parts on the labels. This concept helps the label get continuous design and hence a high recognition value, while emphasizing the quality of the music. Furthermore it saves money and is a good way to get a lot for a low budget, which can be pretty useful in the hard-fought music market.

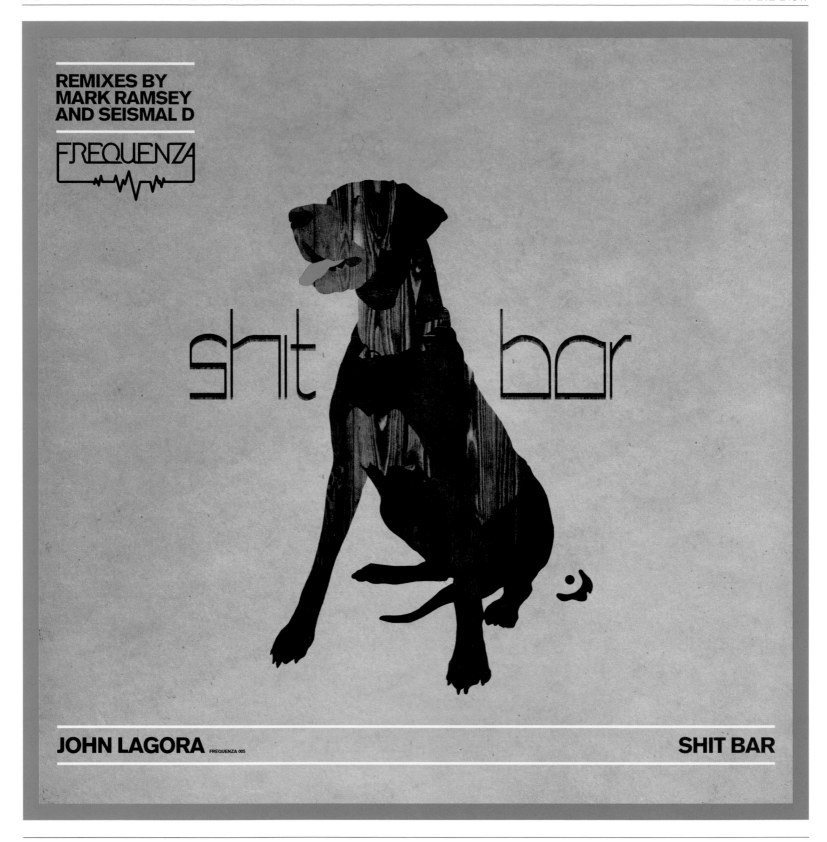

REMIXES BY MARK RAMSEY AND SEISMAL D

FREQUENZA

JOHN LAGORA FREQUENZA 005 **SHIT BAR**

ICE CREAM FOR FREE // Oliver Wiegner // Berlin, Germany // www.icecreamforfree.com

Founded in 2005, ICE CREAM FOR FREE is a Berlin-based design studio with a focus on print. Having developed from a collective, ICFF has access to a multidisciplinary team of designers.

Describe your early influences. Since school I have been interested in the De Stijl and Bauhaus era. Artists like Theo van Doesburg, Piet Mondrian, Gerrit Rietveld, or Gunta Stölzl fascinated and influenced me, and I've learned a lot about balance, consistence, and subtlety. David Carson influenced me the most during my studies.

Do you have a work motto? I don't really have a motto but I like to identify myself with something from Anthony Burill: "Work hard and be nice to people."

On a more practical level, what can be found on your desktop? My displays, keyboard, mouse of course, lots of Post-Its, water and a small fan, which is actually superfluous at the moment, 'cause it's pretty cold here in Berlin.

What inspires you? A lot of different things, starting with the way to my office, my closest friends, partying, other designers but especially Berlin, with all it's beauty, kookiness, and happiness.

Where do you find new energy? In the sun. That's why I think it would be a good idea to spend the time between October and March somewhere other than Berlin.

What is your dream of happiness? A working life full of success and a private life full of love.

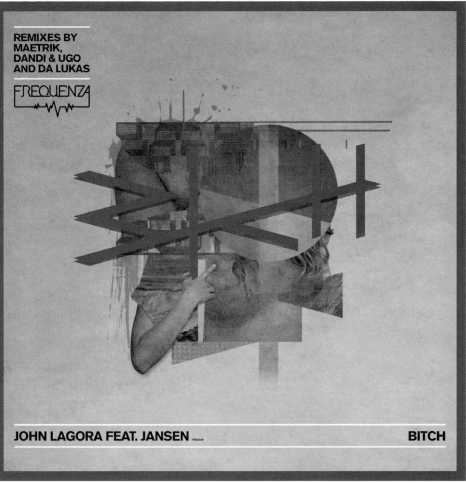

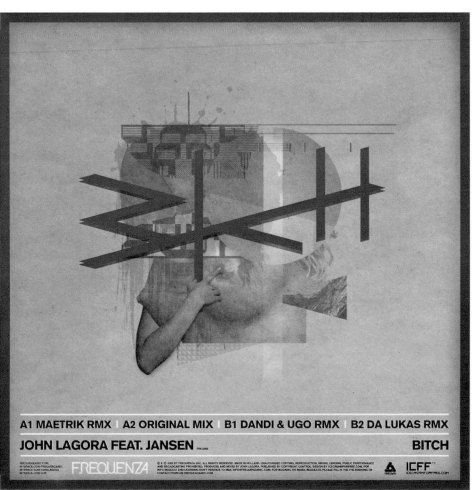

Fischerspooner, *Entertainment*

Photography: Dusan Reljin
Typography design assistance: Enrico Bonafede
Fischerspooner's third full-length album *Entertainment* is all about light. We wanted something minimal and subtle yet enigmatic. Fischerspooner has always sought to blur the distinctions between art, music, and performance, so it was apt that they showed their vibrantly trashy yet intricately choreographed "Get Confused" video installation at the aptly titled *It's Not Only Rock 'n' Roll Baby* exhibition in Brussels in 2008, which also featured work by Brian Eno, Laurie Anderson, and Yoko Ono.

Homework // Jack Dahl // Copenhagen, Denmark // www.homework.dk

Homework, established in 2002 by Jack Dahl, is an independent graphic design studio and consultancy that focuses on art direction, visual identity, and communication for lifestyle, fashion, and cultural clients.

Do you have a work motto? "So much more to learn" has been Homework's mindset motto for a long time. This season I changed it to "So much more to live," which is applicable both on professional and personal levels.

What aggravates you? Ignorance aggravates me a lot, and being badly treated. Also, fear and people's constant affirmations of bad thought. Our thoughts make things beautiful—just as our thoughts can make things ugly.

On a more practical level, what can be found on your desktop? As little as possible. I have my to-do-list, research and references folders, music… but to be honest with you, there's is quite a lot of files and folders these days. I'll clean on Friday.

What does your working environment look like? My work environment means a great deal to me. Light, calmness, and clean desk space—also for my desktop!

What is your dream of happiness? Being well, glad, safe, and satisfied (with myself). And to continue seeing "traveling" as my goal.

Tell us five things you are crazy about. Rain, spring, books, music, and dirty martinis.

LUKESTAR
Lake Toba

Luke Star's *Lake Toba*

I was thinking about these human shapes comprised of star clusters from different galaxies and wanted to play with scale and identity and see how far I could stretch it. The LP, cassette, 7", and CD edition follow the same theme but with different backgrounds and star images. It starts with an embryo (the 7") and develops into a male figure on the vinyl LP and a female figure on the CD and cassette.

Snasen // Robin Snasen Rengard // Oslo, Norway // www.snasen.no

The work of Norwegian graphic designer and illustrator Robin Snasen Rengard is a mixture of editorial, bespoke typography, and textural images, with a musical influence.
Describe your early influences: Cartoons and graffiti were early sources of inspiration for me and the reasons I started drawing. I wanted to go into graphic design after seeing the Motorpsycho covers by Norwegian designer Kim Hiorthøy. The fact that one could make a living by creating visuals for my favorite bands was mindboggling to me.
How do you get new ideas when you are stuck? I kick and scream and work my ass off and most of the time it works out.
Where do you find new energy? In doing nothing.
Are you a team worker or a lone fighter? I prefer working alone on the creative part without distractions and with the freedom to take the process in any direction I want to.
Tell us the story of the name of your studio: Snasen is a farm in Mo i Rana where my mother grew up. The name also translates as "snazzy" and is, therefore, a good name for a company working with aesthetics.
Tell us five things you are crazy about: Flowers, music, videogames, conjac…

LUKESTAR

A: White Shade
B: Peregrin

PhoneMeRecords 2007
Recorded early 2007 by Carl Vikman,
Ear Studios, Uppsala.
Taken from the album Lake Toba.
Sleeve by Made.

www.lukestar.com
www.madebymade.no

Turboweekend's *Ghost of a Chance*

We see the forest as a mythical and compelling space that represents the unconscious state of mind, a symbol of the unknown; soil for both hardships and fairytales. We think the ball is a very nice counterpart to nature, and its mathematical construction works beautifully together with the organic shapes of the woods. These contrasts are also found in Turboweekend's music. Hard pumping beats combined with thoughtful lyrics give the music a bodily yet structured sound. The back cover shows a photo of the members of Turboweekend having a secret gathering in a lit tent. They might be singing or planning occult rituals! The inside of the cover is all white as a contrast to the dark front and back cover, and is meant to give a feeling of having entered the tent.

Hvass&Hannibal // Sofie Hannibal, Nan Na Hvass // Copenhagen, Denmark // www.hvasshannibal.dk

Hvass&Hannibal is a design and art studio based in Copenhagen. Sofie Hannibal and Nan Na Hvass work on everything from album covers to music videos, and their expertise covers graphic art, silkscreening, art direction, illustration, installation, and lots more.

Which work of yours are you especially happy with and why? We are very fond of the project where we designed the stage and costumes for a concert with Efterklang and the National Danish Chamber Orchestra in 2008. It was a very big project involving a lot of people, and we learned a lot in the process. The production was on a very low budget so it was quite a challenge.

On a more practical level, what can be found on your desktop? Books, sunglasses, CDs, a drilling machine, paint brushes, a giant comb, external hard drives, calendars, loudspeakers, notes, money, matches, a pencil sharpener, a baking tin, and a banana peel.

What does your working environment look like? It's small, colorful, messy, and cozy. If a gnome or a child were to start a business and decide to get an office, this would be their office.

What is your dream of happiness? A big studio with a dog and a lot of friends who work together!

TURBOWEEKEND
AFTER HOURS

TURBOWEEKEND
HOLIDAY

MISCELLANEOUS

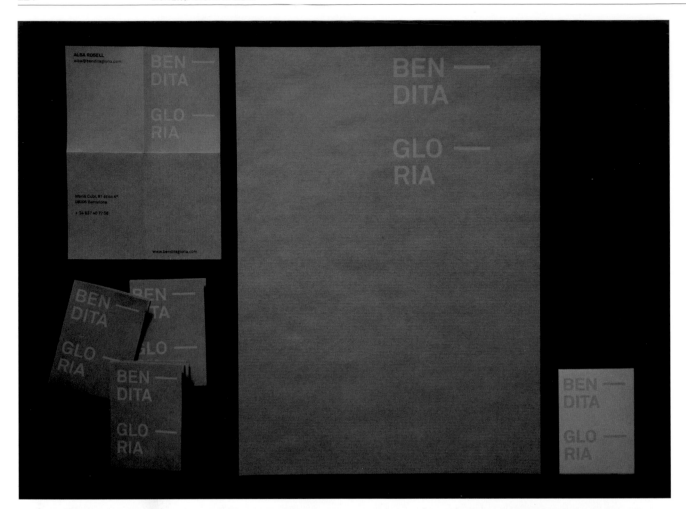

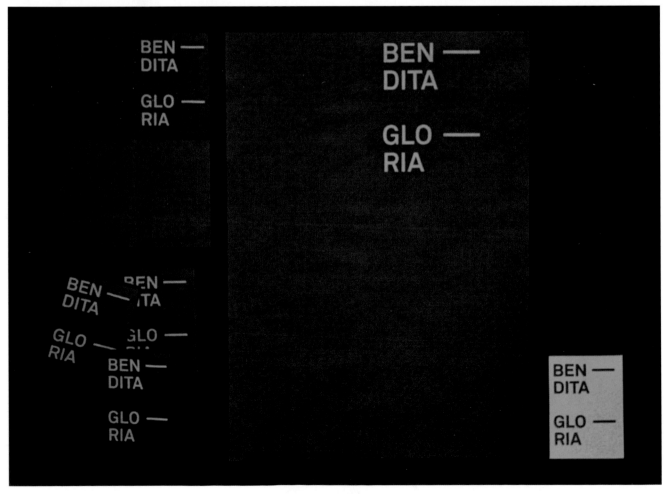

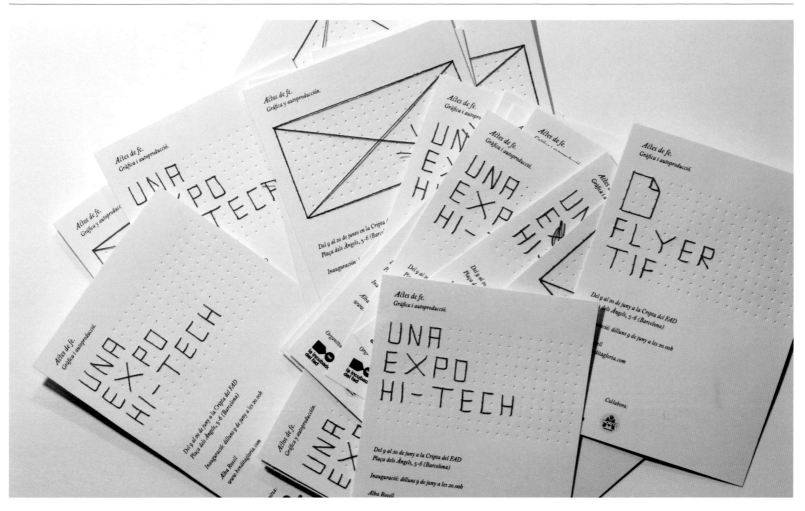

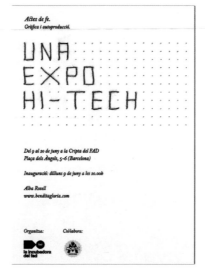

Bendita Gloria's Stationery

What was your inspiration for this work? The idea of "light" as something related with glory. The studio's stationery is printed with phosphorescent ink, giving off its own light. It was not easy to use this ink on kraft paper, but the printers did great work.

Do you recall unexpected reactions to this work? Many design blogs published this work. We felt flattered!

Actos de fe. Gráfica y autoproducción — La incubadora del FAD

Inspiration for this work was the DIY philosophy, which encourages people to take technologies into their own hands to solve needs. The artists explain, saying, "There's a hand-sewed message in every communication item of the exhibition. As we had to sew too many invitations, we needed to ask some friends to help us. It's a very small project, but it opened doors to some other amazing design opportunities."

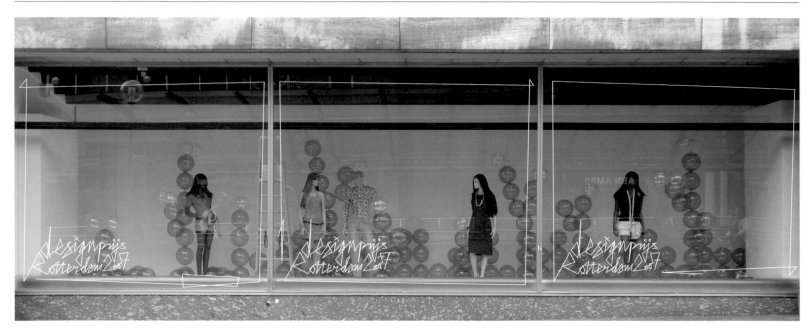

Desingprijs Rotterdam, 2007

What was your inspiration for this work? The pen tool and the ignorance in how to use it and fill it with color.
What is special, unusual or unique about this project? No images are used.
Did you run into any specific problems while creating this work? No, not really. The commissioner, Annemartine van Kesteren, understood what it was about.
Do you recall unexpected reactions to this work? Irma Boom called us and said she found it very ugly. That was nice of her.

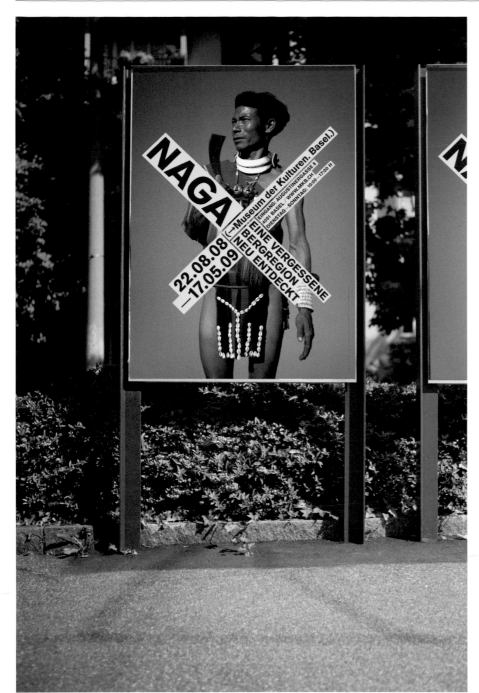

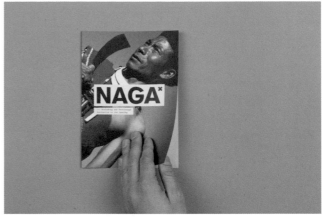

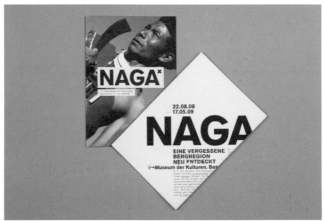

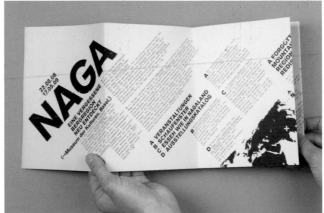

Naga — A Forgotten Mountain Region Rediscovered

(Photo on Poster: Milada Ganguli, 1975)
We were commissioned to design the identity for an exhibition at the Museum der Kulturen Basel about the Naga people, who are living in the border area of Northeast India and Myanmar (Burma), a mountain area that has been sealed off for many years.

We found a couple of old analog photographs from this period in the museum's archive, and they gave us a starting point. The central idea of the project was the fact that the region has been inaccessible to the rest of the world for a long time.

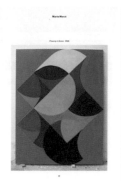
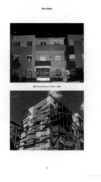

Better than Grey

This small publication plays on the theme of the exhibition *Better than Grey* by making use of different colored papers. The title is screen-printed grey on seven different colored covers to represent the colors of the rainbow. For the interiors, the text is printed on a grey uncoated paper that wraps around the image section, which is printed on a white matte coated paper.

Fraser Muggeridge Studio // Fraser Muggeridge, Sarah Newitt, Stephen Barrett // London, United Kingdom // www.pleasedonotbend.co.uk

Fraser Muggeridge Studio is a London-based graphic design company working on a wide range of formats, from artists' books and exhibition catalogs to posters, maps, and postcard invites.

Describe your early influences. I studied typography and graphic communication at the University of Reading, so I was influenced by everything there, the teaching of Michael Twyman, Ken Garland, and Paul Stiff, in particular.

On a more practical level, what can be found on your desktop? The end of a carrot.

What does your working environment look like? A studio in Clerkenwell, London, with a big desk with five computers on it. Books everywhere.

What inspires you? Making good work.

What aggravates you? Not making good work.

What is your worst nightmare? The end of print.

What guidelines and advice would you give students of graphic design? Work hard and look at what you are doing.

How do you get new ideas when you are stuck? Leave the studio and do something else. Forget what you have done and start again.

Where do you find new energy? In carrots.

What is your dream of happiness? Being happy.

facepartnership.com

face

Logotype, branding, and Web site for face, the premier British performance cycling gurus. Tomato utilizes the bicycle frame as an icon that is used as a typographic element. The repetition in spirals generates complex, abstract forms. Fran Millar and James Pope set up face in 2003. They have been managing athletes and creating innovative events ever since.

Who's Your Hero?

I like the idea of a very simple concept applied to a book. I was thinking of ways to break an endless loop, and didn't want something too clumsy. This book is very accessible, but you can think twice about it. I mean there is more than one reading. I like that everyone can be affected by this book.

Do you recall unexpected reactions to this work? In general, people found these illustrations very kitsch.

ANDY'S HERO IS MRS. BIRD,

MRS. BIRD'S HERO IS JOSH, HER SON,

JOSH'S HERO IS THE NURSE,
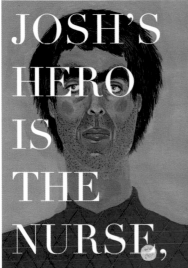
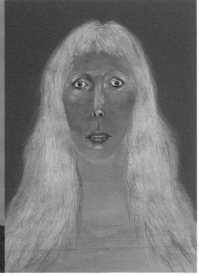

THE NURSE 'S HERO IS MR. BIRD,
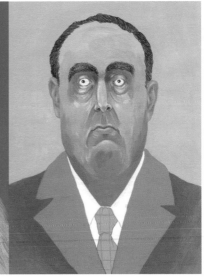

MR. BIRD'S HERO IS MICK JAGGER,
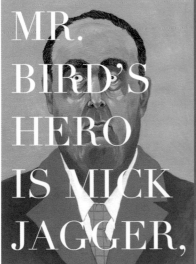

MICK JAGGER 'S HERO IS MICK JAGGER.

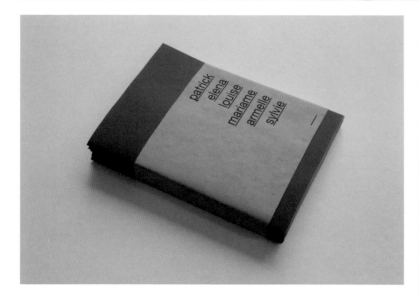

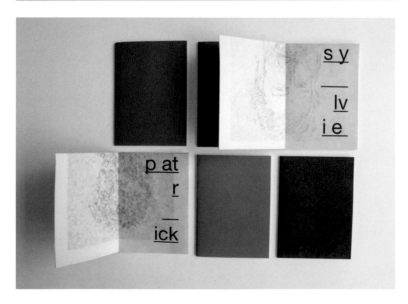

Patrick, Elena...

I like graphic design, but my first love is drawing. To bring together my sketches, I wanted to find something simple, but also pleasant. I'm very interested by the notion of series; I chose to make a collection of booklets. One booklet for one model. The paper I chose is a special sketch paper, glossy on one face and matte on the other, lightly transparent. Although this work looks very simple, it took me quite a long time to find a correct way to show my drawings.

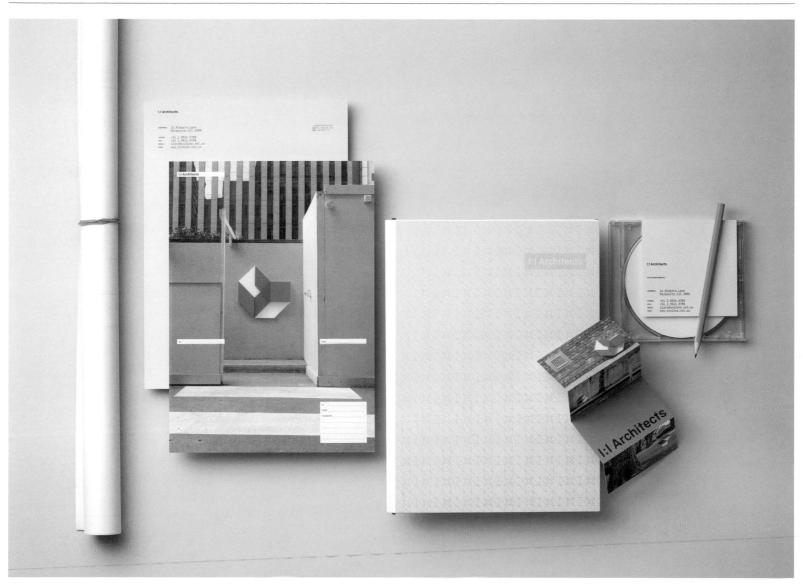

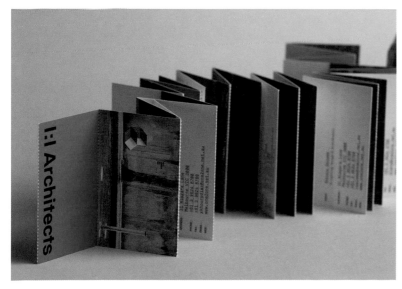

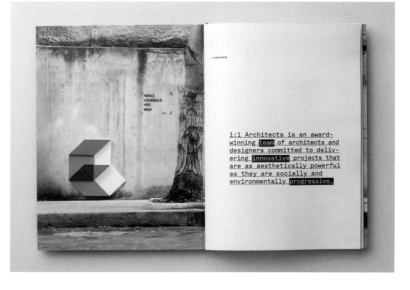

1:1 Architects

1:1 Architects is a mid-sized architectural practice. Founded to deliver projects with a much-needed human scale, the studio builds conversational relationships with clients, partners, and end-users. Aligning with the unique characteristics of the practice, a layered corporate identity was developed consisting of a logotype, three-dimensional picture mark, series of brand images, typography, patterning, studio photography, written language, and primary, secondary and accent color palettes. The mark was based on the geometric principals of the tesseract (a four-dimensional cube), where imagination and varying inputs create many possible angles. Unique in its three-dimensional form, the picture mark references the process of architecture. Not complete until constructed, the mark was imagined, sketched, planned, rendered, and built.

left Right up down under over around in between in front behind in out and back again.

First Class Mail
US Postage
PAID
New Haven, CT
Permit No. 526

MFA Graphic Design
Thesis Exhibition
May 10–14, 2008
Opening May 10, 7 pm
Green Hall Gallery

(203) 432 2600
art.yale.edu/gdshow

Yale School of Art
1156 Chapel Street
New Haven, CT 06511
United States

Julian Bittiner
Stina Carlberg
Tomáš Celizna
Daniel Harding
Dawn Joseph
Jin-Yeoul Jung

Emily Larned
Lan Lan Liu
Thomas Manning
Ken Meier
Min Oh
Bethany Powell

Nicholas Rock
Stewart Smith
Fan Wu
David Yun
Roxane Zargham

MFA Graphic Design
Thesis Exhibition
May 10–14, 2008
Opening May 10, 7 pm
Yale School of Art
Green Hall Gallery

An installation by 17 graduate graphic design students at the Yale School of Art. art.yale.edu/gdshow

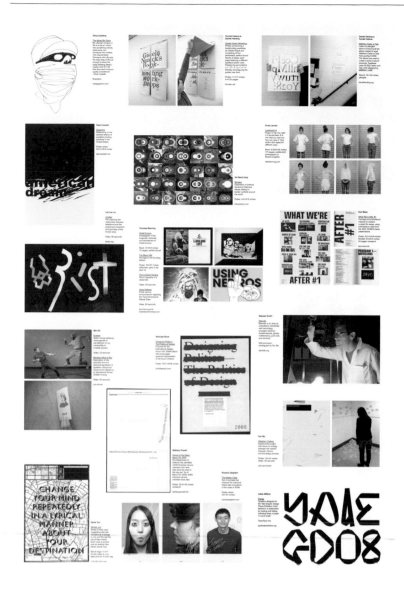

Left Right Up Down

This poster served as an invitation to my class' graduate thesis exhibition at the Yale School of Art, and the custom typeface I created for it served as the exhibition's identity. The idea for the type came from a scale model we had created for the purposes of planning the exhibition. Our idea for the show was to print all of our work on one continuous sheet of paper. As we were plotting the path of the paper through the various levels of the gallery, I realized its potential for creating letterforms.

Julian Bittiner // New York, USA // www.julianbittiner.com

Julian Bittiner, originally from Geneva, Switzerland, established his New York-based practice in 2004, focusing primarily on the cultural sector. His work is characterized by an interest in the greater context of art and design and its relationship to our social environment.

Which work of yours are you especially happy with? I enjoy making different work for different reasons, but in general I enjoy the element of surprise or discovery, like, for instance, when I find a solution to a particularly troublesome problem, or an opportunity where there seemingly was none.

What do you consider quality in graphic design? The Dutch designer Karel Martens often characterizes work as having varying levels of "authenticity," by which I think he means direct, purposeful work that bears the unique qualities of the individual designer—work that has strong and clear intentions usually makes for an interesting project whether I personally like it or not.

What inspires you? The short answer might be people and places.

What aggravates you? People with no empathy. Places with no character.

Are you a team worker or a lone fighter? I generally work alone but enjoy collaborating on occasion.

If you could live in another place for one year, where would that be? Almost anywhere but perhaps somewhere in southwest France.

If you were not a graphic designer, what would you be? A croissant taster, if that job exists.

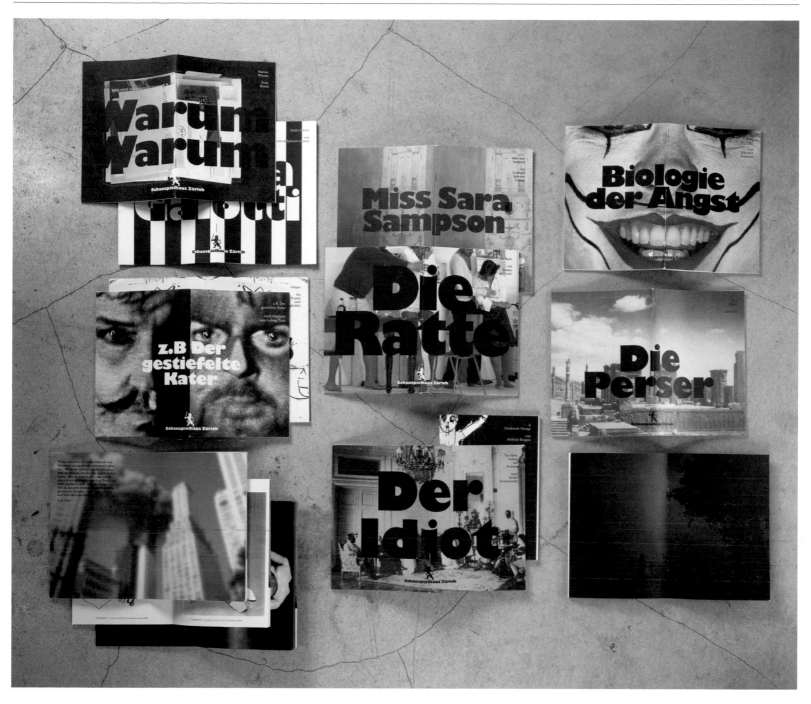

Schauspielhaus Zürich

What is special, unusual, or unique about this project? The use of the exaggerated Gill Super Bold as a brace throughout the many applications. It had to be something that was very simple to use and still had a strong character.

Did you run into any specific problems or challenges while creating this work? The dramatic advisers are pretty hard to work with. We didn't expect that at all. I guess customers are customers, even if they come from a creative field.

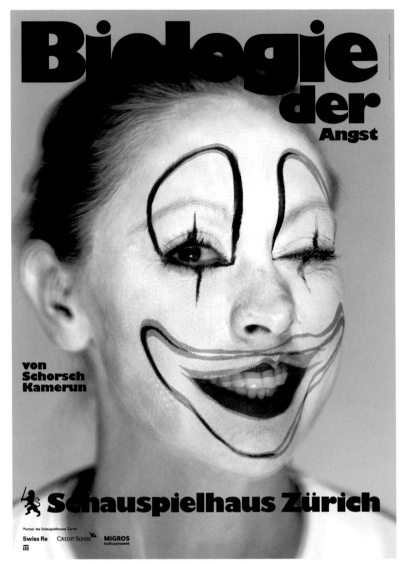

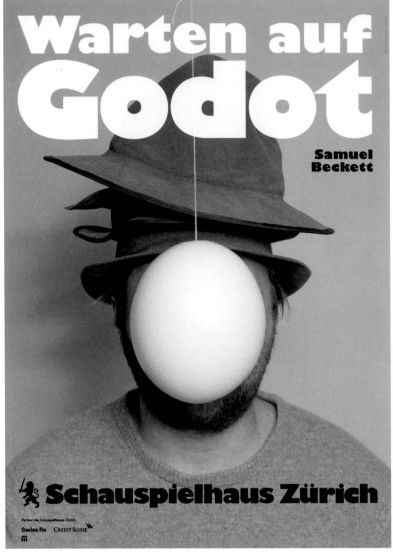

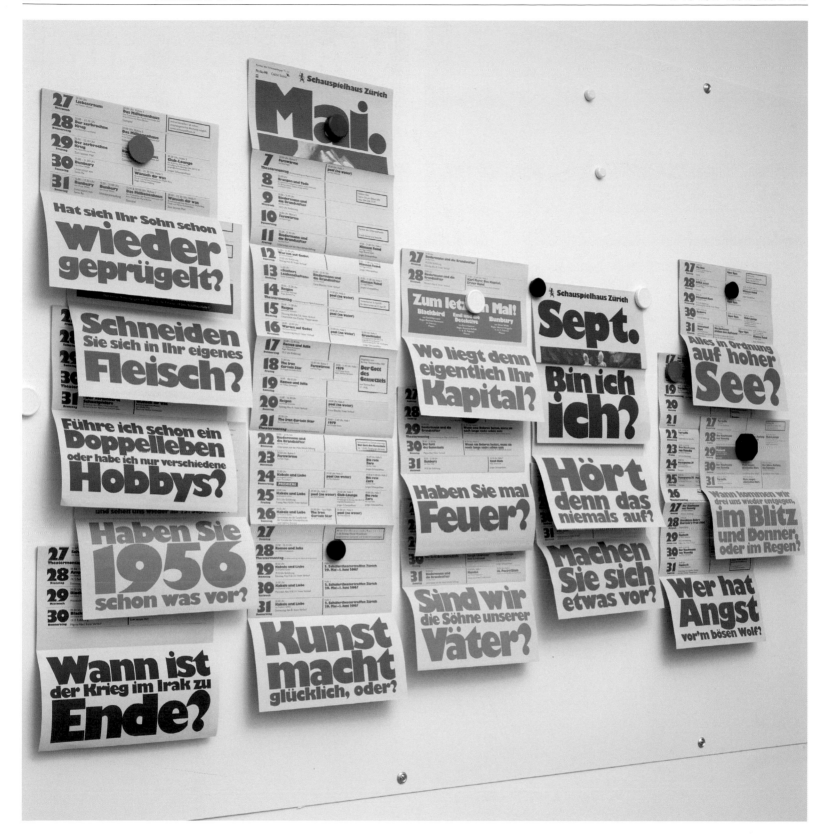

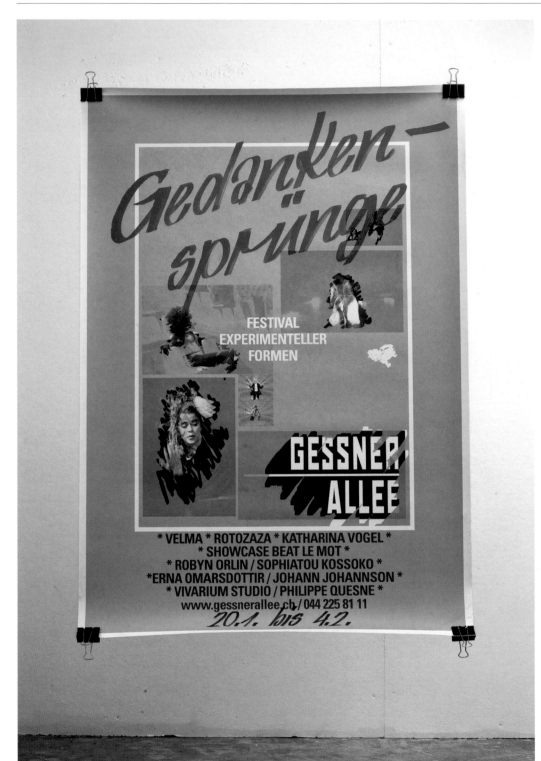

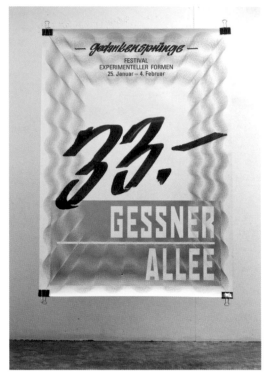

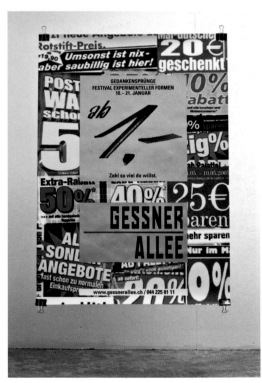

Theaterhaus Gessnerallee

What is special, unusual, or unique about this project? With very limited resources, we created maximum attention.
Did you run into any specific problems or challenges while creating this work? The client is very happy with the concept, so it was difficult to make any new changes to the design.

Do you recall unexpected reactions to this work? A theater in Lyon has copied our layout.

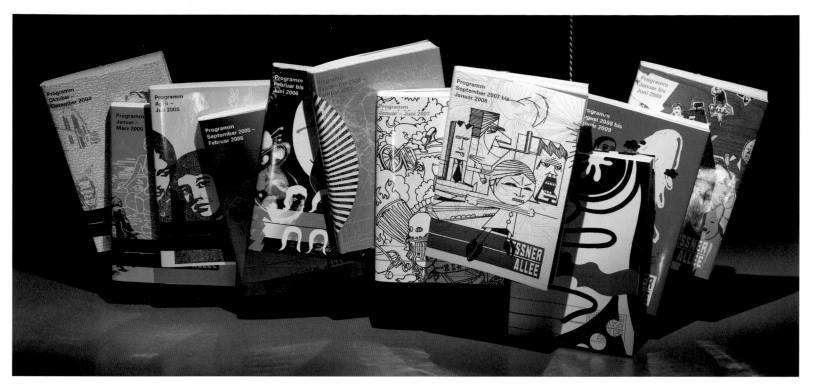

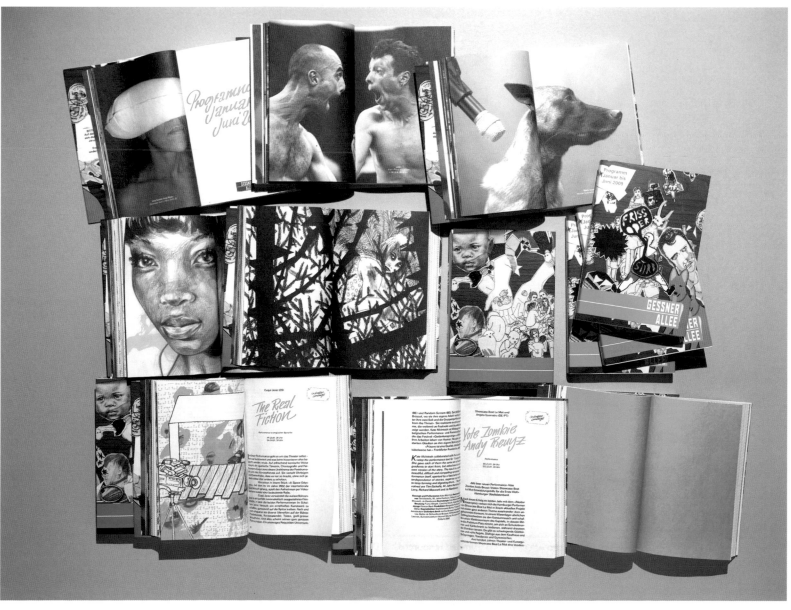

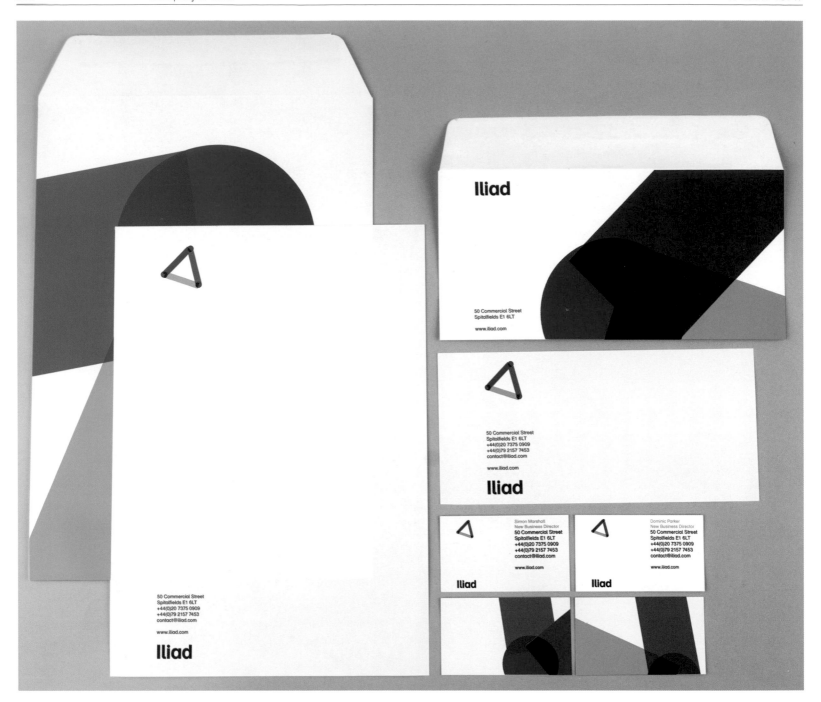

Iliad

This exclusive business network for young executives wanted an identity that stands out from the competition.
Taking the idea of connections as our inspiration, we linked three "i"s (individual, relationship, network) to create a tilted, triangular logo that radiates energy and movement.

The bold choice of colors reflects the dynamism of the product, while the inter-connected colors represent the transformative power of networking. Crops of the logo were used for the stationery.

Company // London, United Kingdom // www.company-london.com

Launched in 2006, Company is a small design studio based in London. With a close team of designers, developers, and project managers, Company works in all fields of graphic design, with a focus on the art sector. Their designs are inspired by a desire to make people think, smile, or see things differently.
What do you consider quality in graphic design? Strong ideas in simple and direct messages. Good knowledge of typography.
What does your working environment look like? A craftmaker's studio; everyone sitting and chatting around one big table.
Do you have a work motto? Simple, direct, playful.
What inspires you? Music, architecture, movies, and everyday life.

How do you get new ideas when you are stuck? We find new ideas by sharing our thoughts with others or we just go for a walk.
What guidelines and advice would you give students of graphic design? To find strong reasons why they are choosing to study graphic design and to always learn and play. To not look at graphic design books. They can make you lazy.
Are you a team worker or a lone fighter? Definitely team workers. We believe it's all about sharing ideas.
Five things we are crazy about: Music, architecture, films, Penguin's Great Ideas publications, coffee.

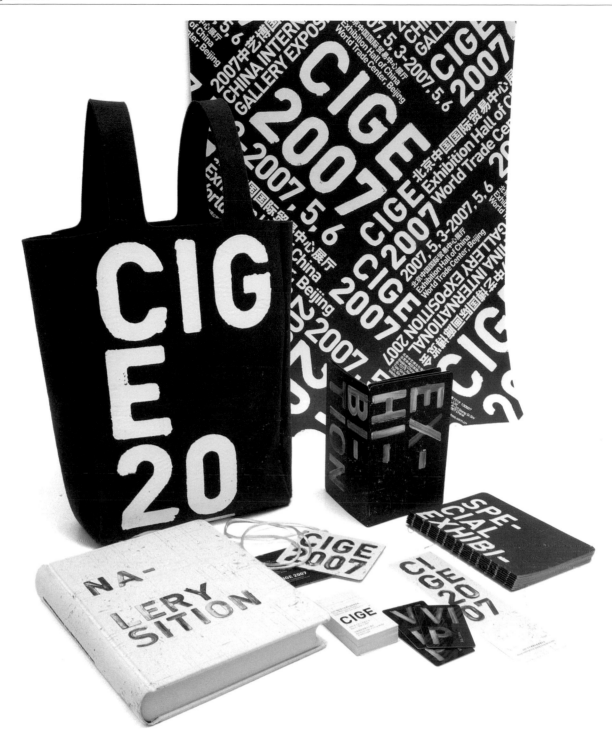

CIGE (China International Gallery Exhibition)

The promotion material is made by the technique of screen printing. The cover of the catalog is offset printed with two colors on cloth, which gives the effect of the trace of eraser. Then it is screen overprinted multiple times to add the thickness of the raised text string. To achieve the exact thickness on this bag, it was printed more than eight times. The bag was very popular. Many other clients also started to order similar products. And some people still carry the bags around today.

Undesign // Guang Yu/ Beijing, China // undesign@163.com

Being a founder of the Mewe Design Alliance, Guang Yu established his own studio "undesign" in 2009 in Beijing, collaborating within a network of various designers.
Describe your early influences. I was influenced by UK design and Japanese design.
Britain has a lot of independent graphic designers and studios, and their works are filled with a wealth of imagination, expression, and conception, especially in typography and illustration. The Japanese designers are more concerned about Eastern philosophy.

Do you have a work motto? Undesign.
What inspires you? Rich and colorful life.
What guidelines and advice would you give students of graphic design? No lectures.
Tell us the story of the name of your studio. It's my Eastern philosophy: undesign.
What is your dream of happiness? Not being satisfied in any of my work.
If you could live in another place for one year, where would that be? Tokyo.
If you were not a graphic designer, what would you be? Musician.

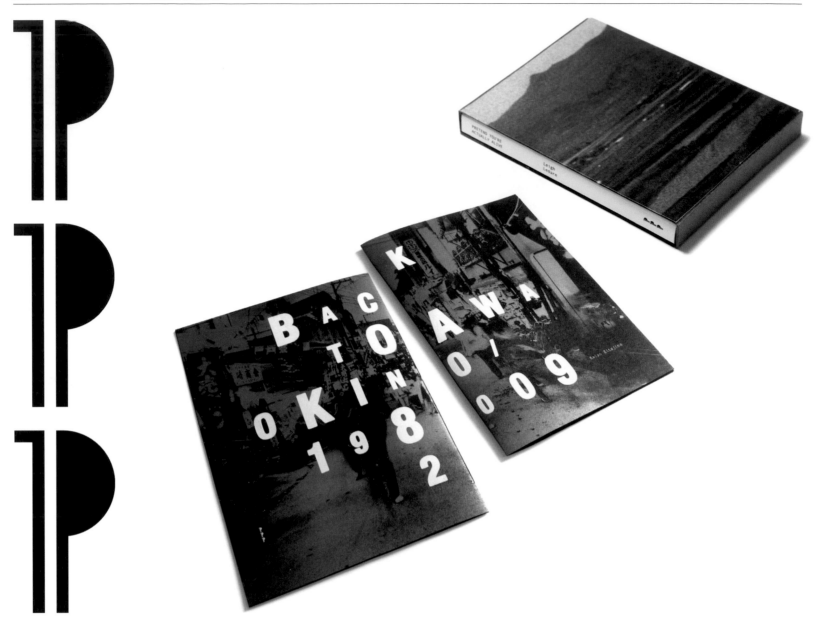

PPP Editions

PPP Editions is a publisher of limited-edition art and photography books. When we were working on the logo, the only direction the client gave us was that the logo should work well vertically on the spines of his books. Instead of using the letter "P" we used three pilcrow (or paragraph) symbols. By their nature, three of these symbols would have to fall on top of one another, thus the logo can only exist vertically.

Also we liked using a symbol that is specific to proofreading and production (the behind the scenes part of publishing), yet using it in the logo forces it to be consumer-facing. Currently we design all materials for the brand, books and exhibitions, plus related invites and ephemera.

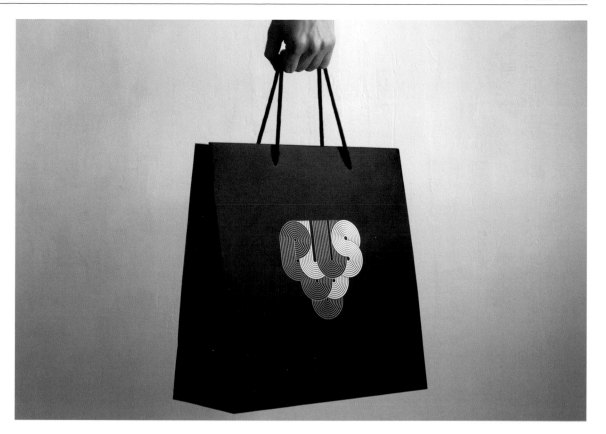

Plus

For this work, we just tried to create an identity with the name hidden in modular
shapes. We wanted to create an icon, an image more than a logotype.

HKDA Awards

The multidisciplinary award for professional designs in the fields of graphic, product, spatial, and new media has been organized for the past thirty years by the Hong Kong Designers Association. Creating the campaigns and event identity on everything from Call-for-Entries and Judges Seminars to Award Presentation and Exhibitions, including all printed materials and accompanying Web sites, we came up with the theme "Design. No Junk Food." The Call-for-Entries posters, using bold red and white typography, were designed as wrapping papers for all the participants to "wrap their fresh stuff" in. The six overseas judges that were invited to give a seminar, were asked to provide a short statement on what "Design. No Junk Food" meant to them. Six stamps carrying different statements were made for students to choose their favorite by stamping on the invitation card as ticket. The Award Presentation and Exhibition was the conclusion to the project. The selection entries wrapped with "Design. No Junk Food" posters was the key image echoing with the Call-for-Entries series. All large statements were also wrapped as wall graphics at the exhibition.

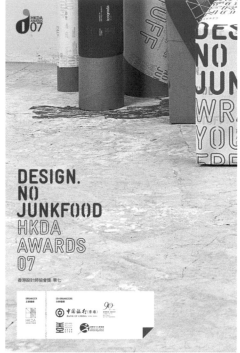

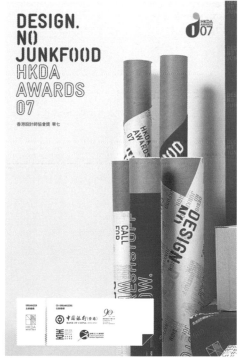

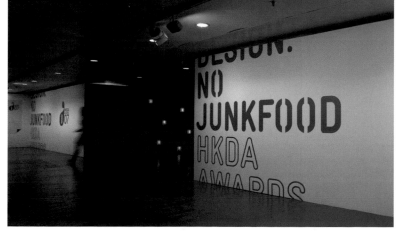

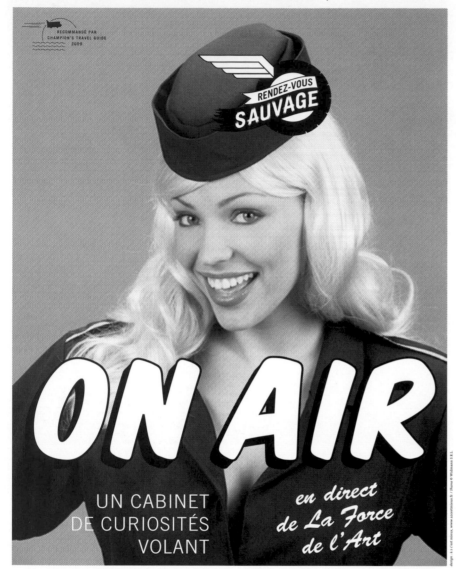

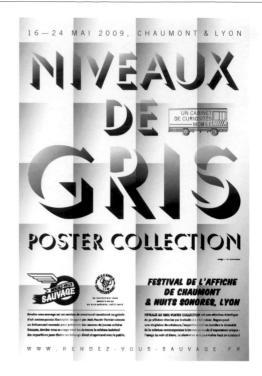

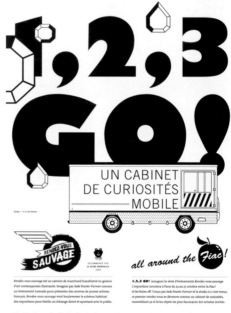

Rendez-vous sauvage

The Rendez-vous sauvage is an unconventional artistic event: we have transformed a canteen truck into a mobile contemporary art gallery. We shaped the graphic identity of the project (our logo is an homage to U.S. bikers) and the communication tools: posters, Web site, press release books, leaflets, truck signage, and souvenirs of the show.

à 2 c'est mieux // Aurore Lameyre, Vincent de Hoÿm // Paris, France // www.a2cestmieux.fr

Aurore Lameyre and Vincent de Hoÿm work within the fields of print and digital medias. Aurore and Vincent provide their clients with simple solutions, paying particularly close attention to the fabrics used and various production processes. They enjoy curating events and building collective projects. In September 2008, they co-founded with Jade Fourès-Varnier the travelling art gallery Rendez-vous sauvage.
Describe your early influences. We love the direct style of Anglo-Saxon design: strong ideas with a playful twist.
What do you consider quality in graphic design? Freedom, creativity, and a sense of humor.

Do you have a work motto? *Mieux voient quatre yeux que deux* (Four eyes are better than two).
How do you get new ideas when you are stuck? Going back to the south of France, where we are both from. Vive la Méditerranée!
Tell us the story of the name of your studio. When we were looking for a name for our studio, we wanted a name that sounds like an assertion.
If you were not graphic designers what would you be? Aurore: Madonna. Vincent: Maradona.

IABR – Visual Identity and Brochure

The design of the logo for the International Architecture Biennale Rotterdam was inspired by the beauty of the symbols and patterns on maps. The logo is variable and comes in different colors and patterns.

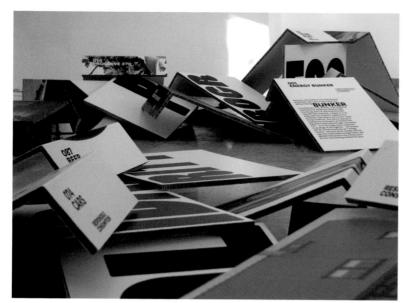

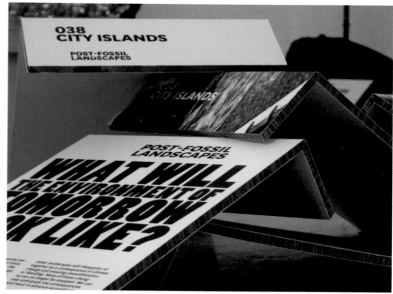

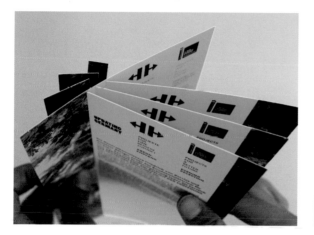

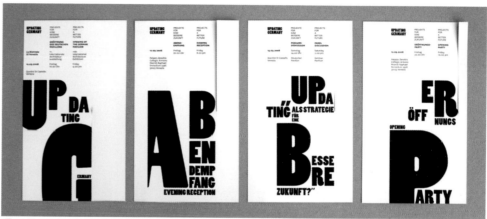

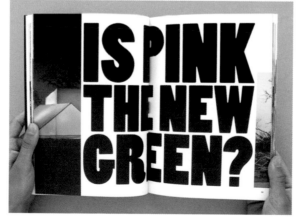

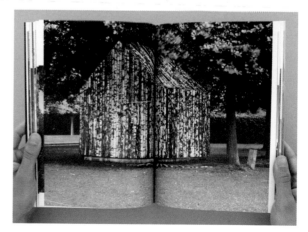

Updating Germany

The inspiration for this work was the balance of nature, that ecological systems are usually in a stable equilibrium. We had to manage to stage one hundred totally different projects for a better future within a book and, at the same time, in an exhibition space. The main problem was to be able to tell a story using a metaphor so that the visitors understands the challenge, without being didactical or pathetic. Architecture journalism is very academic and I was surprised that the press understands our purpose and message in a constructive way.

NORA SCHULTZ

23.4.–7.6.09

Kölnischer
Kunstverein

Die Brücke
Hahnenstraße 6
D-50667 Köln
www.koelnischerkunstverein.de
Design by Manuel Raeder and Nora Schultz

Kölnischer Kunstverein

All the work came into existence through having a direct dialogue with the artists and the curators. Therefore, its design evolves through the content and collaborative act with the curator/artist and me. The invites and posters for the Kölnischer Kunstverein are fixed in size and in the fact that the name of the museum is always type set in two lines as Akzidenz Grotesk. But apart from that, the design changes every time in relation to what the exhibition is about. Therefore, the poster or invites sometimes form a parallel dialogue to the exhibition. They might even question the content of the show or contradict it totally.

Manuel Raeder // Berlin, Germany // www.manuelraeder.co.uk

Working in the field of graphic design and art, Manuel Raeders output includes exhibition catalogs, artists monographs, posters, and invitations as well as drawings, photographic images, videos, and installations.

What do you consider quality in graphic design? A design practice that is open to interpretation and widening dialogues rather then narrowing them down. Design is capable of creating social circles and also it's capable on criticizing and creating a dialogue on political and social situations.

Do you have a work motto? It changes every couple of days or even hours or minute.

If you could live in another place for one year, where would that be? I'm constantly trying to move back and forth between different places. So partly I was based in Mexico City the past years. But also this year I had worked for one month from Brazil. Still the main base and the studio base is in Berlin.

What does your working environment look like? The studio is based near Alexanderplatz; it's in a back yard and has three separated working rooms. One with a huge bookshelf and some of the furniture in the studio was designed by me.

What inspires you? Friends, family, reading, walking, swimming, talking, everyday life really.

What aggravates you? Conservative thinking and the way it is accepted on a big scale nowadays.

PROGRAMM KÖLNISCHER KUNSTVEREIN HERBST 07

E L E G A N C E

Many

Challenges

Lie Ahead

Vladimir Nikolić

in the Miloš Tomić

Near Bojan Šarčević

Lulzim Zeqiri

Future

Kölnischer
Kunstverein
AUSSTELLUNG
Die Brücke
Hahnenstraße 6
D-50667 Köln

Öffnungszeiten:
Dienstag–Freitag 13–19 Uhr
Samstag–Sonntag 11–18 Uhr

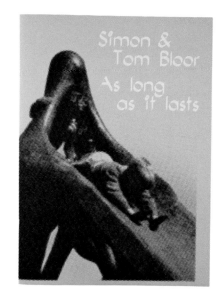

Simon and Tom Bloor: *As Long As It Lasts*

This was a collaboration between myself and the artists Simon and Tom Bloor. It is a documentation and extension of their exhibition *As Long As It Lasts at Eastside Projects* in Birmingham, UK. The book is printed entirely in fluorescent inks—the process cyan, magenta, and yellow are substituted with fluorescent colors and an additional fluorescent green. These inks are used to reproduce the coloring of several works in the exhibition that used fluorescent papers and spray paints. Each image had to be converted and individually color corrected to exploit the effects possible with the special inks.

Photo Credits

Many thanks to the producers of print design featured in this book, especially for granting us the right to reproduce their images. Should any third-party copyrights have been overlooked despite of our thorough research, we ask the owner of these rights to contact the publisher.